NOBEL SYMPOSIUM 45
The Feeling for Nature and the Landscape of Man

THE FEELING FOR NATURE
AND THE LANDSCAPE OF MAN

Proceedings of the 45th Nobel Symposium

held September 10—12, 1978 in Göteborg

to celebrate the 200th anniversary of

THE ROYAL SOCIETY OF ARTS AND SCIENCES

OF GÖTEBORG

Edited by Paul Hallberg

Göteborg 1980

Distr.:
Kungl. Vetenskaps- och Vitterhets-Samhället i Göteborg
c/o Göteborgs Universitetsbibliotek
P. O. Box 5096 — S-402 22 GÖTEBORG — Sweden
ISBN 91-85252-23-9

RUNDQVISTS BOKTRYCKERI, GÖTEBORG 1980

Editorial Preface

On 19th August 1778 King Gustaf III of Sweden signed the charter giving his sanction to the Society of Arts and Sciences of Göteborg, thus making it a Royal Society.

In order to celebrate the 200th anniversary of this event the Society organized two international symposia in September 1978. The theme of the first symposium (8th-10th September) was "The Condition of Man", and that of the second — a Nobel symposium — was "The Feeling for Nature and the Landscape of Man" (10th-12th September). H.M. King Carl XVI Gustaf honoured the symposia with his presence on 10th September. The sessions were open to an invited audience as well as to members of the Society. Each of the symposia was concluded by a general discussion which was attended by a wider public.

The Nobel symposium on "The Feeling for Nature and the Landscape of Man" was financed by the Nobel Foundation through grants from the Bank of Sweden Tercentenary Foundation on the recommendation of the Swedish Academy.

This volume contains all but one of the papers presented at the symposium on "The Feeling for Nature and the Landscape of Man", with summaries of the subsequent discussions. The sole exception is the contribution by Mr. Richard Adams, who spoke without a manuscript on "A Country Childhood: the Inspiration for *Watership Down*" and showed a series of colour slides depicting some fifty of the actual places described in his book. Unfortunately, because of the very close connection between words and pictures, it has not proved feasible to include the lecture in this book.

In some instances papers have been amended by their authors after the symposium. I am indebted to Professor Gunnar von Proschwitz for transcribing the discussions in French from the tape recordings.

<div align="right">The Editor</div>

CONTENTS

INTRODUCTORY ADDRESS

By Erik Lönnroth

Ladies and gentlemen, most distinguished guests from abroad and from our own country!

A Nobel symposium is meant to be something rather special — at least the institution is only to be found in Sweden. Such symposia take up themes of importance within the Nobel prize areas, recommended by the prize-awarding institutions. Our symposium belongs naturally to the province of the Swedish Academy: it is a study of art and fiction and of the ecology of certain fiction, of the interchange between ideals of landscape and the practical forming of landscape by cultivation or by exploitation. To an historian this is very natural as a main theme. It helps us to understand how people have reacted to their environment and to appreciate the pictures they have made of their surroundings in art and poetry. To some people today such a study may seem fanciful — there is a common tendency to regard everday experience as empirical truth valid for all times. That this is not the case is a truism, but how can we find the way to a right understanding of the past?

This symposium is an experiment in confronting literary creation with a realistic study of nature. We do not populate our woods and pastures with Greek gods and dryads any more — we usually avoid the pantheistic spiritualization of nature which characterized the deep feeling of the age of romanticism. But our need to identify ourselves with certain landscapes is still urgent. Perhaps this is more characteristic of Swedes than of others — we are the people of Linnaeus and his followers, and at the same time a nation with an intense nature poetry born of the longing for the miracle of summer in the long annual torment of cold and darkness. We are not boasting of being unique in these matters, but they mean much to us, and we are eager to learn about the feelings and experience of others.

And so, ladies and gentlemen, I declare the first session of the symposium open, with the sincere hope that you will find these few days both stimulating and rewarding.

11

AN INHERITED PERSPECTIVE:
LANDSCAPE AND THE INDIGENOUS EYE

By Ronald Blythe

'Any landscape is a condition of the spirit,' wrote Henri-Frédéric Amiel in his *Journal Intime*. As a Swiss he could have been reproaching all those British intellectuals and divines who abandoned what their own country had to offer by way of transcendental scenery, the Lake District then beginning to lose its efficacy as a spiritual restorative by the mid-nineteenth century, for the Jungfrau and the Matterhorn. *Any* landscape is a condition of the spirit. A few months ago I happened to glance up from my book as the train was rushing towards Lincoln to see, momentarily yet with a sharp definition, first the platform name and then the niggard features of one of the most essential native landscapes in English literature, John Clare's Helpston. I had not realised that the train would pass through it, or that one could. It was all over in seconds, that glimpse of the confined prospect of a great poet, but not before I had been reminded that he had thrived for only as long as he had been contained within those flat village boundaries. When they shifted him out of his parish, although only three miles distance — and for his own good, as they said — he began to disintegrate, his intelligence fading like the scenes which had nourished it. Of all our poets, none had more need to be exactly *placed* than John Clare. His essential requirements in landscape were minimal and frugal, like those of certain plants which do best in a narrow pot of unchanged soil.

I observed this tiny, yet hugely sufficient, world of his dip by under scudding clouds. A church smudge — and his grave an indefinable fraction of it — some darkening hedges, probably those planted after the Enclosure Act had stopped the clock of the old cyclic revolutions of Helpston's agriculture, and thus initiating Clare's disorientation, a few low-pitched modern dwellings, and that was all. It was scarcely more impressive in Clare's lifetime. A contemporary clergyman, gazing at it, said that 'its unbroken tracts strained and tortured the sight'. But not the poet's sight, of course. This it nourished and extended with its modest images. He liked to follow the view

past the 'lands', which he disliked because of the way they over-taxed the strength of his slight body when he laboured on them, to where the cultivation dropped away into a meeting with heath and fen. From here onwards the alluvial soil swept unbroken to the sea. It was this landscape of the limestone heath, he said, which 'made my being'. And thus it was in this practically featureless country that genius discovered all that it required for its total expression. From it Clare was to suffer a triple expulsion. The first entailed that fracture from his childhood vision of his home scene — something which we all have to endure. The second was when the fields and roads of Helpston were radically re-designed in 1816, evicting him from all its ancient certainties, and third, and quite the most terrible, when it was arranged for him to live in the *next* village, a well-meaning interference with an inherited perspective which, in his special case, guaranteed the further journey to Northampton Lunatic Asylum.

To be a native once meant to be a born thrall. Clare's enthralment by Helpston presents the indigenous eye at its purest and most naturally disciplined. By his extraordinary ability to see furthest when the view was strictly limited, he was able to develop a range of perception which outstripped the most accomplished and travelled commentary on landscape and Nature, of which in the early nineteenth century there was a great deal. He had no choice. He did not pick on Helpston as a subject. There was no other place. As a boy, like most children, he had once set out from his village to find 'the world's end', and got lost.

> So I eagerly wanderd on & rambled along the furze the whole day till I got out of my knowledge when the very wild flowers seemd to forget me & I imagind they were the inhabitants of new countrys the very sun seemd to be a new one & shining in a different quarter of the sky.

is how he described this adventure in his *Autobiography*. And twice more in this book, when he was aged twenty and when he was aged fifteen, he tells of a kind of geographical giddiness, such as that which one has when being spun round blindfold in some game, when he had to leave the balanced centre of his native village to look for work in nearby market towns, and his sense of psychic displacement went far beyond that which could have been brought on by the strain

13

of interviews, etc. Listen to Clare again as the universe itself careens out of control because he is unable to use his village reference points.

> I started for Wisbeach with a timid sort of pleasure & when I got to Glinton turnpike I turnd back to look on the old church as if I was going into another country Wisbeach was a foreign land to me for I had never been above eight miles from home in my life I coud not fancy England much larger than the part I knew . . .
>
> I became so ignorant in this far land that I coud not tell which quarter the wind blew from & I even was foolish enough to think the sun's course was alterd & that it rose in the west & set in the east I often puzzled at it to set myself right . . .

'I became so ignorant in this far land . . .', 'to set myself right' — these are the telling words. Beyond his own parish boundary Clare felt that he was ignorant. He felt his intelligence desert him and that another man's scene — even another man's sun — could not be understood. When the success of his two collections of published poems brought him into contact with literary London, an event for which many a provincial writer prayed in the hope that their work would provide the exit visa from the limitations which had inspired it, Clare reacted very wisely indeed. 'It seems', says John Barrell in his excellent study *The Idea of Landscape and the Sense of Place: An Approach to the Poetry of John Clare*, 'that the more the poet began to understand about literary London, the more tenacious became his desire to write exclusively about Helpston.' London's literary landscapes knew no bounds at all. They swept back in immense, formal vistas carrying the educated eye to valleys in Thessaly and to Roman farms. Knowing that he can never be entirely free at home and accepting an element of imprisonment as the major condition for his being a poet, Clare chose the local view.

I believe that, whether with a feeling of relief or despair — or both — the majority of what are called regional poets and novelists come to a similar decision. Their feeling for nature and the landscape of man, the subject of this symposium, deepens when it remains hedged about by familiar considerations. Paradoxically, they discover that it is *not* by straying far from the headlands that they are able to transport their readers into the farthest realms of the imagination and its truths, but by staying put.

14

I find that I have two states of local landscape consciousness. The first I would call instinctive and unlettered, a mindfulness of my own territory which has been artlessly and sensuously imbibed. On top of this I have a country which I have deducted or discovered from scientific, sociological, aesthetic and religious forays into its intellectual depths. Of course, like the rest of us, I want my cake and eat it too. I do not want the first knowledge, wherein lies all the heart and magic, to give way entirely to the second knowledge, wherein lie all the facts. It is the usual dilemma of intuition versus tuition and how to reconcile the one with the other without patronising either. Because my boyhood East Anglia was by far the major source of all the references which have directed me as a writer, I find myself constantly hankering after primordial statements which still float around in my memory, and which seem to say something more relevant about my own geography than anything my trained intelligence can tell me, yet which tantalisingly avoid definition. All the same, I must say something about the fields and streams and skies, the cottages, Gothic churches, lanes and woods of Suffolk as I first recognised them. This could have been the time when I knew the river but did not know its name. Certainly it is a verifiable fact that much which can be seen now could be seen then — when I was ten or twelve. Or two or three. When does one begin to look? Or does landscape enter the bloodstream with the milk?

'Local' — a limited region, says the dictionary. And 'location', the marking out or surveying of a tract of land. Also a position in space. So, early on, we begin to take stock of our limited regions, marking them out, and with never a suspicion that they at this period could be marking *us* out. I took stock of flowers first, then paths and then architecture. I do not know that I ever at this time took stock of weather or of inhabitants. The latter were thin then, pared down to the high cheek-bone by the long agricultural depression and with skins polished by the winds. But however great the omissions, I saw enough to lay in a lasting stock of feeling and emotion, for as Lord Holland said, 'There is not a living creature . . . but hath the sense of feeling, although it hath none else.' We, of course, are taking feeling beyond such an elementary sensation and into human sensibility. It is this proto-sensibility created by the impact of Nature on our earliest awareness that intrigues us later on. We know that

15

climates create cultures and cultures create types, but an individual voice within us says that there is more to it than this, conceit notwithstanding.

'Those scenes made me a painter', wrote John Constable, acknowledging the river valley in which I now live and just above which I was born. It has been said that from these scenes he fashioned the best-loved landscapes of every English mind. Thomas Gainsborough too, another local boy pushed into art by scenery, was born in this valley and was sketching along the same footpaths in the eighteenth century as I, when a child, was wandering in the twentieth. Indeed, my old farmhouse is roughly perched at the frontier of these two artists' territorial river inspirations. Gainsborough's landscape was upstream and flowing back in golden-brown vistas to the Dutch masters; Constable's was downstream and flowing forward to the French Impressionists. When I was an adolescent, these two local painters dominated my equally native landscape to an alarming extent, often making it impossible to see a field for myself. And I was further alarmed when I heard that Sickert had called the entire district a sucked orange. Would there be anything left for a writer to feed on, or would I be like someone attempting to take an original view of Haworth or Egdon Heath? Ancestry decided it. Not that I knew much about the centuries of farming fathers stretching away from me, perhaps into Saxon days, but the realisation that our eyes had repeatedly seen the same sights began to promote a way of looking at life which was vigorous and questioning, and which did not depend on past conclusions.

And so what was my inherited perspective? What, particularly, was I recognising before I was educated in history and ecology and, most potently, in literature? Or even in local loyalty, for in all the provinces, in every hamlet, one might say, there is this beaming self-congratulation of those who have been born there and who indicate that it would be superfluous to ask more of life. In milage terms, although not quite as restricted as Clare, as a boy in those immediate post-World-War-Two days from a rural family apparently existing on air, I saw a very little world indeed. Until I was twelve or so, East Anglia was for me no more than a small circle of villages round a small town, plus an annually visited beach, or rather a slipping, clinking wall of cold shingle, monotonously piled up and pulled

down by the North Sea. The landscape of Crabbe, in fact, who had made the definitive statement about it. Benjamin Britten was able to say something more, or else, about it in another medium. I saw this beach as the edge to my interior landscape, disregarding the distance in between. So from the beginning I was laying claim to a broader scenic inheritance than some writers.

The Cumbrian poet Norman Nicholson has not only restricted himself to Millom, his home town, but finds himself far from cramped, creatively speaking, in the modest house where he was born and where his grandparents' wallpapers lie beneath his own interior decoration like a palimpsest of their domesticity. Nicholson warns us, particularly writers, of how we tend to overload infant experience with intelligence of a later date. At the beginning of his autobiography he gives a remarkably convincing apology for the merest squint of landscape being adequate for a child's imaginative growth. In comparison with his first contemplation of Nature, mine was on the scale of the Grand Canyon. His confession is all the more interesting because just a mile or two away from where he was making do with a creeper on a brick wall rolled landscape with a capital L, Wordsworth's landscape of the Lakes! During his early years this great scene had been bricked out without cost. It was the *bricked-in* prospect which became so perversely satisfying and which made his blood thunderous with imagination. Nicholson wrote of this backyard behind his father's tailor's shop as

a little Eden, a Garden Enclosed. Even today I survey it with a complacency equal to that of any Duke of Devonshire looking out from Chatsworth ... seen from the yard, there was only the sky, broken by two telephone poles and a pulley for a washing-line. And when you looked out of the window of the little back bedroom, you could see the explanation of this emptiness, for the whole length of the other side of the street was taken up by the wall of the old Millom Secondary School, almost every corner of which could be kept under watch from our house ... But if I climb up to our second storey and push my head out of the fanlight in the back attic, I can look ... and see what I used to see, the St George's Hall, the scraggy, slag-clogged fields, the old mines at Hodbarrow, the hills of Low Furness across the estuary (though) the view and even the school playground were all too far away to mean much to me at that age. I rarely ventured out into the street ... I stayed be-

hind the door, teasing the dog, trotting up and down the slate slabs that paved the yard or dibbling a fork into the few clods of soil we called our garden. For when my father first came to The Terrace, he had up-ended a row of black tiles, cemented them to the slate paving about a foot away from the wall and filled in in the space between tiles and wall with soil dug up with a pen-knife on his walk round the fields and carried home carefully in brown paper bags. In this he planted a few cuttings of Virginia Creeper (which) has routed its black arteries all over the walls, giving them the withered, sinewy look of an old coal-miner's arms . . .

Lying unclaimed and ignored, and within walking distance of this artfully skimped outlook, was the view proper, the massive outcrops of the Lake District rock and the broad Irish Sea, no less. Nicholson waited until he was grown-up before entering into this inheritance, and has half-mockingly rejoiced in being fashioned by a minimal view in one of the world's maximum areas of the literary imagination, and to have succeeded in getting himself awakened by it without having any idea that Wordsworth and Coleridge were crying 'Awake!' so profoundly a mile or two away.

My own powerful landscape inheritance was not walled off from me until I grew up. There was no pittance to start with in the shape of an elementary soil brought home in paper-bags, no rationing of the sky, no ignoring of the native scene's prophets, one of whom was no less than the foremost artist of the English Romantic Movement, John Constable. And yet, how little of it I comprehended as a boy! Looking back, I am as much intrigued by my blindness to the obvious, as by the way I sometimes instantly grasped some central truth. There seems to be a considerable osmotic action in landscape, particularly one's native landscape, which causes it to be breathed in as it thrusts against our earliest senses. Being there, right under our nose, we inhale it as well as comprehending it with our intellects. For some it is a fatal air, for others a kind of inescapable nourishment which expands the soul. Quite where the emotional — I will not say mindless — absorption and the instructed viewpoint began to fuse in myself, I find it impossible to say. Nor can I tell if I have continued all these years, living as I have among the first earthly patterns and colours I ever saw, to absorb them instinctively as well as intellectually. But I do recall some of those instances in which the obvious

18

says nothing to the child. For example, I climbed a road called Gallows Hill every day and never once did it say something agonising, macabre and morbid to me. What it said was freedom, running loose. Gallows Hill was the path to the white violet and cowslips sites — for plants remained undisturbed in their locations for generations then, and village people of all ages saw them as a form of permanent geography by which the distance of Sunday walks could be measured, or where tea or love could be made, or, in my case, where books could be read. These special flowers in their hereditary places were solidly picked, I might add, but there were always just as many next year. Had the victims of Gallows Hill picked them in the years before they picked pockets? I expect so.

Gallows Hill also led to Froissart and Malory for me, for just above stood a little moated manor with a castellated tower and swans on the dark water, and even now I see this as an annexed scene, as a house which does not belong to its residents, but to my most personal countryside. So do the aged village relations who sat foursquare in their lush gardens like monuments, as if growing out of the Suffolk clay itself, their bodies wooden and still, their eyes glittering and endlessly scanning leaves and birds and crops, their work done and their end near. I remember very distinctly how these old country people were not so much figures in a landscape, as local men and women who, in their senescence, were browning and hardening back into its simple basic elements.

As a rule, children draw back from the illimitable, except when they catch such suggestions of it in the experience of running down grassy slopes with open arms on a windy day, and prefer the secret, the clandestine and the enclosed. I had to grow up to see that East Anglia was not a snug den but a candid plain, an exposed and exposing place. Once it was all manageable privacies and concealments, each memorably furnished with its particular stones, flora, water and smells. In this secret range I included the North Sea, for although it was all of thirty miles off and seen so rarely, perhaps only once a year, I felt the same parochial tenderness about it as I did about the meadows — fields, really, gone to weed due to the agricultural depression — which led to my grandmother's house. As I sighted this quite unimaginably immense liquid wall at the end of the coast road, with the Rotterdam shipping riding its horizon, I can remember how it

revoked all the feelings I had for the interior. The sea makes us treacherous; it captures our senses and makes us faithless to the land. I found myself in a different state by the sea; not freed, but in another kind of captivity. I lived by it briefly when I first became a writer and felt myself both in my own deeply-rooted country and on the edge of things. The entire ecology changes long before one even suspects the presence of the Suffolk sea. A twelve-mile belt of light soil, which we call the sandlings, produces heath and coniferous forests, and pale airy villages, dyked meadows and vast stretching skies, and by the time one has reached the rattling beach, still guarded by forts built to repel Bonaparte and Hitler, the interior seems remote. This is the land of our 7th-century Swedish kings who lie buried in their great ships at Sutton Hoo and whose palace is under a Nato bomber base. Screaming sea-birds and screaming planes on practice runs, and often profound silences, this is the indigenous periphery. Also a cutting wind and an intriguing marine flora which between them force the gaze to the ground. This is Benjamin Britten's rim of country. When, at the end of his life, he worked for a brief spell in a cottage sunk in the cornlands of Suffolk, he told me how utterly different the imaginative stimulus was, and I realised that we had shared similar experiences of territorial disorientation within the home area, but from opposite directions.

What half-entranced, half-shocked me about the the coast was its prodigious wastefulness. Here nature was humanly unmanageable, and I was not deceived by breakwater and drain or the sly peace of the marshes. There was another kind wastefulness in the central clay country which, to my child's eye, was transmuted into a private harvest of benefits. Every hollow held water, and in the ancient horse-ponds and moats, under coverlets of viridescent slime starred with water ranunculus, lay the wicked pike, fish of legendary size, cunning and appetite which we believed were a century old, and which grew fat on suicides. The small heavy land fields had not then been opened up to suit modern machinery, and most of them possessed what the farmers called 'muddles', or uncultivated scraps which were crammed with birds, insects, flowers, shrubs, grasses and animals. Towering quickset hedges from enclosure days survived as well as mixed shrub hedges from Saxon, Norman and Tudor times, all still containing the oaktrees which Shakespearean ploughmen must

have used to set their first furrow. The surface of the land was littered with flint, and no matter however much was picked up for making churches and roads, no field was ever cleared, even when it was hand-'quarried' for a millennium. It was a kind of catch-crop which worked itself up to the surface from its silican depths to provide assured hard labour for each succeeding generation of country people. Its permanency was like that of the mountains to field-workers in the north. 'So light a foot will ne'er wear out the everlasting flint,' says the priest as Juliet approaches to marry Romeo. We expended a massive amount of energy splitting these weighty stones to find the toad which was said to live inside them. We also spent hours in vast old gravel-pits searching for 'dawn stones' (eoliths, as I was to learn in my gradual enlightenment), but which then I was convinced meant the first stones warmed by the sun in the first chapter of Genesis. We would spend whole days in these workings, many feet below the peripheral corn, scraping away at the partly-known and the unrealised, but really at our ultimate ancestry, the Scandinavian Maglemose forest folk who, ten thousand years ago, before the sea washed us away from the continental mainland to which we were tenuously attached by salty lagoons, walked to Suffolk and began the agricultural pattern-making on its fertile clays. We learned that they were followed by the Windmill Hill folk and the Beaker people, and these homely appellations would cut through time as the blade cut through June grass, making hay of its density. Distant past has moments of tangibility to a native, particularly to one who has not yet encountered the written history of his area. I can remember the need or compulsion I had to touch stones. I suppose I felt them for their eloquence and because an adjacent artifact told me that a Windmill boy might have done the same. Later, I came to love the stoniness of the symbolism in the poetry of Sidney Keyes, one of the best poets of the last war, who died in African sand, aged twenty-one.

It must be added that, seascape or richly delapidated clayscape, the natural history of my childhood was marvellously impacted with mystery. There were swaying rookeries and barns like dust-choked temples almost within the precincts of our market town, behind the main streets of which ran a maze of courts and yards fidgetty with sullen life. Naphtha flares blazed over the banana stalls and cheapjacks in the square, whilst mediaeval bells burled their sound for

miles along the river valley when the wind was right. Having the wind right for this or that was something one heard a lot about. It was the bitter wind of a dry country and you had to stand up to it, they said. Vagrants and itinerants brewing up in the shelter of marl-pits fought a losing battle against it, and the silk factory operatives, sweeping in and out of their villages on bicycles, were swept along by it like peddling birds. The scene was one of stagnant animation. One would catch the eye of a solitary worker among the sugar-beet, and it would be strangely hard and transparent, like glass. Extremes were normal. I once saw twenty men joyfully and silently clubbing scores of rats to death in a stackyard. No words, only rat-screams. Only a few yards from this spot Gainsborough had posed Mr and Mrs Robert Andrews against a spectacle made up of trees and towers and bending stream, and painted what Sir Sacheverell Sitwell has called the finest English domestic portrait. The young husband is seated between his gun and his wife. And once on this hill I heard the rarest, most exquisite aeolian music when the wind was right. It was a sound that made one weightless and emancipated, and I had that momentary sensation of *being* Nature — nothing less or else.

Richard Jefferies used a nineteenth century language to describe this transition of man-into-landscape and landscape-into-man in *The Story of My Heart*. We may have a later language or no language at all to put this feeling into words, but we have shared the experience. This is his way of putting it:

> Moving up the sweet short turf, at every step my heart seemed to obtain a wider horizon of feeling; with every inhalation of rich pure air, a deeper desire. The very light of the sun was whiter and more brilliant here. By the time I had reached the summit I had entirely forgotten the petty circumstances and the annoyances of existence. I felt myself, myself. There was an intrenchment on the summit, and going down into the fosse I walked round it slowly to recover breath . . . There the view was over a broad plain, beautiful with wheat, and inclosed by a perfect amphitheatre of green hills. Through these hills there was one narrow groove, or pass, southwards, where the white clouds seemed to close in the horizon. Woods hid the scattered hamlets and farmhouses, so that I was quite alone. I was utterly alone with the sun and the earth. Lying down on the grass, I spoke in my soul to the earth, the sun, the air, and the

distant sea far beyond sight. I thought of the earth's firmness
— I felt it bear me up . . .

Recognisable in this post-Darwinian, pre-Freudian landscape con-
fession is that confusion of the newly articulate response and in-
communicable sensation which all of us have known. Jefferies was
often exasperated by not being able to find a natural way to talk
about Nature. He saw that men operated on the assumption that Na-
ture was something which surrounded them but which did not enter
them. That, glorious though it was, and inspiring, they were outside
its jurisdiction. When they spoke of the influence of environment on
a person, they meant some aspect of men's social environment, not
climate and scenery. The man who, for some reason or other, re-
mains on his home ground, becomes more controlled by the control-
ling forces of all that he sees around him than he could wish or rea-
lise. Jefferies sought such a control in a quasi-religious and poetic pil-
grimage to the grassy heights above his Wiltshire farm, and Thomas
Hardy and Emily Brontë created immense dramas by allowing their
characters to be activated as much by weather and place as by society.
These, and many other writers and artists, shock us by showing
us the malignancy of the native scene, how it imprisons us as well as
releases us. Jefferies and Hardy, of course, were cynically amused
that we should imagine it would be interested in doing either.

However, because we have had such a considerable hand in the
actual arrangement of the local view, we must be allowed some sub-
jectivity. Over the centuries we introduced the non-indigenous trees
and flowers and crops, we made the roads, fields and buildings, and
we filled in the heath with forests and levelled the woods for corn.
What we see is not what Nature, left to its own devices, would let us
see. To be born and to die in an untouchable scene, in the wild moun-
tains, for example, is quite a different matter. Comparatively few
people do this. And so what the majority of us celebrate as natives is
native improvements. The shapes, colours and scents have an ances-
tral significance, and what moves us is that the vista does not radiate
from some proto-creation like a dawn-stone but that it is a series of
constructions made by our labouring fathers. Within these, the
normal partisan provincial will insist, must lie all that the inner and
outward life requires.

Landscape and human sensibility can come to shallow terms in villages, which are notorious for the resentment they display when some indigenous guide, poet or painter, presents them with the wider view. The field workers who saw Cézanne and Van Gogh painting, and John Clare writing, believed that they were in the company of blasphemers. In a letter to his publishers Clare complains how isolating it is to be in possession of a literate landscape.

> I wish I livd nearer you at least I wish London woud creep within 20 miles of Helpstone I don't wish Helpstone to shift its station I live here among the ignorant like a lost man in fact like a man whom the rest seem careless of having anything to do with — they hardly dare talk in my company for fear I should mention them in my writings & I find more pleasure in wandering the fields then mixing among my silent neighbours who are insensible of everything but toiling and talking of it & that to no purpose.

And yet, ironically, it was only by keeping their faces to the earth could these neighbours and their forebears carve out the sites where the poet's intelligence could dwell. The average home-landscape entailed more looking down than looking around. As for the agreeability of a used countryside, as the poet and critic Geoffrey Grigson said, 'When I see men, and women, bent over the crops, I realise it isn't so agreeable for them. 'C'est dur l'agriculture' (read Zola in La Terre). I like seeing machines which keep the human back from bending, as in the last five thousand years.'

Among other things when I was writing Akenfield, and thinking of the old and new farming generations, it struck me that I was seeing the last of those who made landscapes with the faces hanging down, like those of beasts, over the soil. Grigson also notes how artists and poets push landscape forward, thrust it into view and make contact with it unavoidable. In the past the figures which inhabited it were both gods and mortals, Venus and the village girl, Apollo and the shepherd. The scene was both natural and supernatural. And the indigenous man will occasionally look up from his disturbance of the surface of his territory as he earns his living, to draw into himself all that lies around him in a subconscious search for transcendence. From childhood on, what he sees, he is. Flesh becomes place. Although it was said of my East Anglian countryman, George

Borrow, that he could look at Nature without looking at himself. What an achievement!

Discussion

Richard Adams: The amount of education that a poet or a writer receives makes a great deal of difference to his feeling for his native landscape. John Clare was extremely unusual in being not only a not highly educated man, but a virtually *uneducated* man. A more intellectual poet is likely to be developed by getting beyond his original native landscape, which he very often seems to forget about altogether. For example, those contemporaries of Clare, Byron and Shelley, had no feeling for their native landscape — indeed they adopted other landscapes. They went to Italy and to Greece, and shortly afterwards Browning did exactly the same thing. In the present day we have the example of the British poet Laurie Lee, who having written a magnificent book about his native country got beyond it and wrote an equally magnificent book about his travels in Spain.

Then again we find economic and psychological restrictions in many British writers. Jefferies, Crabbe, Clare, Norman Nicholson, the Brontës — all these people were economically restricted to some extent to their native heath. In other cases, such as Cowper and Gray, there was a kind of psychological restriction; they were hypersensitives, which prevented them from getting out. Gray was acutely unhappy when he made the Grand Tour with Horace Walpole. Cowper was a melancholic who needed continual looking after and who remained in one place with a devoted woman for most of his adult life.

In fact it seems to me that very often — and certainly in my own case — an intense and passionate feeling for one's native landscape is the result of restriction, either economic or psychological. It is as though we cannot be happy without the one landscape which seems to us to be a kind of protective mother. Some people get beyond this, others do not, and the interesting thing is that it seems to make no difference to the *quality*, by which I mean that Clare is as splendid a poet as Byron, if not a finer one.

Ronald Blythe: Yes, of course you are right. Clare's publishers and some of his newly-made literary friends did advise him to escape,

not from Helpston but into the classical landscape which influenced most English poets, the Augustan concept of landscape. They actually said to this simple, uneducated and most brilliant poet, some of whose lyrics have been compared quite properly with Shakespeare's, that he should escape from these complexities by getting into this classical landscape, in fact that he should use the imagery of the educated poet. He didn't, of course, because he couldn't and he knew he didn't need to.

A lot of art has been produced, poetry as well as painting, by people unable for various reasons — family reasons, lack of money, lack of introductions, lack of knowledge of the world sometimes — to escape from where they belonged, and therefore using material at hand.

THE GARDEN AS PARADISE, ARCHITECTURA
NATURALIS AND IDEAL LANDSCAPE

By Sten Karling

Man's feeling for nature is part of what is most central to his being.
From what we know of the cultic notions of various peoples it is
clear that it has a religious basis. In the presence of sacred trees and
springs, groves and caverns, Man felt the nearness of the gods, and
this feeling was particularly strongly developed in the Greek and Ro-
man worlds. "Every spring had its nymph, every river its god, and
Zeus dwelt on every mountain top," says Martin P:son Nilsson.
Early Christian and Byzantine bookpainting preserves this classical
tradition. It is true that the Greeks associated life after death with
gloomy Hades, but they also connected it with Elysium, where those
favoured by the gods lived in green meadows, where the earth bore
harvests thrice a year, where frost was never known and the west
wind and the sea brought an agreeable freshness. This dream of
Elysium has much in common with one of the oldest descriptions of
a garden that we have, the description in the *Odyssey* of Alcinous's
estate:

> ... without the courtyard, hard by the door, is a great orchard
> of four acres, and a hedge runs about it on either side. Therein
> grow trees, tall and luxuriant, pears and pomegranates and
> apple-trees with their bright fruit, and sweet figs, and luxuriant
> olives. Of these the fruit perishes not nor fails in winter or in
> summer, but lasts throughout the year; and ever does the west
> wind, as it blows, quicken to life some fruits, and ripen others;
> pear upon pear waxes ripe, apple upon apple, cluster upon clus-
> ter, and fig upon fig. There, too, is his fruitful vineyard planted
> ... There again, by the last row of the vines, grow trim garden
> beds of every sort, blooming the year through, and therein
> are two springs, one of which sends its water throughout all
> the garden, while the other, over against it, flows beneath the
> threshold of the court toward the high house ... Such were
> the glorious gifts of the gods in the palace of Alcinous.

This garden blessed by the gods and so temptingly described re-
minds us a good deal not only of Elysium but also of the Christian

idea of Paradise, the pleasure-garden which, according to Genesis, the Lord God planted eastward in Eden and where the first human beings lived until, after the Fall, they were driven forth to a harsher existence. For Christians, the notion of Paradise became associated with that of the abode of the blessed. The name is of Persian origin, and was connected by Xenophon with the extensive royal walled pleasure-gardens which he had learned to know during his stay in Persia about 400 B. C. The Persian pleasure-gardens contained both grassy meadows, rich in herbs, and hunting-grounds filled with game; there were flower-beds and bowers, pools and running water, pavilions and courts for social intercourse. There were also buildings of a sacred character. Although these gardens included so much of primitive nature, they were at the same time laid out in accordance with well thought out principles. The pleasure-garden could be regarded as an ideal picture of the world as a whole, with fields, woods, rivers and hills.

Knowledge of these Persian pleasure-gardens spread, partly through Xenophon, to Greece and the Hellenic world, to Rome and at length to the medieval West. The crusaders became acquainted with the riches of the gardens of the Levant. Tales were told of their charms, of the wealth of fragrant flowers and delicious fruits. The descriptions provided material for conceptions of the heavenly Paradise; and the way in which this was interpreted can be seen in mosaics, mural paintings and book illustrations from early Christian and Byzantine times. With their four rivers, and their stylized trees and animals, they are full of religious symbolism.

In Europe, during the Middle Ages, the art of gardening developed with the blessing of the Church and the support of the monasteries. The usefulness of fruit trees, kitchen gardens and medicinal herbs was appreciated, but the garden was esteemed for its aesthetic value, too: for the softness of the lawns, the scent of the flowers, the song of the birds, the cool freshness of the spring and the shade of the trees. The garden lay sheltered behind wall or fence in a world full of scourges and perils, and was felt to be an earthly paradise. Medieval art offers many representations of such gardens with elements of religious symbolism. We can often see Mary with her child seated on a grassy mound in a flowering meadow or in the shade of a rose-arbour, listening to the song of birds in her *hortus*

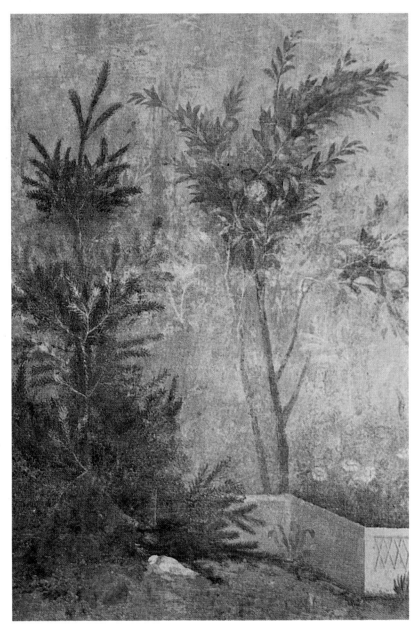

Fig. 1. Garden scene. Detail of wall-painting from the villa of Livia at Prima
Porta. Late first century B. C. Museo Nazionale Romano, Rome.

conclusus. Fra Angelico painted the blessed embracing one another in a flower-studded meadow in Paradise.

In the East, a pleasure-garden of this sort was more an inducement to enjoy life and love than a call to religious worship. Nordic ballads have young lovers meeting in a grove. Gardens gay with flowers became the setting for the cult of courtly love that grew up in 13th-century France and was celebrated in the *Roman de la Rose*. The young people in Boccaccio's *Decameron* who escaped from plague-stricken Florence assembled in a pleasure-garden full of trees and flowering meadows to listen to each other's stories. In paintings and engravings of the late Middle Ages we see enclosed gardens used as places for social intercourse with philandering, music and song. Here, the numinous seems very remote, but if we look closer we can detect didactic allusions in the symbols conveyed by plants and animals.

Study of the history of gardening shows that the garden's contents, its design and embellishment through the ages, retain elements that throw light on its breeding-ground of nature myth. This can be seen especially clearly in Greek and Roman gardening. The Renaissance carried on the tradition unbroken, and even the Baroque garden was permeated with strongly numinous elements. But the anthropomorphic conceptions of the gods, so manifest at the beginning, developed towards a stylisation and abstraction, indeed an outlook on life, that permit Man to put himself in the place of the gods. This development culminates in the French 17th-century classical art of gardening, called by the French author Corpechot "les jardins de l'intelligence", with its extensive parterres distinctly patterned with arabesques, sweeping avenue vistas and optical effects. Gardens of this kind also formed a framework for the princely courts and noble houses of the 18th century. Even before this theatrical horticultural style had reached its height, however, new ways of thinking opened a path towards a deeper understanding of nature's inmost essence. A pantheistic feeling for nature, intensified during the Romantic period, pervaded the minds of men and induced them to create gardens and parks that expressed their longing for both the idyllic and the sublime.

Just as the prince of the desert lands of the East caused to be laid out walled pleasure-gardens, so have the men of our own times felt the need to surround themselves, in an urbanised existence, with

something that resembles the Paradise of legend, a place secluded from the world around, with lawns, flowers, bushes and trees, on which they can bestow care and attention, a meeting-place for friends and relatives. In the grounds of his private house or in the patch of garden around his cottage, modern man feels the link with growth and maturity in nature, the processes which he has always felt to be something essential for him. In his technocratically underpinned idyll he does not feel so intensely as did the ancients the proximity of the sacred forces of nature, but poetry, music and art are more susceptible to their influence and remind him of their message and mystery.

The Persian pleasure-gardens which in their day enchanted Xenophon had a long existence and inspired imitations in the East, where they still fascinate us by their riches and beauty. Persian and Indian miniatures often picture them, concentrating on their attractions in the form of luxuriant vegetation, beautiful birds and men and women absorbed in the enjoyment of life. The principal motifs — flowers, trees and animals — were adopted by the decorative arts and used in the adornment of household goods and walls, carpets and other textiles. The treasures of the garden supplied ideas for ornament even in the ancient Mediterranean culture. Painted garden motifs were popular in Roman houses, in both town and country. People had illusionist gardens painted on the walls of the atrium or the peristyle of their houses. They had a predilection for decoration in the form of wreaths, friezes of leaves and garlands. Through these, they felt near to a garden, possessed its *topoi*, even within the walls of their homes. The patterns, charged with significance, that derived from the garden, and that were thus introduced into man's intimate surroundings have remained there ever since, and have become an archetypal element that continually recurs in Western culture.

Palmettes, acanthus leaves, garlands, roses, lilies and trailing vines — they have all been used in different ways for decorative purposes during the course of centuries and the various changes of style. Time and again they have received a new injection of vitality direct from nature — this happened, for instance, during the Gothic period and the Renaissance, through the Arts and Crafts movement in England, and not least during the Art Nouveau (Jugendstil) period. Despite interludes of purism, among which we may count functio-

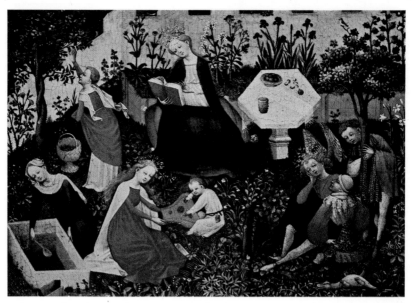

Fig. 2. Paradise garden. C. 1420. Städtisches Kunstinstitut, Frankfurt a. M.

nalism, flower and leaf shapes still survive on our wallpapers and our household crockery as an ancient legacy from the old Oriental pleaure-gardens and the first earthly paradises. But it was not only the decorative motifs that were an indoor reminder of the garden. By means of paintings of entire gardens and landscapes, too, Man wanted to conjure up the impression that the powers of nature were active within the home, while at the same time he tried to expand the limits of his rooms. Eva Börsch-Supan's work *Garten-, Landschafts- und Paradiesmotive im Innenraum* (Berlin, 1967), rich in facts and ideas, provides a wealth of material to illustrate this interesting subject.

The architectonic treatment of the terrain to make the construction of gardens possible began early. The "hanging gardens" laid out on terraces in ancient Babylon are renowned. Here, the terracing was bound up with the system of watering and contributed to the creation of gardens that were characterised by regularity and architectonic consistency. In ancient Egypt, too, gardens and buildings were brought close together. Open courtyards whose arcades afforded shade were provided with flower-beds and pools of water. In Per-

sia, trees were planted in regular rows that appeared to be straight when seen either from the front or diagonally. Xenophon introduced this system of avenues into Greece, where it was used in the sacred groves around the temples as well as at the schools of philosophy and the gymnasia. The architectonic treatment did not prevent the cult of sacred trees and springs; the latter, in particular, were given an architectonic frame in the shape of a nympheum. Small temples and sculptures were introduced into the gardens as a reminder of the presence and power of the gods. It also became common to reproduce this kind of garden architecture against a background of rocks and sea. These so-called *topia* came to play a prominent part in Roman gardening, where *topiarius* was the name given to the gardener who attended to the ornamental gardens.

The wall paintings from the villa of Livia at Prima Porta and a number of the excavated houses at Pompeii give us an idea of the close relationship that existed between architecture and garden. From the entrance, one came into the atrium with its open roof and central basin, beyond which was usually the peristyle and finally, at the end, the ornamental garden itself, the *xystus*, with its flower-vases, its sculptures and urns and its long basin. The *xystus* is the model for the parterre of later gardens. In the atrium and peristyle were set up cult images. Here was created a protected sanctuary, a *locus amoenus*, the *sanctum sanctorum* of the Roman great man's house. The villa estates described by Cicero and the two Plinys included plantations in a complex synthesis of buildings, peristyles and terraces. The ornamental garden, the *xystus*, finished off in the extensive, semicircular so-called "hippodrome", which had its roots in the race-course and was a predecessor of the grass-covered "bowling-green" of English and French gardens. Everything was arranged for walks, philosophical in the style of Plato's Academy or the Lyceum of Aristoteles, or merely for enjoyment of the view. Here were pavilions, casini, where one could rest and partake of refreshments. A background to the understanding of the Roman feeling for nature may be found in the bucolic poems of Theocritus, where the poet, with his recollections of Sicilian villas, calls up pictures of idyllic landscapes with lovers, scenes and motifs that became classical elements in poetry as in painting and gardening. The lovers lie stretched on a bed of reeds and vine-leaves beneath a grove of poplars and

elms, while high above their heads the leaves rustle in the breeze. The water from a sacred spring runs purling out of the nymphs' grotto, cicadas and tree-frogs can be heard in the foliage and the grass, goldfinches and doves call from the trees, and everything is redolent of summer and harvest. The Romans attempted to incorporate some of the nature of this golden age into their parks and buildings, at least they did this in the landscapes they painted on the walls of their houses. The landscapes described by Virgil in his eclogues also have an idealised character. But the Romans had not the anthropomorphic pictural imagination of the Greeks. They did place images of the gods, in particular those associated with Pan and the world of the satyrs, in their gardens and wilder parks, but where the *xystus* and the *locus amoenus* were concerned they confined themselves to suggesting the divine presence by means of trees and bushes clipped to represent figures, the so-called *opus topiarii*. On the other hand, however, it must not be forgotten that even Lucretius's visionary pictures of nature's wildness are a reflection of an essential strain in Roman feeling for nature.

The choice of a site for a country villa was of the greatest importance. Prevailing winds, sunlight and, not least, the view were taken into consideration. A slope towards the south-east was regarded as the most suitable. In his letters, Pliny the Younger gives some interesting information about the villas he owned. One was on the coast at Laurentum; the other, in Tuscany, was chiefly intended for a stay during the winter months. In spite of the mass of details given in his accounts, it is difficult to reconstruct the layout of his grounds in their entirety, with all their buildings, cryptoportici and terraces, but one gets a strong impression of the devotion with which the Romans engaged themselves, not only in purely botanical and practical studies, but also in meditation and observation while resting in their pavilions or while walking on their terraces. It is not least interesting to notice the large part played by wild nature in the Romans' feeling for nature. Pierre Grimal (*Les jardins romains à la fin de la République et aux deux premiers siècles de l'Empire. Essai sur le naturalisme romain.* Paris, 1943) and Götz Pochat (*Figur und Landschaft.* Berlin & New York, 1973) give us a deeper insight into these conditions.

The rich complexity of a Roman garden may perhaps be seen best in the Emperor Hadrian's estate at Tivoli. Here the architectural contribution is of decisive importance, but sculpture and water also have a large part to play. The composition cannot be taken in in the same way as in a medieval garden or a garden from the Renaissance or Baroque periods. The visitor strays between monument and vegetation and in fascinating spatial compositions of different kinds. He is continually meeting with surprises not unlike those that the theatre can offer. The boundary between reality and imagination is fluid; the numinous is constantly felt to be present. The Roman's feeling for nature as reflected in his gardens is revealed as being far from a naïve absorption in a free nature. He established intellectual as well as emotional contact with nature when he met it in the varying play of water or in the darkness of a cave; we know that he even felt the existence of the divine powers in those mute figurants, his clipped miniature trees. He loved a distant view over the sea, a rocky valley or fertile fields, and as he gazed he had a sense of both devoutness and security. Hadrian's gardens at Tivoli have rather the character of a sanctuary than of a park for recreation. They remind us of the sacred origin of the garden and of its ability to lead our thoughts and feelings towards eternity. In a similar way Shah Djahan erected in the 17th century a marble mausoleum over the tomb of his consort, the Taj Mahal at Agra in far-off India, and surrounded it with a garden to represent Paradise. Also at the Skogskyrkogården cemetery in Stockholm, the architect E. G. Asplund and his assistants created in the 1920s and 1930s, through the formation of the terrain and expressive tree plantation, an open-air space filled with transcendentalism.

The Renaissance brought about a resurrection not only of ancient poetry and art but also of the forms of the Roman garden and the ideas behind it. Cosimo dei Medici invited his friends to philosophical conversations after the example of Plato at his villas. Outside the villa he laid out gardens with laurels, box hedges, myrtles and cypresses. A new feature of this garden consisted of carnations, and orange and lemon trees, planted in pots and placed on the terraces. Alberti, the leading architect of Florence, had studied the Roman garden in Vitruvius and was influenced by his views when he described the correct way to lay out a garden. He was also sympathetic to

the Roman custom of bringing the garden with its symbols into the house. He describes grottoes and ingenious fountains, even fountains that were practical jokes. Like the Romans, he and his contemporaries were also interested in setting aside a part of the garden for meditation and devotion; this was called the *giardino segreto* or *giardino pensile*. The Romans' partiality for *opus topiarii* continued along with their feeling for the symbolic function of the topos. In accordance with the ancient Roman custom, wild woods serving as hunting-grounds or animal reserves were retained adjacent to the large gardens. Even the medieval flowering meadow was an important feature in the gardens of the early Renaissance, both at Florence and in the neighbourhood of Venice. An illuminating contribution to understanding the Renaissance garden's complicated world of symbols may be found in the book entitled *Hypnerotomachia Poliphili*, beautifully illustrated with woodcuts, which was written by Vittorio Colonna about 1467 and published at Venice. Here we see not only *opus topiarii*, trellises and artistically designed patterns of parterres that were later to be developed especially in the French garden during the 17th century. The environment and the style revealed in the *Hypnerotomachia* are rather sophisticated.

In Italy, the garden became during the 16th and 17th centuries a matter mainly for the architect. Buildings were introduced into a vast general plan. Approach roads, ramps, flights of steps, terraces and a series of different garden themes made up a whole which usually had a strictly axial composition. At the same time, the architect took advantage of undulating or steeply sloping ground to obtain effects of perspective and extensive views. Pioneering designs of this kind were Bramante's planning of the Vatican courtyards, Raphael's Villa Madama and Pirro Ligorio's layout of the garden of the Villa d'Este at Tivoli. Here, the garden area stretches in immense platforms, linked by steps and ramps, below the villa on the height above. The water rushes in cascades along the length of the garden, but also enters from one side in the form of a booming water-organ. A 16th-century engraving shows the regularity of the plan, but does not reveal the intimate connection with the nature worship of antiquity which Ligorio, however, was anxious to preserve. Yet it can be seen that the transverse axis ends at one side in a terrace shaped like the stage of a theatre with a number of houses, and that the

garden also comprises wild parts, *boschetti*. "The *boschetti* and the rustic elements present in gardens should be seen ... not only as a generalized imitation of literary *topoi*, the grove, the wild wood, etc., and as an evocation of mood, nostalgia, luxury or fear, but also as a constant reminder of an intellectual and philosophical concern; the role of man in the world of nature, and the creation of order from chaos" (Elisabeth Macdougall, "Ars Hortulorum: Sixteenth Century Garden Iconography", in *The Italian Garden*. Dumbarton Oaks, Washington, D.C., 1972). One can feel this very strongly today as one stands in the shade of mighty trees and listen to the rushing of the shade of mighty trees and listens to the rushing of the waters over waters over moss-grown sculptures.

To the visitor, the Villa Farnese at Caprarola near Viterbo, with its mighty pentagon, has the appearance of a fortress high up on a rocky slope. At the rear, parterres in geometrical patterns have been laid out on high bastion-like terraces. But even higher up, on the tree-clad slopes, is a villa, smaller and of a more intimate character, surrounded by terraces with fountains and pools, a place for meditation with the background suggested by Macdougall. ". . . There can be few places where architecture is so closely allied to nature, and where mythical creatures like the sea-horses of the fountains and the guardian herms seems so natural a part of the scene. Here the beauty of the pagan world lives again and looking at it Queen Christina of Sweden's strange comment upon the gardens of Caprarola: 'I dare not speak the name of Jesus lest I break the spell' can be understood." (Georgina Masson, *Italian Gardens*. London, 1961, p. 141.)

These lingering traces of paganism distinguish the majority of the large Italian gardens. In them, the numinous is indicated by the sculptures that are found in such quantities, sometimes simply as decorative elements but most often as symbols, at times even with the obvious intention of inspiring awe. This is the case with the grotesque and fantastic creations that have made the park of the Villa Orsini at Bomarzo famous. Men felt intensely that they were close to Pan and the world of the satyrs. Even for the visitor of today it is clear that all these statues, pools, fountains and elaborately clipped box hedges do not imply a repudiation of wild nature but must be seen as symbols of its mystic essence. With their impressive design, the Italian villa gardens, not least those in the neighbourhood of Rome, give

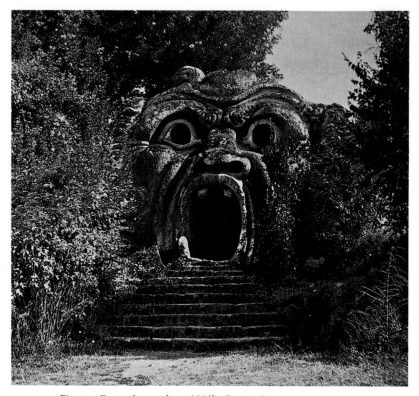

Fig. 3. From the garden of Villa Orsini, Bomarzo. C. 1560.

evidence of the architects' extraordinary capacity to fit the buildings
and all the details of the garden into the terrain so as to form a
whole. We must not overlook the fact, however, that these gardens
not only satisfied man's need for contact with nature but also con-
tained space for experiments in cultivating exotic trees and flowers
and in the skilful construction of hydraulic works.

In relation to the Italian garden, so richly varied, with such a mas-
terly execution of architectonic form, the French garden appears to
have remained for long deficient in dominant ideas. Yet the Italian
art of gardening had made a strong impression on the French Renais-
sance kings in the course of their military campaigns, and they called
in professional gardeners and artists to help them to produce similar
arrangements around their own châteaux. They concentrated on ex-

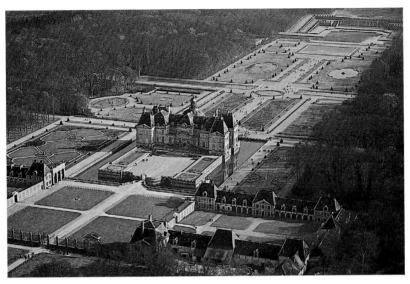

Fig. 4. Vaux-le-Vicomte. C. 1660.

tensive parterres with box hedges in patterns and flower plots in
regular squares. The compartment was bounded by leafy walks, and
in many places the whole garden was surrounded by channels full of
water. Soon, however, the garden was linked with the buildings to
form a unified composition. The main building was surrounded by
symmetrically placed wings flanking a courtyard, and behind it
spread a large parterre like a huge Oriental carpet. One of the first
designs of this kind was that of Anet, outside Paris, constructed by
Henri II for Diane de Poitiers. The parterre was surrounded by a
cryptoporticus and a moat. The creator of this garden was the Italian-
trained architect Étienne Dupérac. He introduced the "embroidery
pattern" parterre, which became a French speciality developed par-
ticularly by the Mollet family of gardeners. One of these, André Mol-
let, besides working in England and Holland was also active in Swe-
den where he published a monumental work on the theory and
practice of gardening, illustrated with large engravings (*Le jardin
de plaisir*. Stockholm, 1651). Italian elements in the form of cascades,
grottoes and nympheums appeared in some of the more lavish of the
French Renaissance gardens such as those at Gaillon, Fontainebleau

and St. Germain-en-Laye. Among the Italian specialists called in may be mentioned in particular Thomas Francini, who built for Marie de' Medici a grotto-like fountain in the Luxembourg garden which is still preserved. This large garden was designed on the model of the Boboli gardens at the Palazzo Pitti in Florence, but in Paris the hippodrome-shaped central part of the Florentine garden was replaced by a large *parterre de broderie*. Among the sculptures decorating the garden was a gigantic figure representing the Demiurge, or spirit of the earth, the moss-grown statue of an old man. The statue evidently came into being under the direct influence of a similar figure, the 19-metre high statue which represented the personification of the Apennines which is still one of the sights of Pratolino, outside Florence. In French gardens, these elements of nature myth were, in general, replaced by sculptures of gods and goddesses, of Hercules and his exploits or other dramatic scenes from ancient mythology. What is notable here, however, is that attention was not directed to these features; instead, the designers tried to make use of perspective and optical effects, for example by studying the way in which the surface of a pool reflected the sunlight. Garden designers became interested in mirage phenomena and worked with different artistic perspective devices. One of the more outstanding technicians in this field was Salomon de Caus, who published writings on the subject and whose foremost contribution was the layout of the castle gardens on the terraces at Heidelberg. These aroused the admiration of his contemporaries; among those who expressed their appreciation was Gustavus II Adolphus.

While England and Holland never lost interest in *opus topiarii* — the trees and bushes clipped to represent figures that had been taken over from antiquity — nor in the knot gardens and mazes with their magical associations, in the French axially-planned gardens long parterres were laid out along the central axis. These mostly consisted of *parterres de broderie* followed by a parterre of grass edged with flower-beds, behind which were *bosquets*. The perspective ended in a background effect in the shape of an exedra or something similar. The parterres were laid out on different levels, their colourful surfaces creating an effect of space in contrast to the density of the bosquets. The prototype of the fully developed French Baroque garden was the garden at Vaux-le-Vicomte. The château was erected

in the 1650s for Fouquet, the Superintendent of Finances, after the plans of the architect Louis Le Vau, the vast garden being laid out at the same time according to the design of André Le Nôtre, perfecter of the formal garden. During the years following, these two masters created at Versailles an even more extensive and more richly complex design on similar principles.

Nature was pressed back or given architectonic form in these gardens with their patterned open spaces and dense thickets with small arbours, and their vast perspectives accentuated by alleys and canals. Like the Italian gardens, these are embellished with a profusion of sculptures and urns; yet there is no numinous message, only primarily an allusion to the position and virtues of the prince. At Versailles, the dominating iconographic elements were Apollo and the Sun. The French garden of this type became a symbol and a sign of absolute princely power. Its elegant composition and the close link between buildings and garden became a model that was adopted by the leading architects and garden designers of the whole of Europe.

It was an art that had become the expression of the completeness of human power and that had utilised all the means available to create an extensive milieu that accorded with the fashion of the day. Nature mysticism was not entirely stifled, however, nor its ancient message of the might of the elemental spirits. Nicodemus Tessin the Younger, together with his associate Johan Hårleman, had made himself more familiar than most with André Le Nôtre's art and gave a fine example of it in the gardens of the palace at Drottningholm. At his own little palace opposite the castle at Stockholm, Tessin created a small, intimate garden, a *locus amoenus*, a *giardino intimo*, with clipped trees and bushes, urns decorated with reliefs, aviaries, and even a nympheum, a grotto with a babbling spring. At the entrance to the grotto he intended to place two statues of philosophers as an invitation to meditation and a reminder of the great thinkers of Greece. Here he could rest on a couch of branches, with a coverlet painted to represent plaited straw. Here Tessin sought to resurrect something of that idyllic world of which Theocritus sang and in which the Greek philosophers were supposed to have lived. It is interesting to see how, like the Greeks and Romans, Tessin attempted by the use of illusionist paintings of park-like landscapes to extend the limited space. He also made use of others of the perspective devices that were of such im-

portance in Baroque art, and not least in the magical elements of the Baroque garden. So this, the most artistic and most architectonically developed little palace garden, preserves close contact with the mystical sources of the garden. Even in the interior of his palace, the architect sought to enlarge the rooms with paintings of landscapes and illusionist views and bring great nature to life, both in its wildness — for instance, the cascades at the Temple of Vesta at Tivoli, Vesuvius in eruption — and in its more Elysian form in association with Poussin's painting.

Already, towards the end of the 17th century, the barrenness and artificial character of the dead-straight alleys and the clipped thickets of the French Baroque garden had begun to be felt. In the new feeling for nature that now grew up and found strong expression at the beginning of the 18th century, the garden came to have a central place. It was in fact the stilted formal garden that provoked this reaction. Ironically enough, it was the trees clipped into various figures that called forth the most venomous criticism, ignorant as the critics were of the archetypal significance of these topiarian shapes. Thus Alexander Pope jeered at the garden tailoring that would not allow these trees to grow freely but made them take on all kinds of human, animal and geometric shapes. Without directly dwelling on the art of gardening, Shaftesbury, in his treatise "The Moralists" (*Characteristicks*, 1711) paid homage to wild nature, to its mossy rocks and its cataracts. A year later Joseph Addison, in his famous reflexions in *The Spectator*, maintains that no work of art can stand up to those that nature herself paints with wild and reckless brush. He imagined that by means of suitable plantations a farm could be transformed into a beautiful landscape. He did not accept nature in its untamed state but recommended certain measures that would allow the beauty of meadows, trees and hills to show to more advantage. He dreamed of an ideal landscape. These views were developed by a long succession of authors, and a newly acquired knowledge of Chinese gardening came to play an important role. Those who passed on these new ideas, as Osvald Sirén has made clear, were William Temple, William and John Halfpenny and later, in particular, William Chambers (*China and Gardens of Europe of the Eighteenth Century*. New York, 1950). By the introduction of different elements to create atmosphere, such as grottoes, temples, memorial monuments and even sculptures,

Fig. 5. The summer-house of Gustaf III, Haga, Stockholm. C. 1790.

an effort was made to obtain results not unlike those achieved by
the Italian garden, but without its weighty architectonic apparatus.
A walk in the garden and park should not be interrupted by steps
and terraces, although it could lead over a bridge, even one in the
monumental style of Palladio, as far as a temple with columns, often
to a hermit's cabin or a secluded Gothic chapel. Men yearned for the
Elysian as well as for the picturesque and the sublime.

William Kent, one of the leaders in the shaping of the English land-
scape style, in such gardens as those at Chiswick and Stowe adopted

43

many details from Roman gardens. But the number of buildings and pavilions could be too overwhelming. The Swedish garden architect Fredrik Magnus Piper was aware of this danger when he wrote after a visit to England: "Through this [decoration] alone, [the garden] loses much of the simple and 'champêtre' aspect that one observes with such deligt [at Henry Hoare's Stourhead in Wiltshire]." Walpole characterises Kent in the following way: "He felt the delicious contrast of hill and valley changing imperceptibly into each other, tasted the beauty of the gentle swell, or concave scoop, and remarked how loose groves crowned an easy eminence with happy ornament and while they called in the distant view between their graceful stems, removed and extended the perspective by delusive comparison ... But of all the beauties he added to the face of this beautiful country, none surpassed his management of water. Adieu to canals, circular basons, and cascades tumbling down marble steps, that last absurd magnificence of Italian and French villas ... The gentle stream was taught to serpentine seemingly at its pleasure ... The living landscape was chastened or polished, not transformed." (Quoted from Oswald Sirén, op. cit., p. 32.) But when Kent, with the intention of giving the scenery a stronger impression of truth, planted dead trees in Kensington Gardens, he was held up to derision.

During the 18th century, thanks to the contributions towards the development of a completely new art of gardening that I have referred to in this paper, the garden came to occupy a central position in the history of ideas and culture in Europe. In his work *Observations on Modern Gardening* (London, 1770), Thomas Whately made the following reflexions which are valid even today:

> Gardening, in the perfection to which it has been lately brought in England, is entitled to a place of considerable rank among the liberal arts. It is as superior to landskip painting, as a reality to a representation: it is an exertion of fancy, a subject for taste; and being released now from the restraints of regularity, and enlarged beyond the purposes of domestic convenience, the most beautiful, the most simple, the most noble scenes of nature are all within its province ... the business of a gardener is to select and to apply whatever is great, elegant, or characteristic in any of them: to discover and to shew all the advantages of the place upon which he is employed; to supply its defects, to correct its faults, and to improve its beauties. For all these

operations, the objects of nature are still his only materials . . . Nature, always simple, employs but four materials in the composition of her scenes, *ground, wood, water* and *rocks*. The cultivation of nature has introduced a fifth species, the *buildings* requisite for the accommodation of men . . .

But the landscape garden that the writer evokes in this way has its rules. Wild nature is not accepted in all its forms, especially rocks. Fearful they may be and stimulate the beholder's fancy, but grotesque shapes are not to be tolerated. In this connection, it may be opportune to recall a drawing by C. A. Ehrensvärd, in which the ice-rounded shapes of the Swedish rocks take on the form of the human posterior. In such drastic fashion does Ehrensvärd, seduced by all that is classical and Italian, reveal his want of sympathy for the barren nature of the North. Closer to his heart was the idyllic landscape, which the English-trained garden architect Piper laid out around Swedish palaces and manor houses. More impressively than perhaps anywhere else a piece of mid-Swedish nature at Haga was combined with an architecture characterized by its classic grace, where Tempelman's pavilion gently opens out on to the trees in the park, the meadows and the water.

In England, towards the end of the 18th century, a reaction set in against the too Arcadian, the over-idealised character of the landscape garden. One sought to attain a more everyday, more realistic park-like environment in which tree stumps and fallen twigs and overgrown meadows were acceptable. Over against the beautiful was set the picturesque (Richard Payne Knight, *The Landscape.* London, 1975). But other excesses came under attack also, and, under the inspiration of Rousseau and his ideas on the superiority of the rustic life, nature herself was called upon for support. Surrounded by his nearest and dearest, a man should withdraw into the bosom of nature to enjoy the delights she offers. What is important is not the size of the park, but the environment of the common man. In opposition to the large parks with their feudal background, the small, intimate gardens are stressed, where men can have a sense of well-being, where utility is the foundation, variety, order and tidiness the adornment (Claude Henri Watelet, *Essai sur les jardins.* Paris, 1774). Here, in this lower middle class outlook, we can recognise the background of the garden patches and suburban gardens of our own day.

DIE SPRACHLICHE ERSCHLIESSUNG DER LAND-
SCHAFT IM DEUTSCHEN

Von Rudolf Schützeichel

In den Bildern der Genesis[1] über die Schöpfung wird alles erfaßt, was
als geschaffen in Raum und Zeit hineingestellt und dem Menschen
anheimgegeben vorgestellt werden kann. Da sprach Gott: 'Es werde
Licht'. Und es ward Licht ... Gott nannte das Trockene Erde, und
das zusammengeflossene Wasser nannte er Meer. Es ist aber ebenso
bemerkenswert, daß die Sprache selbst nicht geschaffen wird[2], denn
sie war schon 'im Anfang bei Gott', so daß hier etwas von der Macht
der Sprache, wenn auch der göttlichen Sprache, spürbar wird, aber
doch in durchaus menschlichen Vorstellungen, daß nämlich die
Sprache die Dinge benennen, die Tatbestände als solche schaffen und
Handlung und Aufforderung zur Handlung sein kann.

Die geschichtliche Handlung, die hier im Blickfeld stehen soll, ist
die Erschließung der Landschaft in einer indoeuropäischen Sprache,
im Deutschen. Dazu sind einige Schritte vonnöten, die die sprach-
wissenschaftliche Bewältigung des Themas wenigstens skizzieren
sollen.

1. Menschliche Sprache als Ganzes ist nicht ohne weiteres irgend-
einem anderen Phänomen vergleichbar. Wir werden sie auf gleicher
Ebene mit Sozialstruktur und Kultur ansetzen müssen, verschränkt
mit der Kultur und der Sozialstruktur[3]. Sie kann aber nicht eigent-
lich der Kultur untergeordnet oder als Ableger oder Produkt der So-
zialstruktur verstanden werden. Die menschliche Sprache wäre jedoch
von der Sprache der Tiere abzuheben, und zwar deswegen ausdrück-
lich abzuheben, weil es Übereinstimmungen durchaus gibt[4]. Die
Sprache der Tiere ist offensichtlich ein Mittel der Verständigung, die
bei verschiedenen Tieren auch über den eigenen Bereich hinaus zu
Kommunikation mit den Menschen führt. Und die menschliche
Sprache wird von den Tieren 'verstanden'. Das zeigen Wirkungen
der Auslösung[5] an die Tiere, die solchen Appellen folgen, sie jeden-
falls als Appelle 'verstehen'. Das zeigen auch Kundgaben der Tiere,
die die Menschen verstehen, Appelle der Tiere, die bei Menschen

durchaus Handlung auslösen, wie das Zurückweichen vor drohendem Gebell. Es kommt mithin auf die Unterschiede an, die eben darin liegen, daß die Sprache der Tiere offensichtlich nicht über die logische Operation der Nennung verfügt, daß das Tier offensichtlich auch nicht die sprachliche Leistung der Darstellung vollbringen kann, daß es weiterhin die Operation der Hereinnahme in Zeit und Raum und damit die Schaffung eines Tatbestandes nicht vollziehen kann, was natürlich nicht heißt, daß ein hochentwickeltes Tier eine Situation nicht begreifen und insofern erkennen könne, was das Tier zu entsprechenden Reaktionen bringt, aber nicht zu sprachlicher Formulierung. Bei sprachlicher Formulierung ist gerade die Verfügung über die Zeit durch den Menschen ein sehr wichtiges Kriterium, während das Tier, um mit Friedrich Nietzsche[6] zu sprechen, an den Augenblick angepflockt ist. Der Mensch hingegen verfügt über ein Gedächtnis[7], über Vorstellungen von der Zeit[8] und über die Möglichkeit, die Dinge in zeitliche Nähe oder zeitliche Distanz zu setzen[9]. Das bedeutet dann freilich zugleich, daß es bei den Menschen zwar kein Angepflocktsein an den Augenblick gibt, aber dennoch eine unveränderbare Bindung an das Jetzt, so wie es eine unveränderbare Bindung an das Hier und eine ebenso konstante Bindung an das Ich gibt.

2. Das aber sind Einsichten von grundsätzlicher Bedeutung, weil sie die sprachliche Orientierung des Menschen bestimmen[10]. Es geht hier um die Bindung des Menschen an sein Ich, die über alle sonstige Veränderung fortbesteht und die er auch sprachlich eigentlich nicht transzendieren kann. Der Sprecher einer Sprache ist immer ein Ich. Und das Ich kann keine andere Rolle einnehmen als die des Sprechers. Es existiert nur als sprechendes Ich. Von hier aus wird auch der soziale Aufbau der Sprache bestimmt. Das Ich rückt nie aus seinem Mittelpunkt hinaus, schafft sich aber im Du ein Gegenüber und damit eine zweite unentbehrliche Komponente der Sprache, nämlich den anderen, mit dem es sprechen kann und in dessen Gemeinschaft die Sprache sich konstituiert.

Die zeitliche Festlegung auf das Jetzt gestattet es dem Menschen, auch alles in dieses Jetzt hineinzunehmen, wofür es auch im Deutschen hervorragende Beispiele gibt. Der Mensch kann sich aber auch eine zeitliche Distanz schaffen und alles in ein Damals setzen, wobei es immer nur das Damals des sprechenden Menschen sein kann

und kein anderes von einem anderen Bezugspunkt hergenommenes Damals.

Was aber den Raum angeht, so gilt das Entsprechende im Hier des Menschen, das mit seinem Ich und seinem Jetzt unlösbar verkettet ist. Dabei baut sich der Mensch zum Hier ein Dort auf, ohne an nähere, sozusagen objektive Bestimmungen gebunden zu sein. Die Eigenart der räumlichen Vorstellung bringt es zudem mit sich, daß Nähe und Distanz in subjektives Ermessen menschlichen Fühlens gestellt sind, daß sich mit den lokalen Vorstellungen auch Vorstellungen der Richtung verbinden, das Vorne, das Hinten, das Oben, Unten, Rechts, Links und so weiter, wofür sich im Deutschen gerade Präpositionen anbieten, die für den im Raum stehenden, im Raum gehenden und handelnden Menschen geschaffen zu sein scheinen und die von diesem sprechend Handelnden her ihre Bestimmung erfahren[11]. Wir müssen uns eben bei aller Betrachtung sprachlicher Phänomene im klaren darüber sein, daß die Bezugspunkte personal im Ich, zeitlich im Jetzt und räumlich im Hier liegen, daß diese Bezugspunkte immer gemeinsam auftreten und daß der Mensch in seiner Sprache sich zu diesen Bezugspunkten Bezugssysteme aufbaut, die ihm die Kommunikation mit anderen Sprachträgern ermöglichen, nämlich mit allen, die über das gleiche sprachliche System verfügen. Etwas anders ausgedrückt: Wir werden bei jedem sprachlichen Vorgang nach den Menschen, im Sinne der Träger der Sprache, nach ihrer Zeit und ihrem Raum zu fragen haben.

3. Erschließung der Landschaft aber wäre sprachliche Erschließung eines Raumes. Tatsächlich erschließt der Mensch in seiner Geschichte allen greifbaren Raum, er durchmißt und rodet die Wälder, er überquert die Flüsse, befährt die Meere, besteigt die Berge, erschließt die Wüsten, die Eismeere, die Moore und betritt den Boden seines Satelliten, des Mondes. Damit geht gewiß sprachliche Erschließung einher. Dies kann aber nicht so aufgefaßt werden, als ob die sprachliche Erschließung dem Wege der Menschen folgt, den Flußläufen, den Straßen, den Hochtälern und so weiter. Es ist vielmehr so, daß offensichtlich vor jeder Erschließung, jeder näheren Erforschung im kulturell-technischen Sinne, die sprachliche Erschließung vor sich geht. Das Auge des Menschen reicht seit eh und je weiter als sein Fuß. Seine Sicht ist nicht so leicht begrenzbar wie seine anderen Fähigkeiten. Und die Einsicht des Menschen tastet offensichtlich

48

sehr ferne Grenzen ab. Das Moor hat Namen, und differenzierbare Teile haben Namen, bevor sie trockengelegt sind. Die Gipfel der Berge sind Jahrtausende früher benannt, bevor sie bestiegen wurden. Auch die nur einmal gesehene Insel, aber auch die erdachte und erträumte Insel, hat einen Namen. Die Griechen benannten die Sterne und erschlossen auf diese Weise die Himmelslandschaft mit ihrer Sprache. Und der Mond war benannt, bevor der Mensch dort war, und er war bis in viele Einzelheiten benannt, so wie man es gerade sah oder zu sehen glaubte und also von 'Meeren' sprach, denen man die Namen im einzelnen gab. Mit der Sonne ist es ebenso. Aber bei ihr ist es natürlich auch anders, insofern die Sonne mit ihrem Licht mitten unter den Menschen ist, ganz unabhängig von ihrer Entfernung und ihrer schrecklichen Unzugänglichkeit. Die Sonne hält nicht die Distanz der Sterne. Sie ist aufdringlich mit ihrem blendenden Licht, im Tag der Menschen, mit ihrer Wärme, mit ihrer Hitze unter ihnen.

Die sprachliche Erschließung des Raumes ist mithin etwas anderes als die technische Erschließung eines Gebietes, als die Besiedlung eines Landes, als die politische oder sonstige Erfassung. Sie ist diesen Inbesitznahmen graduell voraus. Und sie ist qualitativ davon verschieden. Sie ist eine Angelegenheit des menschlichen Geistes, des menschlichen Denkens in einer ganz anderen Weise als andere Erschließung, als andere Inbesitznahme, so sehr die Kultur vom menschlichen Denken, vom menschlichen Geist getragen ist und ohne sie nicht zustande käme, einmal ganz zu schweigen von der Erschließung der Räume durch die Tiere, das Wild in den Wäldern, die Herden in den Ebenen, die Fische in den Flüssen und so weiter. Freilich ist zugleich zu sehen, daß menschliche Kultur nicht ohne Sprache existiert, was wenigstens gilt, wenn wir die Schöpfung menschlicher Kultur betrachten und einmal 'übersehen', daß es menschliche Kultur in gewaltigen Resten gibt, die uns für sich genommen sprachlos erscheint.

4. Der Geist, das menschliche Denken, das Vorstellungsvermögen, die Noemata als die Inhalte menschlichen Denkens im allgemeinsten Sinne sind allen Menschen gemeinsam, was natürlich nicht heißen kann, daß alle über das gleiche Denkvermögen verfügten, was aber hingegen heißt, daß die Tatbestände menschlichen Denkens dem Menschen prinzipiell zur Verfügung stehen, daß die Gegenstände universal sind, insofern sie prinzipiell jedem Menschen Gegenstand

sein können. Das scheint mit der unübersehbaren Tatsache nicht in Einklang zu stehen, daß es keine einheitliche und gemeinsame Sprache der Menschen gibt, keine so gesehen universale Sprache, die die Noemata auch in der gleichen Weise sprachlich gestaltete. Es zeigt sich hier eben ein für alle Sprachen gemeinsames Bezugssystem, das in der Noetik anzusiedeln wäre[12], ein Bezugssystem, vor dem sich die Gemeinsamkeiten und Verschiedenheiten der Sprache abheben müssen und vor dem insbesondere die sprachlichen Kategorien im Unterschied zu den Kategorien menschlichen Denkens sichtbar werden, ein interlingual konstantes Bezugssystem, das auch die schärfere Beobachtung dessen gestattet, was die sprachliche Darstellung gleich und verschiedenartig strukturierter Tatbestände ermöglicht, welche Grundlagen die Nennung, die Benennung der Personen und Sachen haben und unter welchen Bedingungen die sprachlichen Mittel und Möglichkeiten stehen. Die babylonische Sprachenverwirrung betrifft die Kommunikation der Menschen untereinander, sie scheint aber nicht das Vermögen einer jeden Sprache zu betreffen, Gegenstände menschlichen Denkens zu nennen, Tatbestände zu formulieren, sie darzustellen oder sie im kommunikativ-handelnden Zusammenhang kundzutun oder sie als Appelle zu artikulieren.

5. Das alles darf nun nicht dahingehend verstanden werden, als generiere der Mensch aus einer universalen Basis in binären Schritten mechanistisch nach Art einer Maschine dann die jeweiligen 'Oberflächen', die die Sätze der verschiedenen Sprachen sind [13]. Die vorgebrachten Formulierungen sollten nur das Augenmerk auf die Tatsache lenken, daß im Denken und in den Denkinhalten des Menschen das Bezugssystem liegt, daß es durchaus logisch formulierbare Relationen gibt, daß von dem Kalkül der Nennung, dem Kalkül der Hereinnahme in Zeit und Raum und dem Kalkül der Leistung der Sprache gesprochen werden kann, ohne daß damit die Sprache von der Logik als solcher her voll erfaßt und beschrieben werden könnte[14]. Die Sprache muß ihrem Wesen nach nicht logisch sein, und sie ist dieses auch weithin nicht. Die Überlegungen zur Sprache dürfen der Logik natürlich nicht widersprechen, und sie müssen das Logische wie das Ontologische wie auch das Psychologische in dem Geschehen ins Auge fassen, das wir das Sprechen einer Sprache nennen. Die klaren Abgrenzungen sind notwendig, wenn die Sprache in ihrem eigentlichen Wesen nicht von vornherein verfehlt werden soll und wenn ein

Phänomen wie die Erschließung der Landschaft durch eine Sprache wirklich richtig verstanden wird. Es dürfte auch sehr schwer halten, gerade die Erschließung einer Landschaft als mechanistisch generierten Prozeß klarzumachen. Vielmehr wird es notwendig sein, die Bedingungen zu untersuchen, die die sprachliche Erschließung ermöglichen und gerade diejenigen Komponenten ins Auge zu fassen, die ein solches Phänomen von der jeweiligen Sprache und ihren universalen Grundlagen her überhaupt verständlich machen.

6. Die sprachliche Erschließung einer Landschaft setzt sprachliche Kreativität[15] voraus, die die Freiheit der Sprachträger zur Bedingung hat. Sprachliche Neuerschließung bedeutet aber auch Vermehrung des Namen- und Wortschatzes einer Sprache, damit also Sprachwandel. Der hier in Rede stehende Sprachwandel basiert auf den bei synchroner Betrachtung vorliegenden Möglichkeiten. Das heißt: Ein in der Geschichte erfolgender Sprachwandel, wie hier im Sinne der Erweiterung des Wort- und Namenschatzes, ist zwar ein diachron zu beobachtender Vorgang. Er muß aber synchron schon als Möglichkeit vorhanden gewesen sein. Solche Möglichkeiten bestehen in dem Vorhandensein traditioneller Muster. Mithin wird die Tradition als Komponente der Sprache schon bei dieser Gelegenheit sichtbar. Bei der Benennung von Bergen, Tälern, Flüssen, Mooren, Ebenen (und so weiter) geht es hier um die im Deutschen etwa seit erkennbarer Zeit vorhandenen Wortbildungsmuster, vom einfachen Grundmorphem angefangen über die verschiedenen Arten der Komposition und der Derivation bis zu besonderen Wortbildungsmöglichkeiten[16]. Diese Wortbildungsmuster existieren schon, indem ein einziger ihrer Vertreter existiert. Das Muster gestattet dann die Anwendung in unzähligen weiteren Bildungen im einzelnen. Diese Muster sind nicht bildlich gesprochen 'gebraucht'. Sie sind vielmehr jederzeit anwendbar. Sie sind als Traditionen in der Sprache vorhanden und dienen im einzelnen der Neuschöpfung von Traditionen. Die kreative Schöpfung von Traditionen basiert also auf traditionellen Möglichkeiten. Die Neuschöpfung ist in einem Muster früherer Zeit bereits angelegt. Ein solches Muster der Wortbildung sind auch die sogenannten Satznamen[17], die im appellativischen Wortschatz vorkommen, die aus dem Lateinischen und Französischen und aus anderen Sprachen ebenso bekannt sind. Das Muster ist als Familiennamenmuster im späten Mittelalter stark zur Blüte gekommen, hat aber

auch gelegentliche Entfaltung in der Landschaft gehabt, wie etwa der Bergname 'Schauinsland' zeigt. Das wenig entfaltete Muster verdeutlicht, daß die Möglichkeit der Entfaltung prinzipiell besteht, wenn entsprechende historische Bedingungen dem zustatten kommen.

7. Zu den traditionellen Möglichkeiten einer Sprache gehört aber auch das zur Verfügung stehende lexematische Material. Das sind zunächst einmal diejenigen Vokabeln, die bei der Bezeichnung oder Benennung von Landschaften oder landschaftlichen Elementen in Betracht kommen können. Das müßte im Deutschen germanisches Sprachmaterial sein, ist es aber gerade bei den Ortsnamen und Landschaftsnamen, den Gewässernamen (und so weiter) vielfach nicht. Vielmehr treffen wir im Flußnamensystem sehr alte Bestandteile aus einem westindogermanischen Zusammenhang, der über das Deutsche weit hinausreicht[18]. Dazu kommen Namen aus dem Keltischen westlich des Rheins, Namen aus dem Lateinischen aus der Zeit des Imperium Romanum westlich und südlich des Limes, schließlich Einwirkungen, die die kirchliche Organisation in vielem zur Voraussetzung haben. Die germanischen Benennungen müssen zunächst im Zusammenhang der Südwanderung und der Westwanderung germanischer Stämme vom Ostseebecken aus gesehen werden. Sie treten zu den älteren Schichten hinzu. Dann aber bemerken wir die Ablagerungen französischen Einflusses in der staufischen Zeit und aus dem jüngeren Zeitalter des Absolutismus, schließlich jüngere deutsche Bildungen aus der Binnensiedlung und der Ostsiedlung, die eine Ausweitung der deutschen Binnensiedlung war.[19]

8. Die gesamte Erschließung der Landschaft durch das Deutsche wirkt wie eine Ablagerung mit verschiedenen Schichten. In Wahrheit handelt es sich aber um Namen, die als sprachliche Einheiten über die Jahrhunderte hinweg ebenso gebraucht werden, wie sie von vorgermanischer und vordeutscher Bevölkerung gebraucht wurden oder wie sie in anderen Sprachen existieren. Das bedeutet aber, daß gerade auch die Namen nichtgermanischen Ursprungs und mit nichtgermanischen Elementen von den nachsiedelnden und nachkommenden Sprachträgern übernommen worden sind. Damit stoßen wir auf sehr wichtige Erkenntnisse. Einmal nämlich, daß sich Sprachwandel im Sinne der Erweiterung des Wort- und Namenschatzes insbesondere in der Übernahme[20] vollzieht und nicht etwa allein durch die Benennung. Im allgemeinen sind die Benennungen zwar schon erfolgt, es

treten nur neue Benennungen hinzu. In jedem Falle aber muß Übernahme durch eine kleinere oder größere Sprachgemeinschaft erfolgen, wenn sich der Sprachwandel im Sinne der onomastischen Erweiterung des Sprachschatzes vollziehen soll. Zum zweiten werden wir hier auf die Möglichkeit gestoßen, die in der Sprache jederzeit besteht und die das System der Sprache auch in dieser Hinsicht als ein völlig offenes System ausweist. Schließlich sind diese Vorgänge nicht ohne die Sprachträger selbst zu sehen. Das heißt, die Sprache existiert nur mit ihren Sprachträgern, die dann imstande sind, alte Benennungen von anderen Sprachträgern zu übernehmen, neue Benennungen zu schaffen, Benennungen abzuwandeln, Benennungen fallen zu lassen. Das ist Vollzug der Sprache im Sinne beständig neuer Konstituierung der Sprache. Die Sprache wird im Sprechen immer neu konstituiert[21]. Diese Neukonstituierung hat beständig die Möglichkeit der Abwandlung in sich. Zur Abwandlung und zum sozialen Charakter der Sprache gehört in gleicher Weise die Übernahme von schon Vorhandenem, die Übernahme durch eine Sprachgemeinschaft auch bei der Übernahme einer neuen Tradition, die gerade gebildet worden ist. Die historischen Vorgänge können nur bei einem solchen Verständnis der Sprache wirklich verständlich werden. Der Blick ist mithin auf die Sprachträger zu richten. Wird eine Sprache von niemandem mehr gesprochen, so ist sie tot. Einzelne Elemente einer solchen Sprache können von anderen Sprachgemeinschaften übernommen worden sein. Sie gehören dann zu einer lebendigen Sprache.

9. Die Vielfalt der Möglichkeiten und die Vielfalt der Ergebnisse, wenn man die Nachwirkungen der Jahrhunderte im Nebeneinander des heutigen Namensystems sieht, vermitteln zunächst, wie gesagt, den Eindruck der Kreativität, und das heißt, der Freiheit der Sprachträger. Diese Freiheit der Sprachträger ist auch nicht durch einen den sprachlichen Systemen etwa innewohnenden Mechanismus eingeschränkt. Die Vorgänge sind insgesamt aus keinem Determinismus heraus zu erklären, da sonst schon allein die Vielfalt des Beibehaltenen und die Vielfalt des Neugebildeten nicht denkbar wären. Das bedeutet aber nicht, daß die sprachlichen Vorgänge, und hier die sprachliche Erschließung der Landschaft, nicht doch an historische Bedingungen gebunden sind. Damit sind historische Bedingungen gemeint, die in der Sprache selbst liegen können, aber auch solche Bedingungen, die gerade in der Geschichte der Sprachträger liegen. So

ist das Vorhandensein bestimmter Wortbildungsmuster eine historische Bedingung für die Anwendung eines solchen Musters in einer Neubildung. Der Lautvorrat einer Sprache ist Bedingung für die Übernahme anderssprachigen Wortschatzes, was sich gerade an Substitutionen fremder Lautungen erkennen läßt. Bedingungen sind aber auch die großen Wanderungen der Völker, das Eindringen der Germanen in das zentrale Europa, die Ausbreitung und lange Existenz des Römischen Reiches, die römische Kirche mit ihren Institutionen, insgesamt auch religiöse und politische Entwicklungen, das vorbildhafte Wirken französischer Kultur in der höfischen Zeit, die Wirkungen französischen gesellschaftlichen Lebens in Absolutismus und Aufklärung, die Vorgänge der deutschen Ostsiedlung, die Vermischung mit slawisch sprechender Bevölkerung, die niederländischen Siedlungen, dazu modernere politische Entwicklungen, Forderungen der Bürokratie[22] (und so weiter). Dies alles sind Bedingungen, ohne die die Vorgänge der landschaftlichen Erschließung, so wie sie erfolgt sind, nicht gedacht werden können. Das hat nun nichts mit einem negativen Teleologismus zu tun, als sei wenigstens auf ein Ziel hin vorausbestimmt, was nicht mehr geschehen könne. Der Begriff ist unglücklich, da damit überhaupt mit einem Teleologismus, also der zwanghaften Hinwendung auf ein Ziel gerechnet wird. Es ist aber nicht zu übersehen, daß mit den Benennungsvorgängen in einer Landschaft, wie bei jedem sprachlichen Prozeß, auch Weichen in der Richtung gestellt werden, daß bestimmte bestehende Möglichkeiten eben nicht ausgenutzt werden, und weiter, daß solche Möglichkeiten sich verlieren, weil die tatsächlichen Vorgänge an ihnen vorbeigegangen sind. Das führt aber nicht auf Teleologie. Das führt auch nicht auf irgendeine Form der Determination. Das führt vielmehr auf das sprachliche Phänomen der Selektion, nämlich der immer zu treffenden Auswahl aus verschiedenen nebeneinander bestehenden Möglichkeiten. Hier wird Freiheit sichtbar, allerdings eine Freiheit, zu der der Mensch in seinem sprachlichen Handeln sozusagen gezwungen ist. Er kann der freien Entscheidung nicht ausweichen, muß den Berg so nennen, wie er es in der Sprachgemeinschaft gelernt hat, oder er kann ihn anders nennen, wenn ihm eine Sprachgemeinschaft darin folgt. Er kann die Benennung der einen Sprache oder die Benennung der anderen Sprache wählen. Er kann auch beide Benennungen wechselweise gebrauchen, wie man es in sprachlichen Grenzgebieten

immer wieder beobachten kann, wie man es aber auch in Übergangs-
zeiten sieht, wenn etwa verschiedene Benennungen nebeneinander
bestehen, bis sich eine durchsetzt. Es besteht aber nicht einmal der
Zwang zur Durchsetzung einer von mehreren Möglichkeiten. In der
Sprache kann auch Mehreres zur Bezeichnung des Gleichen, Mehreres
in gleicher Funktion unbehelligt nebeneinander existieren, wie bei-
spielsweise im morphologischen System des Deutschen. Die fak-
tischen Einschränkungen der sprachlichen Kreativität des Individuums
sind durch Bindungen an die Sprachgemeinschaft mitgegeben, was
eine soziologische Komponente eröffnet. Sie ändern aber nichts an
der prinzipiellen Freiheit der Sprachträger und an der Tatsache,
daß der Wandel der Sprache, die Ausgestaltung der Sprache, die Re-
duzierung der Sprache, also jeglicher Wandel, zum Wesen der Sprache
gehört. Das wiederum ist in der historischen Bindung der Sprache an
die Sprachträger begründet und an deren faktische Geschichtlichkeit.
Es ist aber keine Bindung im Sinne naturwissenschaftlicher Kausali-
tät, als könne man von kulturellen, soziologischen, wirtschaftlichen
oder sonstwie extralinguistischen oder von intralinguistischen Kausal-
ursachen[23] sprechen, die eine Wandlung als notwendige Folge herauf-
geführt hätten. Ursachen sind vielmehr die freien menschlichen Ent-
scheidungen unter den Bedingungen, unter denen solche Entschei-
dungen erfolgen können. Nur so ist Kreativität zu verstehen. Die Ur-
sachen sind Finalursachen, in der menschlichen Freiheit und in der
Geschichte der Sprachträger begründet. Sonst wären die vielfältigen
Ausgestaltungen in der sprachlichen Erfassung gleichartiger und
verschiedenartiger Landschaften in ihrer Vielfalt nicht möglich. Die
Vielfalt wird gerade auch durch die konservative Komponente der
Sprache sichtbar, die dem Sprachträger eben Beibehaltung ermög-
licht. Die Möglichkeit der Abwandlung des schon Vorhandenen bleibt
bestehen und wird offenbar von allen Generationen als historische
Möglichkeit genutzt.

10. Sieht man das Ganze vom Ergebnis her, so wird dieses Er-
gebnis nur verständlich als Spiegelung der Schicksale der Menschen
eines Raumes. Im einzelnen können sich Aufschlüsse über das Vor-
handensein verschiedener Sprachen und Sprachstufen in einer Land-
schaft ergeben, aber auch Aufschlüsse über Benennungsmotivie-
rungen und über die Ausgestaltung historischer Muster durch neue
Benennungsmotivierung. Die semantische Interpretation des sprach-

lichen lexematischen Materials, das bei der Bildung der Namen verwandt worden ist, gibt drei große semantische Möglichkeiten zu erkennen: lexikalische Bedeutungen der Form, lexikalische Bedeutungen der Relation, lexikalische Bedeutungen des Materials.

Im Rahmen dieser Möglichkeiten spielen dann beispielsweise rechtliche Relationen eine große Rolle, Landschaftsformen und ihre metaphorische Gestaltung und natürliche Gegebenheiten wie Wasser, Erde, Moor, Steine, Pflanzen (und so weiter). Die gemeinten Formen brauchen nicht mehr zu existieren, die Rechtsverhältnisse nicht mehr zu bestehen, und die natürlichen Gegebenheiten der Landschaft können verändert sein. Solche Veränderung führt nicht an und für sich zu neuen Benennungen, als müßte der Wald immer wild, als könne das Moor nicht trockengelegt sein, der Berg nicht halb abgetragen, das Tal nicht hoch liegen, der Galgen nicht längst vergessen sein. Das hat aber nun nicht ohne weiteres etwas mit dem Bedeutungswandel appellativen Wortgutes zu tun. Das hat im Kern etwas damit zu tun, daß die Eigennamen, indem sie Eigennamen geworden sind, ihre lexikalische Bedeutung verlieren, der Hochberg also kein Berg mehr zu sein braucht, der Wald kein Wald (und so weiter). Daß es in vielen Fällen doch bei der klaren Beziehung zur Motivierung bleibt, daß die Gebirge im allgemeinen nicht verschwinden, die Täler im allgemeinen nicht zugeschüttet werden (und so weiter), ändert an diesem Faktum nichts. Der Name bedeutet nichts im Sinne der lexikalischen Bedeutung, er bezeichnet nur[24]. Das zeigt aber erst recht die Bindung an die Sprachgemeinschaft, die eben diese individuelle Bezeichnung prägt, in der sie verstanden wird und in der sie vor allem richtig verstanden und verwendet wird, als Name des einen individuellen landschaftlichen Gegenstandes. Das erleichtert die Übernahme all dieser Namen, da sie nicht an das 'lexikalische' Verstehen gebunden sind, lediglich aufgrund ihrer Kenntnis durch die Sprachträger, aufgrund der richtigen Zuordnung durch die Sprachträger existieren.

11. Die logische Operation der Benennung steht aber am Anfang und muß von den historischen Möglichkeiten und den historisch gebundenen Motivierungen her gesehen werden. Das führt historisch zu regional geprägten unterschiedlichen Bildern im Deutschen. Das ist nicht in jedem Falle in der geologischen oder sonstwie natürlichen Unterschiedlichkeit der Landschaften angelegt. Das ist fast ausschließ-

lich in der historischen Entwicklung begründet. Und so ist auch ein handelnder Eingriff der Sprachträger in die Landschaften erfolgt, in dem Sinne nämlich, daß Landschaften mit typischen Erscheinungsformen geschaffen werden, deren Existentz allein im Sprachlichen liegt[25]. Ortsnamentypen zusammen mit Flußnamentypen und Flurnamentypen, dazu die Typen der Familiennamen, das heißt, der Familiennamen der heutigen Sprachträger selbst, führen zu Sprachlandschaften, deren Bedingung zum Teil in der natürlichen Landschaft liegen kann, die aber in Wahrheit historische Bewältigungen von Landschaft durch die Sprachträger mittels ihrer Sprache sind.

12. Die Operation der Darstellung erfolgt natürlich in den Texten, die Landschaften beschreiben. Mit Darstellung ist eine Leistung der Sprache gemeint. Es ist eine der möglichen psychologischen Operationen, die die Sätze als solche mitkonstituieren. Darstellung beruht auf der dem Menschen gegebenen Möglichkeit, die ihm erkennbaren Dinge in Distanz zu sehen und sie also 'unpersönlich' zu beschreiben. So können Landschaftsbeschreibungen entstehen, die die natürliche Landschaft mit den Mitteln der Sprache 'naturgetreu' oder 'naturähnlich' wiedergeben. Das psychologische Moment dieser Operation bringt es aber mit sich, daß die Fähigkeiten der Sprecher zur Objektivation in stärkerem oder geringerem Maße wirksam werden, oder aber, daß subjektive Einwirkungen prägend sind. Das hängt von dem Sprachträger ab, seiner Abhängigkeit von literarischen Moden, von Gefühlen, von stilistischen Möglichkeiten (und so weiter). Hier geht vielfach die Bindung an die objektive lückenlose Benennung der Landschaft verloren. Es entstehen dichterische Landschaften, funktionale Gebilde von eigener Lebenskraft und eigener, nämlich dichterischer Wirklichkeit. Hier wird eine Leistung der Darstellung sichtbar, die nicht ohne die logische Operation der Benennung verfährt und auch nicht ohne die psychologische Operation der objektiven Darstellung im allgemeinsten Sinn, die aber stark an die Kreativität des einzelnen dichterischen Sprechers gebunden ist und so neue Landschaften hervorbringt. Diese neuen Landschaften sind nun selbst wieder Gegenstand menschlicher Befriedigung, menschlichen Denkens und Fühlens und wissenschaftlicher Analyse. Sprachliche Erschließung der Landschaft wird hier zur Schöpfung von Landschaft. Sprechen ist hier nicht nur Handeln im allgemeinen, wie es das immer ist. Sprechen ist hier Handlung selbst, nämlich wertende, färbende, ge-

staltende Handlung selbst. Das Produkt ist ein sprachliches Produkt. Aber es ist etwas über die Sprache Hinausgehendes. Es wird durch die dichterische Sinngebung zu einem Gegenstand eigener Natur über die Sprache und ihre Möglichkeiten im engeren Sinne hinaus.

Es geht also nicht um die absolute 'Identifizierung von Sprache und Dichtung', da 'Sprache gerade nicht absolut ist'. Sprache ist Erfassung der Welt und Gestaltung der Welt. Sie ist aber 'keine Interpretation der Welt' und kein Erschaffen 'möglicher Welten'. Hingegen 'ist die Dichtung immer absolut'. Und sie erschafft 'andere mögliche Welten'. Dichtung ist als 'Verabsolutierung der Sprache' zu verstehen, wenn auch nicht als Verabsolutierung auf der Ebene der Sprache als solcher, so doch 'auf der Ebene des Sinnes der Texte'. Mithin sind 'Texte nicht bloß als Sprache als solche zu interpretieren', vielmehr als 'eine höhere Modalität des Sprachlichen'. Die Sprache wird 'zum Ausdruck für Inhalte höheren Grades', ermöglicht 'allerlei Sinne', die in Texten vorkommen, schafft 'andere mögliche Welten'[26].

Die Existenz natürlicher Landschaften, die sprachlich erfaßt, erschlossen und formuliert sind, ist für Arkadien, wenn es einmal dichterisch geschaffen ist, nicht mehr vonnöten.

Anmerkungen

1. 1, 1—2. *Das Alte Testament*. Nach den Grundtexten übers. und hrsg. von Vinzenz Hamp und Meinrad Stenzel. 3. Aufl. Aschaffenburg 1957. S. 1—3.
2. Man vergleiche: Niels Danielsen, Zur Universalität der Sprache. *Sprachwissenschaft* 1 (1976) S. 1—45.
3. Zu den damit zusammenhängenden Fragen sei verwiesen auf: Thomas Luckmann, Soziologie der Sprache. In: *Handbuch der empirischen Sozialforschung*. Hrsg. von René König. Bd 2. Stuttgart 1969. Sp. 1050—1101. — Brigitte Schlieben-Lange, *Soziolinguistik. Eine Einführung*. 2. Aufl. Stuttgart 1973.
4. Sieh etwa: Friedrich Kainz, *Psychologie der Sprache*. Bd 1: Grundlagen der allgemeinen Sprachpsychologie. 3. Aufl. Stuttgart 1962. S. 327—334: Die Sprache der Anthropoiden und Hominiden. — Bernfried Schlerath, Die historische und die kreative Dimension der sprachlichen Systeme. In: *Sprache und Begriff. Festschrift für Bruno Liebrucks*. Hrsg. von Heinz Röttges, Brigitte Scheer, Josef Simon. Meisenheim am Glan 1974. S. 189—211. S. 189—190: Tiersprache.
5. Karl Bühler, *Sprachtheorie. Die Darstellungsfunktion der Sprache*. 2. Aufl. Stuttgart 1965. S. 30—33: Ausdruck (Kundgabe), Appell (Auslösung), Darstellung.

6. *Werke in drei Bänden.* Hrsg. von Karl Schlechta. Bd. 1. München 1954. S. 211: 'Betrachte die Herde, die an dir vorüberweidet: sie weiß nicht, was Gestern, was Heute ist, springt umher, frißt, ruht ... kurz angebunden mit ihrer Lust und Unlust, nämlich an den Pflock des Augenblicks ...' — Bernfried Schlerath. In: *Sprache und Begriff.* S. 190.

7. Sieh beispielsweise: Walter Porzig, *Das Wunder der Sprache. Probleme, Methoden und Ergebnisse der Sprachwissenschaft.* 5. Aufl. Hrsg. von Andrea Jecklin und Heinz Rupp. München 1971. S. 176—186: Das Sprechen und die Zeit.

8. Erwin Koschmieder, *Beiträge zur allgemeinen Syntax.* Heidelberg 1965. S. 82: Arten des Zeitbezugs. — Jean Marie Zemb, Sprache und Zeit. *Sprachwissenschaft* 3 (1978) S. 119—145.

9. Jean Fourquet, *Prolegomena zu einer deutschen Grammatik.* Düsseldorf 1970. S. 126—129. — Rudolf Schützeichel, Zur pragmatischen Komponente der Kasus. In: *Integrale Linguistik. Festschrift für Helmut Gipper.* Hrsg. von Edeltraud Bülow und Peter Schmitter. Amsterdam 1979. S. 573—588. Mit weiteren Hinweisen.

10. Auch für das Folgende: Karl Bühler, *Sprachtheorie.* S. 79—148: Das Zeigfeld der Sprache und die Zeigwörter. — Rudolf Schützeichel. In: *Integrale Linguistik.* Mit weiteren Hinweisen.

11. Harald Weinrich, *Für eine Grammatik mit Augen und Ohren, Händen und Füßen — am Beispiel der Präpositionen.* (Rheinisch-westfälische Akademie der Wissenschaften. Geisteswissenschaften. Vorträge. G 217.) Opladen 1976. — Rudolf Schützeichel. In: *Integrale Linguistik.* Mit weiteren Hinweisen.

12. Erwin Koschmieder, *Beiträge zur allgemeinen Syntax.* S. 70—89: Die noetischen Grundlagen der Syntax. — Karl Hoffmann, *Der Injunktiv im Veda. Eine synchronische Funktionsuntersuchung.* Heidelberg 1967. S. 37—42: Zu den noematischen Kategorien.

13. Zur Kritik der generativen Transformationsgrammatik sieh beispielsweise: Bernfried Schlerath. In: *Sprache und Begriff.* S. 198—203. — Manfred Sandmann, Die Zusammenziehung einfacher S-P Fügungen. In: *Sprache und Geschichte. Festschrift für Harri Meier zum 65. Geburtstag.* Hrsg. von Eugenio Coseriu und Wolf-Dieter Stempel. München 1971. S. 427—442. — Helmut Gipper, *Sprachwissenschaftliche Grundbegriffe und Forschungsrichtungen.* München 1978. S. 156—173: Fehlleitende Begriffe und Scheinprobleme. — Rudolf Schützeichel. In: *Integrale Linguistik.* Mit zahlreichen Literaturhinweisen. — Niels Danielsen, Das generative Abenteuer. *Zeitschrift für Phonetik, Sprachwissenschaft und Kommunikationsforschung* 25 (1972) S. 255—280.

14. Erwin Koschmieder, *Beiträge zur allgemeinen Syntax.* S. 19: 'Um sogleich die elementarsten Mißverständnisse auszuschalten, betone ich von vornherein: ich erhebe keineswegs etwa die Forderung an die Sprache, daß sie logisch zu sein habe, noch stelle ich eine solche Behauptung von ihr auf. Ich weiß sehr wohl, daß die Sprache nicht logisch ist. Logisch aber ist das

Kategoriensystem des Gemeinten ...' S. 70—89: Die noetischen Grundlagen der Syntax. S. 90—100: Aus den Beziehungen von Sprache und Logik. S. 116—123: Ist das Symbolsystem der Logistik eine Sprache? S. 140—152: Die Sprache und der Geist. S. 209—224: Das Allgemeingültige in der Syntax. — Bernfried Schlerath. In: *Sprache und Begriff.* S. 194—196. — Werner Betz, *Sprachkritik. Das Wort zwischen Kommunikation und Manipulation.* Zürich 1975. S. 7—42: Maßstäbe der Sprachkritik. Informationsmenge und Funktionabilität. — Eugenio Coseriu, *Sprachtheorie und allgemeine Sprachwissenschaft. 5 Studien.* München 1975. S. 210—233: Logizismus und Antilogizismus in der Grammatik. Mit zahlreichen Hinweisen. — Manfred Sandmann, Träume — Schäume. Die Nominalparataxen als Ausdruck einer logischen Grundstruktur 'conditio-consequentia'. *Sprachwissenschaft* 3 (1978) S. 1—15.

15. Bernfried Schlerath. In: *Sprache und Begriff.* S. 189—211. — Eugenio Coseriu, *Synchronie, Diachronie und Geschichte. Das Problem des Sprachwandels.* München 1974.

16. Der Terminus Derivation faßt Präfixbildungen und Suffixbildungen (Ableitungen) zusammen, im Unterschied zur Komposition. Der Terminus hat hier also nichts mit der 'Derivation eines Satzes' zu tun und ist auch verschieden von der (semantischen) 'Derivation' bei: Eugenio Coseriu, *Probleme der strukturellen Semantik. Vorlesung gehalten im Wintersemester 1965/66 an der Universität Tübingen.* Autorisierte und bearb. Nachschrift von Dieter Kastovsky. Tübingen 1973. S. 86—89. S. 99—102. — Eugenio Coseriu, Einführung in die strukturelle Betrachtung des Wortschatzes. In: *Strukturelle Bedeutungslehre.* Hrsg. von Horst Geckeler. Darmstadt 1978. S. 193—238.

17. Heinrich Dittmaier, Ursprung und Geschichte der deutschen Satznamen. Zugleich ein Beitrag zur vergleichenden Namenkunde. *Rheinisches Jahrbuch für Volkskunde* 7 (1956) S. 7—94. — Max Gottschald, *Deutsche Namenkunde. Unsere Familiennamen nach ihrer Entstehung und Bedeutung.* 4. Aufl. mit einem Nachwort und einem bibliographischen Nachtrag von Rudolf Schützeichel. Berlin 1971. S. 120—122.

18. Sieh etwa: Hans Krahe, *Die Struktur der alteuropäischen Hydronymie.* (Akademie der Wissenschaften und der Literatur. Abhandlungen der Geistes- und sozialwissenschaftlichen Klasse. Jahrg. 1962. Nr. 5.) Mainz 1963. — Hans Krahe, *Sprachverwandtschaft im alten Europa.* Heidelberg 1951. — Hans Krahe, *Unsere ältesten Flußnamen.* Wiesbaden 1964. — Wolfgang P. Schmid, *Alteuropäisch und Indogermanisch.* (Akademie der Wissenschaften und der Literatur. Abhandlungen der Geistes- und sozialwissenschaftlichen Klasse. Jahrg. 1968. Nr. 6.) Mainz 1968. — Antonio Tovar, *Krahes alteuropäische Hydronymie und die westindogermanischen Sprachen.* (Sitzungsberichte der Heidelberger Akademie der Wissenschaften. Philosophisch-historische Klasse. Jahrg. 1977. Abhandl. 2.) Heidelberg 1977. — Dazu: Rudolf Schützeichel. *Beiträge zur Namenforschung.* N. F. 13 (1978) S. 88. — Wolfgang P. Schmid, *Indogermanistische Modelle und osteuropäische Früh-*

geschichte. (Akademie der Wissenschaften und der Literatur. Abhandlungen der Geistes- und sozialwissenschaftlichen Klasse. Jahrg. 1978. Nr. 1.) Mainz 1978. — Hans Kuhn, *Das letzte Indogermanisch*. (Akademie der Wissenschaften und der Literatur. Abhandlungen der Geistes- und sozialwissenschaftlichen Klasse. Jahrg. 1978. Nr. 4.) Mainz 1978. — Dazu kritisch: Hans Schmeja. *Beiträge zur Namenforschung*. N. F. 14 (1979) S. 153—154.

19. Angesichts der Fülle der Literatur sei der Einfachheit halber verwiesen auf: Adolf Bach, *Deutsche Namenkunde*. II: Die deutschen Ortsnamen. 1—2. Heidelberg 1953—1954. III: Registerband. Bearb. von Dieter Berger. 2. Aufl. Heidelberg 1974. — *Beiträge zur Namenforschung*. In Verbindung mit Ernst Dickenmann hrsg. von Hans Krahe. 1—16 (Heidelberg 1949/50—1965). — *Register der Beiträge zur Namenforschung Band 1—16*. In Verbindung mit Ernst Dickenmann und Jürgen Untermann hrsg. von Rudolf Schützeichel. Heidelberg 1969. — *Beiträge zur Namenforschung*. Neue Folge. In Verbindung mit Ernst Dickenmann und Jürgen Untermann hrsg. von Rudolf Schützeichel. 1—15ff. (Heidelberg 1966—1980ff.). Jeweils mit der neuesten Literatur.

20. Dazu: Eugenio Coseriu, *Synchronie, Diachronie und Geschichte*. S. 58—93: Die Rationalität des Wandels. Neuerung und Übernahme. Die Lautgesetze.

21. Sieh dazu und zum Folgenden: Eugenio Coseriu, *Synchronie, Diachronie und Geschichte*. Passim.

22. Sieh für die Einzelheiten die globalen Literaturhinweise in Anmerkung 19. — Zu modernen Veränderungen in der Namenlandschaft: Irmgard Frank, Namengebung und Namenschwund im Zuge der Gebietsreform. *Onoma* 21 (1977) S. 323—337.

23. Abzulehnen ist die Annahme von 'Teleologie', 'innere Kausalität' (und so weiter) bei: Jan Goossens, *Deutsche Dialektologie*. Berlin 1977. S. 89—101. — Dazu: Rudolf Schützeichel. *Beiträge zur Namenforschung*. N. F. 14 (1979) S. 65—69. — Rudolf Schützeichel, Zur geolinguistischen Methode. In: *Liber Amicorum Weijnen*. Assen 1980. S. 366—378. — Zum gesamten Problembereich: Eugenio Coseriu, *Synchronie, Diachronie und Geschichte*. S. 152—205: Kausale und finalistische Erklärungen. Der diachronische Strukturalismus gegenüber dem Sprachwandel. Vom Sinn der "teleologischen" Interpretationen. — Eugenio Coseriu, *Die Sprachgeographie*. Tübingen 1975. Passim.

24. Zur Theorie des Eigennamens sieh beispielsweise: Dietrich Gerhardt, Zur Theorie der Eigennamen. *Beiträge zur Namenforschung*. N. F. 12 (1977) S. 398—418. — Irmgard Frank. *Beiträge zur Namenforschung*. N. F. 12 (1977) S. 107—108. Mit zahlreichen Literaturhinweisen.

25. Zum Begriff der Sprachlandschaft: Kurt Wagner, *Deutsche Sprachlandschaften*. Marburg 1927. — Zur Namengeographie: Rudolf Schützeichel. *Beiträge zur Namenforschung*. N. F. 14 (1979) S. 65 f. Mit zahlreichen Literaturhinweisen. — Sieh beispielsweise auch: *Das Dorf der Eisenzeit und des frühen Mittelalters. Siedlungsform, wirtschaftliche Funktion, soziale Struktur*. Bericht über die Kolloquien der Kommission für die Altertums-

kunde Mittel- und Nordeuropas in den Jahren 1973 und 1974 hrsg. von Herbert Jankuhn, Rudolf Schützeichel und Fred Schwind. (Abhandlungen der Akademie der Wissenschaften in Göttingen. Philologisch-historische Klasse. F. 3. Nr. 101.) Göttingen 1977. S. 9—36: Rudolf Schützeichel, 'Dorf'. Wort und Begriff. Mit weiteren Hinweisen.

26. Dieser Absatz ist größtenteils wörtliches Zitat aus den wichtigen Ausführungen von: Eugenio Coseriu, Thesen zum Thema 'Sprache und Dichtung'. In: *Beiträge zur Textlinguistik*. Hrsg. von Wolf-Dieter Stempel. München 1971. S. 183—188. S. 188.

EARTHWORM AND COSMOS
HARRY MARTINSON'S VISION OF MAN
AND NATURE

By Peter Hallberg

Harry Martinson's *Poems on Light and Darkness* (Dikter om ljus och mörker, 1971) ends with the poem "The Great Sorrow" (Den stora sorgen). Translated into English its opening lines read something like this:

> The laws of Nature are well on the way
> To bringing us all to account:
> Nature reduced to Law
> Has no longer room for Grace.
> We must all share the great sorrow.
> Only then shall we sustain it.
> Sorrow understood as infinite concern
> Is the sorrow we all must learn.

Now, we are told, that man has got power enough "to cause world sorrow", the time has come

> To cure world sorrow in time
> Before all nature becomes
> A child of sorrow for all of us.[1]

When these words were written, the awareness of approaching disaster had become widespread. The pollution of our environment and the destruction of nature were no longer themes of lonely prophetic voices. Warnings had reached us from many quarters, and we had become more or less accustomed to these fears. But with Harry Martinson this insight had deep and old roots in his own experience. He was prepared by many years' intensive study of man's relations with nature. His development in this respect is a fascinating chapter of modern Swedish literature.

Some biographical features of Harry Martinson's career may give an idea of the background of his knowledge of nature and his interest in it. He was born in 1904 in the Göinge district, on the boundary between the provinces of Blekinge and Skåne. As an orphan in

pre-welfare Sweden, he became a parish pauper at the age of six and had to live for some years on various farms. He thus met with rural Swedish life at a time when that life was still rather old-fashioned. This period provided the material for one of his best known books, *Flowering Nettle* (Nässlorna blomma, 1935).

The experiences of the lonely boy are seen here, of course, from the view-point of the grown-up author, but with a remarkable force of vivid realization of the consciousness and horizon of the child. The boy had to work hard for his masters, and we are told of his various jobs: harvesting turnips in the fields, cutting leaves for cattle-fodder, and so on. The seasons pass by, and nature is observed and described in all its aspects, very often in original and surprising images. Man and nature are seen in close relation with each other. The landscape is not only landscape, it is enlivened and humanized by the experience of man, by history, myth, legend and superstitious beliefs. We get a strong impression of an organic way of life, of man living in deep harmony with his surroundings.

At the age of fifteen Harry Martinson went to sea. He worked as a ship's stoker, and was sometimes a tramp with only occasional jobs. On his journeys he visited India, Brazil and many other countries of the globe. He has told us of these years in his prose books *Travels Without a Goal* (Resor utan mål, 1932) and *Cape Farewell* (Kap Farväl!, 1933). The world-wide travels meant an immense expansion of his horizon and experiences. The young man had to revise many of his conceptions of human life, when he was confronted with other countries, other cultures and other men. He introduces his vision of the "world nomad", the ideal of man in freedom, generously open to the world and his fellow creatures. From now on, all kinds of compounds with *world-* become a conspicuous feature of his poetic language.

His impressions of nature play an important part in these books, and they are perceived with open senses and rendered in an equally fresh language. He can describe a cyclone on the Indian Ocean in a series of striking images — ranging from associations with the Old Testament patriarchs to modern concepts of electricity and burning oil — so that the reader relives the impact of the raging elements. But he can also feel the serene calmness of the sea, as in the following lines from an earlier cycle of poems:

Out at sea you feel a spring or a summer only like a breeze.
The drifting Florida seaweed sometimes flowers in the summer
and on a spring night a spoonbill stork flies towards The Nether-
lands.[2]

Harry Martinson's keen interest in the interplay between man and
nature appears for instance when he watches three Congo negroes
walking along a street in Antwerp. "How swift in their way of mov-
ing and turning their heads", he thinks. They are open to the slight-
est noise. "In their consciousness the city becomes a jungle. And
the calmness of the stone buildings always becomes the crouching,
never safe, before a leap." In his memory he compares them with the
Senegal negroes, "who live on the edge of the desert, where the dan-
ger is visible at a long distance". The Senegal negroes move more
slowly, for their rhythm is adapted to the soft lines of a heavy Sahara
dune, whereas the Congo Negro "is tuned to the irrational manifold
rustle of the bushes at Sankuru".[3]

Or the poet sees a pregnant negro woman — "the luxuriant body
of the six swelling hemispheres" — who surrounded by six children
offers grapefruits for sale. In his vision this scene becomes "a study
in the globes of life [. . .] — outwards to the sun globes in outer space,
inwards to the ovum".[4] Such a correspondence is characteristic of
Harry Martinson's experience of a synthesis of human life and na-
ture, of terrestrial nature and cosmic nature. One night on the South-
American pampas he watches a star reflected in the green protruding
eye of a grasshopper — microcosm and macrocosm are brought to-
gether in one image.[5]

In the books on his childhood and his life as a seaman, Harry
Martinson documented his intimate knowledge of nature and his
unique gift for describing it. But his experience of nature was to gain
still deeper significance for his overall view of human life and its con-
ditions. In the late thirties he wrote three small prose books, sketches
with a very personal stamp: *Sphinx-Moth and Crane-Fly* (Svär-
mare och harkrank, 1937), *The Midsummer Valley* (Midsommardalen,
1938) and *Simplicity and Complexity* (Det enkla och svåra, 1939).

The title of the first text is typical. For here Harry Martinson be-
comes absorbed in the humblest forms of life. He describes vividly the
appearance and movements of flying insects and crawling beetles, but

also many other aspects of fauna and flora. In fact he shows an almost scentific ambition to record precisely. But of course he cannot deny his poetic inclinations either. He constantly introduces personifying and humanizing images in his descriptions. He appears here as an expert writer in what we Swedes often name the "Linnæan tradition". In a later essay "On Describing Nature" (Om naturskildring) he has summarized his personal experience of this literary genre. He sees its main goal in "constantly weaving anew the sensual bonds between nature in its generally comprehensible totality and the human soul". It should revive "the old simple truths that the grass is green, that the cuckoo calls and that the sun glitters on the water".[6]

However, in the years of the expanding Nazi movement, the Spanish Civil War and the approaching World War II Harry Martinson was unable to enjoy the life of nature in peace. Again and again his impressions bring him back to the cursed existence of man. He sees a lark rise into the air and soar there "on trembling wings":

> In the next moment the song pours down. I stand exactly under the shower of the tones. It is magnificent, yes, doubly magnificent at a time when the concepts of wings and bombs have become linked as pitch with Hell and sulphur with the Devil.[7]

The problem of man and nature seems to have been actualized and sharpened for Harry Martinson when the war reached our own remote part of the globe. The first Russian bombs over Finland in the so-called Winter War in 1939—1940 gave a strong echo in Sweden. They also made many of our authors reconsider their former position. Without being politically active Harry Martinson had sympathized with the Soviet Union as the communist workers' state. That was an attitude fairly natural to young writers who came from the working class. But now, in the Winter War, Harry Martinson joined the Swedish volunteer corps in Finland as a kind of postman. His book *Reality unto Death* (Verklighet till döds, 1940) explains why he made that move. And his interest in nature and basic human values develops into a humanistic vision of life, including cultural, national and political aspects.

He begins by giving us a background. As his starting-point he chooses a writers' congress in Moscow in 1934. He had himself been invited there as a guest of the Soviet government. The motto of the

congress was taken from Lenin: "The poet is the engineer of the human soul."[8] Harry Martinson now sees something characteristic of modern Russia in the fact that the poet receives "the feeble-mindedly materialistic title engineer".[9] He ascertains that the Soviet Union has successfully put its "purely material gifts" to good use.[10] At an airport outside Moscow he witnesses an orgy of parachute jumps, a big propaganda show, and comments on it vividly. Not only "modern Russian farmers, newly converted to ultra-technique, rained down from the sky", but also "calves and sheep, panic-stricken dogs, cats hanging under their parachutes and arching their backs at the grinning million down on the earth".[11] Such a scene could be taken as comic. But Harry Martinson knew "with terrible clearness" what would now come over the world. One day "the overgrown children would try the overgrown toys. And then. - - - Then the huge ultra-materialistic Christmas Eve of the world had come."[12]

From this point on the book turns into a sharp attack on modern civilization and technique as a whole. The "cult of the machine", "the incalculable whirling imbecility of a bolting civilization without conscience", threatens to destroy all sound life and to choke all spiritual values.[13] The poet wants to stop the merry-go-round. He defends the right of the irrational, of dream and meditation against the "tyranny of reality", the "concrete idiocy": "everything claims not only to be thing, solidity, hardness, palpability; it also claims to be soul, space, feeling, indeterminacy".[14] We lack consideration and humility or something nameless, akin to what religion once was.

In Harry Martinson's eyes the explanation that Finland was confronted with Asian barbarism, a pet idea in some quarters, is sheer nonsense. On the contrary, she defended herself against a "new-started, new-greedy, new-Russian civilization".[15] The enemy of our small nations, he explains, is "civilization in its degeneration".[16] In this atmosphere of dull materialism there is hardly any margin left for "the lyric and philosophical in man". But the freedom of these spiritual values — however limited it may be — is worth defending "with life, blood and soul".[17] According to Harry Martinson, Finland's defensive war was just a fight for all that is most seriously threatened by modern civilization. "There unyielding poor Finns from the woods ('skogsfinnar') were fighting for paradoxical but true things, for feelings and sentiments, for everything that makes the materialist

spout his bile as soon as he catches a glimpse of the vague and obscure words."[18]

Thus, with a reference to the Finnish woods, Harry Martinson reminds us of our roots in the nature we know and live with. And in a central passage the former "world nomad" tells us that to love one's native country is "to meditate quietly on its biological space and its nature cosmos".[19] He goes on to describe the Swedish woods with their flowers and ants, the soughing of their firs. "And nowhere else can one cultivate the dream and flower of the timeless as one can at home. Eternity must strike root in something definite to grow into feeling and dream."[20] He also turns to myth and history to point out the true values he wants to establish: "We have the woodland trolls and the sovereign glittering of the lakes and the unprecedented glory of the Great Ice Age."[21] It is only consistent with his nature that he now reveals a certain nostalgic longing for the past: "It was on the whole the past or at least the overlooked Sweden that he wanted to defend." "National peculiarity in our time is its *past* peculiarity and its reflexes in our time, creative longing and irrepressibility, incorrigible poetry."[22]

However, we are well on the way to losing our understanding of nature and our true relations with it. And the fault lies with us. "Civilization has gambled with Nature, but one day Nature will refuse to be thus handled."[23] "The sky will abandon us. The soughing of the woods will abandon us. And so will the star, and the memories flee from us, for they have been kicked out."[24] One can notice here the combination of nature with memory. For in the eyes of Harry Martinson memory is a truly human aspect of our connection with nature. But the present is marked by its flatness, its lack of deep dimension.

Harry Martinson's ardent defense of spiritual values is thus closely knit up with his experiences of nature — nature not in its sheer empiric existence, but in its relation to our deepest feeling of life. The picturesque image of the Congo negroes with the rhythm of the bushes at Sankuru in their bodies has acquired new and important overtones.

It is natural that the poet should have some trouble in trying to explain his rather vague message. "This was a very abstract whispering", he admits once.[25] Nevertheless it is not hard to recognize his

arguments. In their essence they are not brand-new, we have met them long ago. Romantic poets of the beginning of the nineteenth century could see "man's original sin, so to speak" in the fact "that he finds himself estranged from Nature", "because human consciousness, in its more limited forms, tends to see the external world as an inert object, as a mechanical assemblage of components for cold rational analysis, instead of as a harmonious unity coexistent with mind."[26] Just as with Harry Martinson, imagination, memory and meditation were seen as ways of restoring our connection with the heart of nature.

Philosophers of our time have treated the theme in much the same vein. Thus in a work on hermeneutics we are told of Heidegger's view of the subtle and pervasive "impact of technological thinking". Thought has gradually become "shaped to the requirements of concepts and ideas that will give control over objects and experience", and is no longer "a matter of open responsiveness to the world but of restless efforts to master it". It "exhausts the world in trying to reconstruct it to man's purposes":

> A river, for instance, has no intrinsic worth any more, and man redirects its course to suit his purpose, building great dams, dumping poisonous refuse in it. The gods have fled, and the earth is relentlessly being consumed.[27]

This comes near to Harry Martinson's view. Nature has no "intrinsic worth" any more; it is seen and treated as a means to an end, serving practical and egoistic purposes. This implies a kind of existential alienation, a state lacking full and spontaneous experience of life. In Old Chinese Taoism Harry Martinson has recognized an attitude which perhaps best corresponds to his own. Taoism is marked by a kind of active and optimistic passivity, a calm acceptance of the world as a whole — without worrying about its ultimate meaning or non-meaning. In an essay on "The Benign Possibility" (Den godartade möjligheten) Harry Martinson praises the Taoists' love of nature, their trust in its balance and harmony. We should be aware that nature with its "constant regeneration" is the "background, soil and preserver of culture". "Taoism is a faith for artists and peasants and for all men who think and feel under the open sky."[28]

As I have already said, Harry Martinson's positive message may be somewhat vague. In contrast, its negative counterpart has sharper outlines than with most of his forerunners. The target of his criticism has taken on more obvious and challenging forms, and his reaction to them is expressed in a broad assortment of invective. He sees modern man as having "a god who looked like an autostrada, with petrol stations at every kilometre, surface, extension".[29] Even words that are otherwise apparently neutral, such as "utility", "concrete" and "reality", acquire a strongly negative accent in his personal vocabulary.

Harry Martinson's later poetry develops the aspects already present in *Reality unto Death*. In one poem, the former seaman describes with sympathy and humour the old sailing-ships and their voyages over the oceans. The scene has a touch of old-fashioned dignity and elegance:

> By the Iberians the ocean of the trade-winds was named
> The Ocean of the Ladies:
> El Golfo de las Damas.
> Out there they brought the ladies to dance.
> In this way they sailed to the New World.[30]

There was a time, this seems to mean, when there still prevailed a kind of quietness, harmony, and even playfulness in the relations between man and his earth. Today, in the age of aircraft and enormous speed, all distances have been arrogantly reduced by man, and there has been a drastic distortion of terrestrial and human dimensions. From the height of the aircraft "the ocean of adventure" becomes only a "carpet", and the lake in the woods looks like a "scale of a herring". From here one cannot hear the song of the throstle nor the surge of the Mississippi.[31] Thus we are by and by losing our ability to experience the earth calmly and intimately in its established measures.

But Harry Martinson himself has kept his relations with nature intensely alive, with the simple things near at hand. As evidence of that gift one can refer to a couple of small poems which have already become classic in our literature. One of them is "The Earthworm" (Daggmasken):

Who respects the earthworm,
the tiller deep under the grass in the earth's soil.
He keeps the earth in transformation.
He works completely filled with soil,
mute from soil and blind.
He is below, the farmer downstairs,
where the fields are dressed for harvest.
Who respects him,
the deep, calm tiller, the eternal little gray farmer in the earth's
soil.[32]

At first sight this homage to the earthworm may seem to cor-respond rather badly with the poet's disparaging judgments on the concept of 'utility': the little creature is praised here for its usefulness in preparing the harvests. But we should notice that its activity is seen not only in relation to man and his interests, but in relation to all nature as an ecological system in its own right. The personification of the earthworm also strikes an intimate and sympathetic note. The worm is our fellow creature sharing the conditions of the earth. We feel the presence of the world of the child and the legend, where things are animated and experienced not as plain objects, but as part-ners.

In a similar way Harry Martinson introduces the humble juniper bush standing "strong and friendly, / squeezed between gray stones". It has given its twigs for graves and floors and brewed a good beer for men.[33] Such a poem bears witness to the author's natural piety, his loyalty to his childhood and his early experience of its people and their time-honoured customs. An unpretentious piece of Swedish nature symbolizes his vision. The "world nomad" is deeply rooted in his native soil.

As already hinted at, Harry Martinson looks upon memory as a consolidating, conserving and refreshing element of human life, pro-tecting it from flatness and establishing a dimension of depth. The memories are a dew over our thoughts, he tells us.[34] In the poem "Childlike Memories" (Barnsliga minnen) he sees these memories not only as a living connection with our own childhood, but with the deepest experiences of our fellow creatures:

> Childlike memories live
> With the nine lives of the cat.

They follow you mewing,
Begging for milk.
[- - -]
Memory is always a well.
Memories that bore deep enough
Reach the land of the folk-tale.
There they become more deeply yours.
There they become more deeply ours.
All of us have there the same tree, the same well
In the eternal soil.[35]

The folk-tale, the tree, the well, the eternal soil — the poet talks of what we all have in common as terrestrial and human beings, in an archetypal way. There exists a true and profound community below the surface of our existence, where we only appear as slaves to the superficial multiplicity of things.

In a cycle of poems, under the title "Li Kan Speaks Under the Tree" (Li Kan talar under trädet), in a Taoistic vein, we are invited to meditate upon the "self-evident elements, the sun, the earth and the sea". The wise man has nothing to add. "And if he finds something to add / Spring will come all the same / And summer and autumn and death."[36]

Naturally Harry Martinson has contemplated the mission of his poetry, and of poetry on the whole, in our time. And he has often done it in terms of his experience of nature:

Between the poetry that dwells in your heart and the poppy
 there is a contract
Written by the wind and signed by transience.
It is written with the feather of a crane
Dipped in the blood of the mayfly.[37]

What can be more fugitive than the wind, a feather of a crane, the blood of a mayfly? Nevertheless the human values which the poet wants to preserve to the utmost are embodied in these symbols of nature. Once more he rejects 'utility' as a universal value, 'reality' as raw mass and facts.

Harry Martinson's most daring attempt to mould his vision of mankind and its impending fate is the epic poem *Aniara*. It was published in 1956, with the subtitle "A Review of Man in Time and

Space". Hardly any other work in our literature after World War II has aroused such an interest as *Aniara*. It is a vision of the future, an account of the journey of the spaceship Aniara, which with eight thousand emigrants on board takes off from an earth poisoned by radiation, to move these people to the planet Mars. Such journeys by now have become routine. This time, however, there is an accident. Veering in order to escape the previously undiscovered "asteroid" Hondo, the spaceship falls away out of course. After that it steers irrevocably towards the constellation of the Lyre — where after a journey of fifteen thousand years it will be engulfed and burnt to ashes, as a gigantic sarcophagus.

When Harry Martinson launched his spaceship, the hydrogen bomb had become a terrible reality, and the epoch of manned space-craft was at hand. The poet has rendered the science-fiction content of his work in verse, often even rhymed verse.

Many concepts, trains of thought and symbols in *Aniara* we know from his earlier writings. But now they have been carried to their ut-most consequences. The spaceship rushing towards annihilation is an image of the technocratic arrogance which Harry Martinson had warned us against for decades. Nature will not allow us to rob her of her last secrets with impunity; we must beware of presumptuously and brutally breaking her locks. The reverence for the earth, the confidence in the balance that dwells in nature and in the unpre-tentious but fundamental human values — all of this acquires a heightened intensity and an almost religious stamp, when it stands out against the background of the waste space of the cosmic universe, where only ice-cold laws of mechanics rule.

In the spaceship, the interest circulates round the wonderful cent-ral instrument, the Mima. It is of an extreme perfection and refine-ment. Its intellectual capacity and stringency is said to exceed by three thousand and eighty times what man could achieve, if he could take the place of Mima. Its "truth is incorruptible / showing the sheer truth of all created things".[38] With unbribable fidelity it me-diates to the passengers all that is going on in the surrounding uni-verse; above all it maintains the connection with the earth which they have left for ever. But in the face of the terrible sights which it reproduces, when the city of Dorisburg is smashed by the atom-

ic bomb, the Mima collapses under the strain, as if it were itself a living being, for

> she had seen the hot white tears of granite
> when stones and ores are vaporized,
> it wrung her heart to hear these stones lament.[39]

Thus the Mima has not only incomparable intellectual qualities, but also soul and feeling. Among other things, it has been seen as a symbol of poetry. The description of the Mima and still more that of the female pilot called Isagel — "our clear-eyed spirit", "ruler of pure thought" — show that Harry Martinson is by no means hostile to science and technology, if only they are used not destructively but in a noble and so to speak morally responsible way, related to human values.[40]

As long as possible the fate of the earth is followed through the Mima, the earth which for the doomed passengers has now become "a noble planet, / on which we long to land".[41] Terrestrial nature in its warmth and harmony and human implications is brought back to our consciousness, perhaps most intensely in "Song of Karelia", the legendary province of eastern Finland. We are reminded of a typical northern night in June, when darkness hardly falls before dawn sets in. And we hear the tones of the cuckoo sending "his flute-like invitation to sweet Aino".[42]

By and by, all life in the spaceship dies out, and this "Review of Man in Time and Space" comes to an end in song 103. The poet has seen "our fate mirrored in the galactic ocean". Now "a silence as clear as glass revolves round our tomb". Through us all goes "the wave of Nirvana".

Aniara is a great and moving poem, but not just because of its message and penetrating warnings. Many other authors have given a similar pessimistic view of our common future. Harry Martinson's vision gets its peculiar intensity because it springs from his own deep experience of the earth in all its aspects, of our existence as human and terrestrial beings beneath the sun and the stars. On board the spaceship, during its fatal journey through the galactic night, he never forgets the earthworm, "the eternal little gray farmer in the earth's soil". He can speak to us of "The Great Sorrow" with the

serene authority of a man who has envisaged and felt that sorrow in a deeper sense — intellectually, emotionally and morally — than most of his fellow-passengers:

> We came from Earth, from Douris' land,
> the jewel of our solar-system,
> the only planet where Life has found
> a land of milk and honey.
> Describe the landscape that was there,
> the days that dawned and darkened,
> describe the men who there in beauty stitched
> the white shrouds of their race
> until God and Satan hand in hand
> from a defiled and poisoned land
> past plains and mountains fled
> the face of Man; the King of Ashes.[43]

Notes

1. "Den stora sorgen", in *Dikter om ljus och mörker* (Poems on Light and Darkness, 1971), p. 128. — I am grateful to Dr Sven Arne Bergmann, Göteborg, a distinguished expert on Harry Martinson's writings, for revising my translations of the poetry.
2. "Ute på havet" (Out at Sea), in *Nomad* (1931) ; quoted from *Eight Swedish Poets*. Transl. and ed. by Frederic Fleisher (Malmö: Cavefors, 1969), p. 99.
3. *Resor utan mål*, pp. 28—29.
4. *Ibid.*, pp. 124—125.
5. *Ibid.*, p. 156.
6. "Om naturskildring", in *Utsikt från en grästuva. Småprosa* (View from a Tuft of Grass. Small Prose, 1963), pp. 9—19. The quotations from pp. 12—13.
7. *Det enkla och det svåra*, p. 56.
8. *Verklighet till döds*, p. 9.
9. *Ibid.*, p. 13.
10. *Ibid.*, p. 22.
11. *Ibid.*, p. 29.
12. *Ibid.*, p. 35.
13. *Ibid.*, p. 34.
14. *Ibid.*, pp. 154—156.
15. *Ibid.*, p. 73.
16. *Ibid.*, p. 176.
17. *Ibid.*, p. 138.

18. *Ibid.*, p. 73.
19. *Ibid.*, p. 65.
20. *Ibid.*, p. 122.
21. *Ibid.*, p. 59.
22. *Ibid.*, pp. 58—59.
23. *Ibid.*, p. 141.
24. *Ibid.*, p. 154.
25. *Ibid.*, p. 155.
26. Anthony Close, *The Romantic Approach to 'Don Quixote'. A Critical History of the Romantic Tradition in 'Quixote' Criticism* (Cambridge: Cambridge University Press, 1977), p. 34.
27. Richard E. Palmer, *Hermeneutics. Interpretation Theory in Schleiermacher, Dilthey, Heidegger, and Gadamer* (Evanston: Northwestern University Press, 1969), pp. 145—146.
28. The essay "Den godartade möjligheten" in the review *Quo Vadis 1* (Göteborg 1948), pp. 9—12. The quotations from pp. 9—10.
29. *Verklighet till döds*, p. 52.
30. In *Passad* (Trade-Wind, 1945), p. 21.
31. "Flygardikt" (Pilots' Poem), in *Passad*, p. 27.
32. "Daggmasken", in *Passad*, p. 83; English transl. by Frederic Fleisher, quoted from *Eight Swedish Poets* (see note 2), p. 113.
33. "Enbusken" (The Juniper Bush), in *Passad*, p. 58.
34. "Minnena" (The Memories), in *Vagnen* (The Car, 1960), p. 27.
35. "Barnsliga minnen", in *Vagnen*, p. 29.
36. From "Li Kan talar under trädet", in *Passad*, p. 120.
37. "Förbindelse" (Obligation), in *Gräsen i Thule* (The Grasses in Thule, 1958), p. 18.
38. *Aniara. A Review of Man in Time and Space.* Adapted from the Swedish by Hugh Macdiarmid and Elspeth Harley Schubert (London: Hutchinson, 1963), p. 25.
39. *Ibid.*, p. 33.
40. *Ibid.*, pp. 116—117.
41. *Ibid.*, p. 25.
42. *Ibid.*, p. 97.
43. *Ibid.*, p. 105.

Discussion

Lars Gyllensten: Harry Martinson was a very learned man. He took a lifelong interest in non-Western cultures and was especially committed to Chinese and Indian philosophies and religions, including Buddhism and Taoism, as Professor Hallberg mentioned. On the other hand there are very few, if any, traces of Christian ideas, feelings and concepts in his writings. I believe that this has something to

do with his vision of man and nature, as it has been described to us this morning.

There are many paradoxes involved in Christian religion and theology. One of them is the curious fact that the Christian faith is regarded as an antimaterialistic religion, and yet it has become *the* religion of the highly materialistic Western civilization. Even if most people nowadays are not very pious and not very adherent to Christian dogmas or beliefs, our attitudes, thoughts and social institutions are stamped by Christian traditions which, for centuries, have constituted the main frame of reference for our cultural achievements. Christianity is an eclectic religion. Two components are of dominating importance: the ancient Hebrew religion, and Platonism or neo-Platonism. According to the Bible, God created man in his likeness to become a sort of demi-god on earth, a sovereign over everything else. Animals and plants, all nature were of no value in themselves, only as servants of man or as prey, food, tools etc. for the benefit of mankind. The salvation and resurrection, heaven and hell, history and eternity were intended only for man — yes, man, perhaps not for woman, but definitely not for plants, animals and the rest of the creation. Christ died for man, not for the earthworm, the dew-drop or the cosmos.

The second great component of the Christian religion, Platonism and neo-Platonism, was still more hostile towards the world of bodies and matter. This world, Nature, was regarded as a source of corruption and decay. Truth and dignity, it was believed, must be searched for elsewhere, in the human spirit, which ought to be liberated from the prison of the flesh. Nature, everything else, including the human body, was to be conquered by the spirit and subdued by its discipline or by grace. Socrates, i.e. Plato in one of his dialogues, explicitly stated that he could learn nothing from the birds and trees and streams, only from his own spirit and from social intercourse with other human beings. Nature was an unworthy companion for the human spirit.

It is a cruel paradox that the main constituents of the Christian religion of love with its antimaterialistic transcendentalism can form a most suitable ideology for a perverted humanity, which regards everything as legitimate prey and tolerates or even promotes a wreckless exploitation of all nature, including man himself — at least other men.

This Western attitude or ideology is very different from those mythologies, philosophies or religions which regard men and animals as parts of the same chain of living or being. In the world of Aesop and Mahabharata, of Shiva, Vishnu and Buddha, of African folktales and totemism and in a great number of other non-Western visions of man and nature, man is not sovereign over all nature but is a citizen and a companion, a listening pupil and not a master.

It is highly probable that Harry Martinson's commitment to non-Western traditions, mythologies and philosophies was a fundamental element in his vision of man and nature.

Gunnar Beskow (Professor emeritus of Geology, Göteborg) wished to connect Gyllensten's last words with the current situation in Sweden, where so many of the finest natural resources, the coniferous forests, the wild rivers etc., were being thoughtlessly exploited out of shortsighted greed and political ambition.

Richard Adams: It has often seemed to me, when I have meditated on this problem of the destruction of nature and the spoiling of the beauty of the world, that everybody is very much concerned about this, everyone is concerned to make noise about it, and nobody is quite clear what it is that we ought to do, apart from continuing to make noise about it and educating people to think about it. Surely the trouble flows entirely from overpopulation of the world. People are always going to want a comfortable standard of existence, they are always going to want to get from place to place easily, they are always going to want machines to do their work for them. These things would be compatible with the preservation of the beautiful earth if only there were not so many people in it. This is the solar plexus of the problem that we should be trying to strike at. If we could succeed in working out between all nations an optimum population for the earth and then sticking to it, and seeing that people stuck to it by whatever means — a difficult enough problem in itself, I know —the solution of the other problems relating to the conservation of nature and the compatibility of a technological world with a beautiful and preserved world would follow as a matter of course.

ROMAN, DESCRIPTION ET ACTION

Par Claude Simon

Dans un article publié à Léningrad en 1927 et intitulé *De l'évolution littéraire,* l'essayiste russe Tynianov écrivait :

« En gros, les descriptions de la nature dans les romans anciens, que l'on serait tenté, du point de vue d'un certain système littérai-re, de réduire à un rôle auxiliaire, de soudure ou de ralentissement (et donc de rejeter presque), devraient, du point de vue d'un autre sys-tème littéraire, être considérées comme un élément principal, *parce qu'*il peut arriver que la fable ne soit que motivation, prétexte à ac-cumuler des descriptions statiques. »

Ce texte (qui à certains égards apparaît comme prophétique) appel-le, me semble-t-il, un certain nombre de remarques.

<div align="center">*</div>

Observons tout d'abord que, pour qualifier l'action d'un roman, Tynianov emploie le mot *fable.*

Or, selon le dictionnaire, ce mot a deux acceptions.

La première est la suivante : « petit récit d'où l'on tire une moralité. »

Tout de suite, alors, une objection vient à l'esprit : c'est que, en fait, le processus de fabrication de la fable se déroule exactement à l'inverse de ce schéma et que *c'est le récit qui est tiré de la moralité.* En d'autres termes, pour le fabuliste il y a *d'abord* une moralité, et *ensuite* l'histoire qu'il imagine (histoire *fictive* faut-il le souligner), élaborée *en fonction* de ce sens, à titre de démonstration imagée pour illustrer une maxime, un précepte ou une thèse que l'auteur cherche, par ce moyen, à rendre plus frappante. Cette thèse, ce précepte, cette maxime préexistants à la fabrication de l'histoire (de l'action) relèvent de ce que l'on appelle le *sens institué.*

Et c'est cette tradition qui, en France, à travers les fabliaux du Moyen Age, les fabulistes et la comédie dite « de mœurs » ou « de ca-ractère » du XVIIe siècle, puis le conte philosophique du XVIIIe, a abouti au roman prétendument « réaliste » du XIXe affirmant, comme le proclamait Balzac, donner une « reproduction rigoureuse » de la société et prétendant par cela même à une vertu didactique.

Novateur à son époque, porté par un certain style et une certaine démesure qui le haussaient au-delà de ses intentions, ce type de roman a peu à peu dégénéré pour donner naissance à des œuvres qui n'en ont retenu que l'esprit purement démonstratif et dont un exemple caricatural dans la littérature contemporaine est offert par une fiction comme *La peste* d'Albert Camus. Chacun sait bien en effet qu'il ne va pas trouver dans ce roman une description de ce fléau (dont Camus, au contraire de Daniel Defoe à Londres, n'a d'ailleurs jamais été témoin), que le titre doit être pris dans son acception symbolique, et que, de même que dans la fable de La Fontaine intitulée *Les animaux malades de la peste*, ce qu'on va lire est un apologue destiné à montrer, selon les idées de l'auteur, les comportements de divers types d'individus en présence d'une catastrophe ou d'une épreuve subie par une communauté.

Ce *savoir* que Camus pense posséder, il nous le transmet par le biais d'une fiction forgée par lui de toutes pièces, et il est bien évident alors que, dans une telle optique, toute description apparaît non seulement superflue mais, comme le souligne Tynianov, importune, « à rejeter », puisqu'elle vient se greffer sur l'action, l'interrompt, ne fait que retarder le moment où le lecteur va enfin découvrir le sens de cette histoire dans laquelle les descriptions qui, toujours dans cette optique, sont, par excellence, *non action*, ne lui apparaissent, très exactement, que comme *non sens*.

<div align="center">*</div>

« L'apologue, écrit La Fontaine, est constitué de deux parties dont on peut appeler l'une le corps, l'autre l'âme : le corps est la fable, l'âme la moralité. »

Voilà les choses bien mises à leur place, et la vieille dichotomie âme/corps, esprit/matière, contenu/contenant, fond/forme, fonctionne avec ces catégroies bien tranchées, accordées à la morale chrétienne qui veut que l'âe, l'esprit, soient choses nobles, sacrées, et le corps, la matière, choses basses, sinon honteuses.

Cependant, si l'on s'arrête, ne serait-ce qu'un peu, à examiner ce corps, cette matière méprisée (indépendamment de laquelle pourtant jamais aucun esprit ne s'est manifesté), une constatation s'impose aussitôt : c'est que le langage (sans quoi il n'est pas de fable, et donc, pour s'exprimer comme le bon La Fontaine, pas d'âme . . .), ce langage,

sa caractéristique « matérielle » si j'ose dire, mesurable, c'est qu'il appartient à l'ordre du linéaire et qu'il s'en suit que toute personne qui parle ou écrit, tout discours (qu'il soit narratif ou descriptif) est obligé de tenir compte qu'il doit transposer dans une dimension unique (la durée) un monde qui est, lui, multidimensionnel, soit dans la simultanéité des perceptions, soit dans celles des qualités d'un objet, des aspects d'un spectacle, soit encore dans celle des actions.

Et de ce simple fait découle une série de conséquences complexes que, très schématiquement, on peut résumer de la façon suivante :

Forcé que je suis d'énumérer successivement ce qui est simultané, je dois décider d'un *ordre*, ne serait-il que syntaxique, ce qui implique une priorité (comme on l'a remarqué, si je dis : « La rivière passe sous le pont », ou « Le pont franchit la rivière», je ne dis pas la même chose).

De plus, les composantes, les aspects de toute action, de tout spectacle, de tout objet étant d'une multiplicité presque infinie, il m'est impossible d'entreprendre de les énumérer tous (je parle bien entendu d'un texte littéraire, pas d'un traité d'anatomie, de botanique ou de géologie) car l'accumulation des informations ainsi éparpillées dans le temps, outre son caractère fastidieux, aurait pour effet inéluctable de détruire dans l'esprit du lecteur toute cohérence.

L'action, l'objet ou le spectacle *écrits* ne peuvent donc être que :

1) déformés selon l'ordre de priorité donné dans le successif à ce qui est simultané.

2) partiels, c'est à dire réduits à quelques-unes seulement de leurs composantes (ainsi nous ne savons rien d'autre de « la dame en rose qui mangeait des mandarines » de Proust que : dame, rose, manger et mandarines — et si, bien sûr, par la suite, de loin en loin, d'autres informations nous seront données sur Odette de Crécy, il est à souligner que chaque fois c'est un groupe (ou une combinaison) d'informations extrêmement partielles, que jamais le personnage d'Odette ne nous sera donné d'une fois, en son entier, et que, de plus, ces informations sont souvent contradictoires, faisant d'Odette un être aux multiples facettes, essentiellement ambigu (une « fonction variable », comme l'on dirait en mathématiques) en accord, comme d'ailleurs tous les autres personnages de Proust, avec la polysémie du texte).

De ces observations, il ressort à l'évidence qu'inévitablement impuissante à représenter, à *reproduire* (contrairement à ce que préten-

dent les « réalistes »), la langue et par conséquent l'écriture *produi-sent* des objets qui, *avant d'être écrits, n'existaient pas.*

<center>*</center>

Quant à la nature de ces objets, quelle est-elle ?

Eh bien, si l'on y réfléchit, on découvre, comme ju viens de le dire pour Odette de Crécy, qu'elle s'avère d'une complexe ambiguïté, et je crois que c'est une question sur laquelle il est encore nécessaire de s'arrêter sous peine de tomber dans l'une ou l'autre de ces simplifications dogmatiques, aussi opposées qu'absurdes, aboutissant soit à la recherche terroriste et naïve d'un sens, soit, au contraire, à une volonté tout aussi naïve et terroriste de répudiation du sens, double naïveté spirituellement stigmatisée par la boutade d'un critique rappelant qu'il y a un siècle, lorsque les Impressionnistes faisaient scandale en exposant ce que l'on appelait alors des « barbouillages informes », leurs rares défenseurs disaient aux gens : « Eloignez-vous, éloignez-vous, et vous verrez que *cela représente quelque chose* », tandis qu'il y a quelques années, au moment de la grande vogue de la peinture « abstraite » ou tachiste, ses défenseurs qui lui cherchaient des appuis dans une certaine tradition, disaient aux gens en leur montrant les mêmes œuvres des impressionnistes (en particulier de Monet) : « Rapprochez-vous, rapprochez-vous, et vous verrez que *cela ne représente rien* » ! . . .

Alors, que peut-on dire ?

Ma foi, je hasarderai ceci : la langue étant, par essence, métaphorique, les mots ne sont pas seulement signes mais, selon l'expression de Lacan, « nœuds de significations » ou, si l'on préfère, comme je l'ai dit dans ma préface à *Orion aveugle*, des « carrefours de sens », en fonction de quoi l'on peut, me semble-t-il, énoncer ce qui suit, à savoir que l'objet décrit ou plutôt *écrit* se trouve en rapport avec l'objet (ou le concept) auquel le mot renvoie mais, *en même temps* (et c'est là que réside l'ambiguïté) il se trouve aussi, *au sein de la langue,* en rapport avec une multitude d'autres objets qui, dans le monde quotidien, le temps ou l'espace mesurables, se trouvent très éloignés de lui et souvent sans rapports apparents, de sorte que Chklovski peut définir très pertinemment le fait littéraire comme « le transfert d'un objet de sa perception habituelle dans la sphère d'une nouvelle perception », définition qui va d'ailleurs de soi si l'on veut

bien se rappeler qu'en grec le sens concret du mot μεταφορα est, très exactement, *transport*.

<div align="center">*</div>

Mais prenons un exemple.

Dans *Les jeunes filles en fleurs*, Proust, parlant des repas qu'il prend avec sa grand-mère dans la salle à manger du Grand Hôtel de la Plage, à Balbec, écrit ceci :

> Pour ma part, afin de garder, pour pouvoir aimer Balbec, l'idée que j'étais sur la pointe extrême de la terre, je m'efforçais de regarder plus loin, de ne voir que la mer, d'y chercher des effets décrits par Baudelaire et de ne laisser tomber mes regards sur notre table que les jours où y était servi quelque vaste poisson, monstre marin qui, au contraire des couteaux et des fourchettes, était contemporain des époques primitives où la vie commençait à affluer dans l'Océan, au temps des Cimmériens, et duquel le corps aux innombrables vertèbres, aux nerfs bleus et roses, avait été construit par la nature, mais selon un plan architectural, comme une polychrome cathédrale de la mer.

Tout de suite, et avant d'aller plus loin dans l'étude de ce texte étonnant, mais ce que l'on peut tout de suite noter c'est à quel point une telle description illustre la définition proposée par Chklovski, c'est à dire que par le travail de la langue un poisson bouilli posé sur un plat est soudain arraché à son contexte dans le monde quotidien (les couteaux, les fourchettes, un déjeuner vers 1900 dans la salle à manger d'un hôtel) pour être transporté dans un cadre aux tout autres dimensions.

Les mots que Proust a choisis pour en parler (et notons encore au passage la sélection qu'ils constituent, car pas plus qu'il ne nous précise son espèce, Proust ne nous dit ni la couleur de sa peau, ni sa forme particulière, ni sa saveur, et ...), les mots, donc, employés (convoqués) pour cette description (soit : vaste, monstre, marin, époques primitives, vie, afflux, Cimmérien, innombrable, vertèbres, bleu, rose, construit, nature, plan, architecture, cathédrale, mer), ont le pouvoir de susciter soudain dans cette banale salle à manger de palace tout un ensemble de majestueuses résonances ou harmoniques mettant en jeu les concepts de préhistoire, de biologie et de structure qui font que, soudain, nous prenons conscience que cet objet n'est pas un accident isolé mais un élément de cette immense et rigoureuse organisation dans l'espace et le temps qu'est le monde auquel il est étroitement lié

par tout un réseau de correspondances qui font de lui un véritable monument.

Assis avec Proust, sa grandmère et une marquise bavarde à cette table d'un grand hôtel normand, nous sommes soudain pénétrés, comme devant une peinture de Cézanne ou de Rubens, par ce sentiment pour ainsi dire cosmique que tout dans la nature se commande, est organisation, dépendances, *rapports*.

<p style="text-align:center">*</p>

Voilà donc quels peuvent être, à un premier degré (car cela va bien plus loin encore) les pouvoirs de la langue et de la description.

Mais ce qu'il faut observer aussi (et c'est là, me semble-t-il, un fait de première importance), c'est le démenti qu'un texte comme celui-là apporte à la timide proposition de Tynianov qui, cherchant à imaginer une nouvelle forme de roman, ne peut concevoir que des descriptions « statiques » et « accumulées ».

Je reviendrai sur le concept d'accumulation. Quant au « statique », on voit encore par là à quel point l'illusion réaliste a pu parquer les esprits, puisque même une intelligence comme celle de Tynianov ne parvient pas à s'en dégager.

Car tout se tient : si, en effet, l'écriture est censée « représenter » (thèse des « réalistes »), alors il est bien certain que la « représentation » par la langue d'un objet *immobile* (comme par exemple un poisson cuit) ne peut être aussi, en toute logique, qu'immobilité ou, en d'autres termes, « statique » . . .

Or, bien au contraire, ce que nous montre Proust (et en ceci il apparaît comme le grand écrivain révolutionnaire du XXe siècle, l'écrivain véritablement *sub-versif*, c'est-à-dire renversant sens dessus-dessous l'optique romanesque traditionnelle), c'est le prodigieux dynamisme de la description qui, littéralement, projette autour d'elle, comme une pieuvre, des tantacules dans toutes les directions, sélectionne et convoque des matériaux, les assemble, les organise.

Et dès lors s'ouvrent de tout autres perspectives, car on voit nettement que, dans le roman, il existe deux sortes d'actions, et par conséquent de sens :

d'une part l'action de la fable, l'histoire racontée qui établit des rapports de causes à effets entre des événements *fictifs* (sujets donc à caution), rapports *découlant d'un projet prééxistant à l'écriture* ;

d'autre part l'action de la description (description d'un lieu, d'un

objet, d'un personnage, description d'une action — qu'il ne faut pas confondre avec sa simple relation : tout le monde comprendra, je pense, la différence qui existe entre, par exemple, écrire : « Le train est entré en gare à 15 h 45 », et décrire l'entrée du train dans la gare, travail qui consiste, sans projet préétabli, à interroger un objet, un spectacle, à le « considérer », comme disent les mathématiciens d'une « figure », pour en découvrir les « propriétés », c'est-à-dire les pouvoirs qu'il a d'attirer à lui d'autres images, d'autres concepts, et établir entre eux, dans et par la langue des rapports dont découlera un sens ou plutôt *du* sens que j'appellerai *sens produit*.

Il n'est pas, j'imagine, besoin d'insister pour montrer à quel point ces deux types d'action s'opposent, et d'abord sur le plan de la fiabilité, car s'il m'apparaît irrécusable (et profondément significatif) que le squelette du poisson de Proust sorti de l'immensité de la mer et du fond des âges soit rigoureusement structuré et évoque le plan d'une cathédrale (« vaste » nef ou navire), par contre, tel ou tel événement rapporté dans le même ouvrage (la mort d'Albertine, par exemple, tuée fortuitement dans un accident de cheval) me paraît simplement *possible* et très exactement *(in-signifiant*, sans valeur, ne serait-ce que parce qu'on fait là appel à ma seule crédulité : d'où la seconde définition que donne le dictionnaire de ce mot *fable* judicieusement employé par Tynianov et qui est la suivante : « récit *faux*, imaginaire », de même qu'aujourd'hui toute information publique ou privée qui semble fantaisiste, abusivement déformée ou tendancieuse, fait aussitôt dire aux gens avec un haussement d'épaules : « C'est du roman ! . . . »

<p style="text-align:center">*</p>

A juste titre, donc, il ne semble plus possible à Tynianov de s'intéresser à des « fables ». Toutefois, abusé par le vocabulaire des prétendus réalistes, il ne paraît pouvoir imaginer d'autre solution pour le roman qu'une fable prétexte à une accumulation de descriptions statiques, ce qui, il faut le dire, ressemble fort à une solution de désespoir.

Pourtant, dans le même essai, il a formulé, peu avant, une autre proposition beaucoup plus suggestive et qui est celle-ci :

J'appelle *fonction constructive* d'un élément de l'œuvre littéraire comme système, sa possibilité d'entrer en corrélation avec

les autres éléments du même système et par conséquent avec le système tout entier.

Et cette proposition me semble capitale car, en quelques mots, elle ouvre au roman de tout autres perspectives et le fait accéder à une tout autre dimension que celle d'une fable plus ou moins amplifiée, plus ou moins ornée : à la conception traditionnelle qui veut que le roman ne soit qu'une simple succession d'événements entrecoupée de descriptions décoratives accumulées, il oppose maintenant la notion de *système*, c'est à dire, précisément, celle d'un vaste ensemble de rapports et de jeux de miroirs.

Je viens d'essayer de montrer, avec le poisson de Proust, comment fonctionne *activement* ou, si l'on préfère, comment, au premier degré, peut agir une description. Mais ce n'était là qu'un examen sommaire de quelques-unes des propriétés de ce petit texte aux multiples implications et qui, en fait, comme le révèle une étude plus poussée, semble bien être une véritable « mise en abyme » de l'œuvre tout entière à laquelle renvoient chacune de ses composantes, c'est à dire que non content de tisser un réseau de rapports entre le poisson et un certain nombre de concepts étrangers à son contexte immédiat dans l'espace ou le temps, Proust trouve encore le moyen, dans ce dispositif phrasique, de mettre en scène par l'effet d'une série de superpositions et de métaphores plusieurs des principaux éléments constitutifs du roman et jusqu'à la construction même de celui-ci.

Je n'ai malheureusement pas le temps, dans le cadre d'une aussi courte communication, d'entrer dans le détail du fonctionnement de ce dispositif et d'en exposer, comme je l'ai fait ailleurs, une analyse détaillée. Je suis donc obligé de me contenter d'indiquer brièvement que ces quelques lignes, constituant comme une sorte de condensé, renvoient le lecteur à l'ensemble des composantes du « système », soit, très sommairement : l'importance de l'élément marin (la déception éprouvée par Proust lorsqu'il découvre que l'église de Balbec n'est pas « battue par les flots », Albertine passion / poisson) et l'importance non moins grande de l'organisation générale de l'œuvre (le plan, semblable, on le sait, à une cathédrale, de *La Recherche du Temps Perdu*).

Ainsi s'établit un vaste *système* d'échos (ce que Baudelaire appelait les « correspondances ») qui montre bien (lorsqu'on s'aperçoit que *La Recherche* est sans cesse le lieu de tels dispositifs) que l'on se trou-

ve ici non plus en présence d'une simple accumulation mais, à l'opposé, d'une *combinatoire*.

<center>*</center>

Et enfin, je me hasarderai à aller plus loin encore : n'est-il pas possible en effet, en partant de l'impulsion donnée par Proust et de l'importance primordiale que joue la nature et ses spectacles dans son œuvre, de concevoir un système romanesque entièrement neuf, entièrement inversé, c'est-à-dire où la description deviendrait pour tout de bon cet « élément principal » dont parle Tynianov en ce sens que l'action, au lieu d'en être simplement le « prétexte », en serait au contraire le résultat, serait engendrée par elle et, dès lors, nécessaire, incontestable et non plus fortuite ?

Soit, par exemple, ces lignes de Faulkner, dans la dernière partie de *The Sound and the Fury* :

> A man in a dirty apron came to the door and emptied a pan of dishwater with a broad gesture, the sunlight glinting on the metal belly of the pan, then entered the car again.

Il y a deux façons de lire ce petit texte :

Première lecture : la lecture traditionnelle. Dans cette optique, ce qui importe (ce qui a un *sens*), nous savons que c'est l'action : homme apparaissant sur la porte d'un wagon, vidant un chaudron et rentrant à l'intérieur. Mais alors, pourquoi nous ennuyer, « ralentir » l'action, avec ce petit détail visuel insignifiant qu'est l'éclat du soleil sur le flanc du récipient ? Que nous importe ! et, comme le dit André Breton dans le *Premier Manifeste du Surréalisme*, de quel droit l'auteur vient-il ainsi nous ennuyer en « nous refilant ses cartes postales » ? . . .

Mais (deuxième façon de lire ces lignes) imaginons au contraire que ce qui importait à Faulkner c'était, *avant tout*, d'écrire ce bref scintillement de soleil.

Et alors tout change ! Parce que pour que ce scintillement ait lieu (ce scintillement qui, en un éclair, amène à notre conscience l'ensemble de la nature, de l'univers, la conjoncture qui fait que par le biais d'un angle d'incidence un *rapport* s'établit entre l'observateur, l'homme qui vide le chaudron, la rotation de la terre, la position du soleil à cet instant précis) . . . pour que se scintillement ait lieu, donc, il faut l'homme, il faut le chaudron, il faut le geste, il faut cette micro-action qui se trouve du coup indispensable, justifiée, générée par la descrip-

tion, comme le signifie bien la conjonction *then* montrant clairement que « l'événement principal » c'est bien, en fait, cet éclat de soleil en fonction duquel tout ce petit scénario semble avoir été monté, car c'est seulement alors, *après* que ce scintillement a eu lieu, que l'homme a le droit de rentrer dans le wagon, à la façon de ces personnages des horloges astronomiques qui sortent de leurs niches ou les reintègrent à un moment précisément déterminé par la position des astres : maintenant, Faulkner n'a plus besoin de lui . . .

<p style="text-align:center">*</p>

Cet exemple, me semble-t-il, nous éclaire mieux que toute théorie sur la nature de l'écrit littéraire, car si, dans ces lignes, on supprime « dirty apron », « broad gesture », « sunlight glinting » et l'articulation « then », il ne reste plus, alors, qu'une simple information. C'est dans la langue travaillée, dans l'unité phrasique où jouent et s'ordonnent tout ensemble les sens, le rythme et ce que l'on a appelé un « rapport de solidarité réciproque » que Faulkner, comme Proust, lie tout ensemble la nature, l'homme, les choses.

Aussi, je crois que, pour terminer, on ne saurait trop insister, pour la dénoncer, sur l'illusion d'une langue qui ne serait rien d'autre qu'un simple véhicule chargé de communiquer, exprimer des idées, des émotions, représenter des images qui existeraient en dehors d'elle. Certes, il y a ce que l'on appelle la « réalité », mais l'art, la littérature, en font aussi partie et, à un certain égard, la fondent : si effectivement les pommes existent ou préexistent aux tableaux de Cézanne et un poisson au texte de Proust, celles et celui qu'ils nous montrent, l'un dans une nature morte, l'autre dans une description, *n'ont existé qu'à partir du moment où les premières ont été peintes, le second décrit.*

« Le style, écrivait Flaubert, est une manière absolue de voir les choses », et il demandait : « Pourquoi y a-t-il un rapport nécessaire entre le mot juste et le mot musical ? »

Voici en réponse à cette dernière interrogation qui touche peut-être à l'un des problèmes les plus fondamentaux de la littérature, ce qu'écrivait, à la fin du Siècle des Lumières et avant que ne se forge au XIXe le mythe du réalisme, un jeune Allemand alors âgé de vingt-sept ans et qui s'appelait Friedrich, baron von Hadenberg, plus con-

nu sous le nom de Novalis. C'était, comme l'on sait, le contemporain de Schiller et de Fichte :

> L'erreur, risible et toujours étonnante, c'est que les gens s'imaginent et croient parler en fonction des choses. Mais le propre du langage, à savoir qu'il n'est tout uniment occupé que de soi-même, tous l'ignorent. C'est pourquoi le langage est un si merveilleux et si fécond mystère : que quelqu'un parle tout simplement pour parler, c'est justement alors qu'il exprime les plus originales et les plus magnifiques vérités. Mais qu'il veuille parler pour dire quelque chose de précis, voilà alors que le langage et son jeu lui font dire les pires absurdités, et les plus ridicules [...] Si seulement on pouvait faire comprendre aux gens qu'il en va du langage comme des formules mathématiques : elles constituent un monde en soi, pour elles seules ; elles jouent entre elles exclusivement, n'expriment rien si ce n'est leur propre nature merveilleuse, ce qui justement fait qu'elles sont si expressives, que justement en elles se reflète le jeu étrange des rapports entre les choses. *Membres de la nature,* c'est par leur liberté qu'elles sont, et c'est seulement par leurs libres mouvements que s'exprime l'âme du monde en en faisan' tout ensemble une mesure délicate et le *plan architectural* des choses. De même en va-t-il également du langage : seul celui qui a le sentiment profond de la langue, qui la sent dans son application, son délié, son rythme, son esprit *musical* — seul celui qui l'entend dans sa nature intérieure et saisit en soi son mouvement intime et subtil pour, *d'après lui,* commander à sa plume ou à sa langue et les laisser aller : oui, celui-là seul est prophète ...

Nous retrouvons ici le vocabulaire même de Flaubert et de Proust : « musique », « plan », « architecture ».

Et c'est là, me semble-t-il, que cette page de Novalis éclaire les relations entre l'œuvre écrite et la nature. « Celui qui veut parler de quelque chose de précis, nous dit Novalis (et nous retrouvons ici la notion de « sens institué »), voilà alors que le langage et son jeu lui font dire les pires absurdités ». Le langage, en effet, ne redouble pas la nature : il en est *membre,* et l'écouter attentivement, prendre conscience de ses contraintes en même temps que de ses propositions, de sa musique, de ses pouvoirs, c'est la seule façon de, comme le dit Novalis, « déceler le jeu étrange des rapports entre les choses. »

Discussion

G. von Proschwitz : Je tiens à dire que j'ai trouvé prodigieusement intéressant, pour ne pas employer un mot plus prétentieux : fascinant, de vous entendre parler de Proust, parce que c'est toujours très révélateur d'entendre un écrivain décrire l'art romanesque d'un collègue. Je tiens à vous dire tout le plaisir et tout le profit que j'ai eus à vous entendre parler de Proust et de sa conception du roman. Proust, vous l'avez fort clairement montré et avec combien de pertinence, lie tout ensemble la nature, l'homme, les choses. En nous initiant ainsi à l'art romanesque de Proust, vous nous avez fait mieux comprendre Claude Simon. Vous nous avez appris comment aborder la lecture de vos propres romans. Je voudrais, pour finir, vous demander de bien vouloir préciser pour quelles raisons vous préférez aux romans de Balzac ceux de Flaubert.

C. Simon : Vous me demandez de justifier mes préférences. Mais c'est très subjectif. Balzac est aussi un très grand bonhomme. La seule chose qu'oublient les critiques et les censeurs qui continuent à s'en référer à lui et à le proposer comme un modèle figé, c'est qu'il était lui-même un formidable novateur, et s'il y a une leçon à retenir de lui, c'est bien celle-là ... Avant lui, avant Stendhal, personne n'avait conçu le roman de cette façon, et ce qu'ils faisaient était, en littérature, totalement révolutionnaire. Toutefois il faut bien se garder de les confondre avec les théories (notamment celle du soi-disant réalisme) qu'ils ont prétendu mettre en pratique. S'ils n'avaient fait que cela, si leur théories n'avaient pas été dépassées par un certain « emportement de l'écriture », selon l'expression de Barthes, ils ne seraient pas ce qu'ils sont. Par exemple, la description de la bataille de Waterloo, dans *La Chartreuse de Parme*, peut être considérée comme la préfiguration de toute la littérature moderne : au contraire de ce qui se produit trop souvent chez Stendhal, les adjectifs de valeur en sont à peu près absents et, pour la première fois, un événement nous est présenté sous un angle subjectif, sans « explications ». Fabrice, par les yeux duquel nous voyons la bataille se dérouler, n'en a qu'un aperçu extrêmement fragmentaire, il n'y comprend rien : c'est l'opposé de cet « observateur privilégié » omniprésent et omniscient qu'est l'auteur du roman traditionnel ... Pour en revenir à Flaubert, il me semble qu'au delà de ses romans, au delà des fulgurants « scénarios »

préludant à la rédaction de *Madame Bovary* et qui annoncent Joyce, son ⸍importance tient justement au fait qu'il a mis en question le dogme du « réalisme ». Dans une lettre à Louise Colet, je crois, ou à George Sand, il a, pour la première fois, posé les bases d'une littérature où le sens se dégagerait d'un travail de la langue : non plus *l'expression* d'un sens mais la *production* de sens pluriels . . .

R. *Pomeau* : Je me permettrai de revenir sur Balzac et de revenir en particulier sur ses fameuses descriptions, fort différentes de celles dont vous avez parlé, qui relèvent plutôt de l'information, de l'inventaire, de l'état des lieux dressé par un huissier : il y a un buffet ici, une table là, une fenêtre, des rideaux, etc. C'est tout de même quelque chose d'assez étonnant. Evidemment, ce n'est pas là votre manière d'écrire des romans, nous l'avons tous compris. Comment expliquez-vous qu'un romancier comme Balzac ait accumulé ainsi tout ce matériel qui nous paraît, aujourd'hui, tout de même un peu statique ?

C. *Simon* : Je vous renverrai la question. La description apparaît avec la littérature dite réaliste, comme si celle-ci cherchait à s'accréditer par l'accumulation des descriptions. Dans *La Princesse de Clèves*, il n'y a pas de descriptions. Avant l'arrivée du réalisme, avant l'arrivée de Rousseau, la nature n'existe, pour ainsi dire, pas. Il est curieux de voir que la recherche du petit détail « qui fait vrai », apparaît, avec une espèce de frénésie, avec la littérature réaliste, comme si l'écrivain réaliste, conscient du peu de fiabilité de la fable qu'il nous raconte, cherche à lui donner une crédibilité en la « situant » avec précision. Par exemple, combien de romans réalistes commencent par une phrase du genre : « Le dix-huit septembre 1842, un vieillard se promenait dans une allée du Luxembourg », etc. ; c'est dater, c'est placer, c'est situer pour nous faire avaler comme véridique la fiction qui va suivre. Là, je vous renvoie votre question. Et je ne suis pas, comme vous, aussi méprisant pour les descriptions de Balzac, même si ce sont des inventaires. Cela peut être passionnant, un inventaire, même sans commentaires, parce que l'inventaire nous met aussi la chose décrite en rapport avec un tas d'autres concepts. Alors, je vous renvoie la question sur Balzac : que pensez-vous vous-même des descriptions de Balzac ?

R. *Pomeau* : Je vais essayer de vous proposer ma réponse, qui est une réponse d'historien, mais c'est ainsi que j'ai orienté mes recher-

ches. Il me semble que le roman, et notamment le roman français, est resté très longtemps, jusqu'au XIXe siècle, dans la mouvance du théâtre. C'est particulièrement sensible dans un certain nombre de romans du XVIIIe siècle. Quand Balzac veut donner un titre d'ensemble à ses romans, qu'est-ce qu'il choisit ? *La Comédie humaine.* Evidemment, le titre renvoie à Dante, mais tout de même, il y a « comédie ». D'autant plus que dans les subdivisions, il dit « scènes » : « Scènes de la vie privée », « Scènes de la vie provinciale », etc. Cette description, qui est souvent un inventaire, qui ne tend pas tellement à nous montrer les choses, se trouve presque toujours au début des romans. On commence par nous montrer les lieux et les choses. Cela fait l'impression des éléments de décor dans un texte de théâtre, de plus en plus détaillés à partir du XVIIIe siècle, avec l'apparition du drame bourgeois. C'est cette impression que me font ces indications de Balzac, qui ne doivent pas être retranchées, bien entendu. Car tous ces inventaires jouent un rôle éminemment dramatique ; tous ces lieux et objets sont dramatisés d'une façon étonnante. Pensons par exemple à la pension Vauquer, pour prendre un texte très connu de Balzac. Il me semble que dans l'évolution de la littérature, il se produit une séparation du roman avec le théâtre qui se marque certainement avec Flaubert et Proust. Il est curieux de voir comment, au XIXe siècle, beaucoup de romanciers ont essayé de faire du théâtre : Balzac et Zola, par exemple. Zola a transposé un certain nombre de ses romans au théâtre. Proust, non. Proust ne fait pas de théâtre, absolument pas. La rupture est consommée. Je sais bien que Claude Simon a fait du théâtre. C'est l'exception qui confirme la règle.

C. Simon : Je vous remercie beaucoup de cette remarque extrêmement pertinente.

R. Pomeau : Vous me permettrez de revenir sur le texte de Proust que vous avez cité. Parmi ces mots que vous avez très justement relevés, il y en a un qui m'arrête. Ce sont ces fameux Cimmériens. Que viennent faire les Cimmériens à propos d'un poisson ? Tout le reste va de soi : le monstre marin, même les époques primitives qui viennent derrière le monstre, les vertèbres, le bleu, le rouge . . ., mais les Cimmériens ? Il ne faut pas s'imaginer que les Français savent ce qu'est un Cimmérien, comme ils ont de vagues notions des Germains, des Gaulois, des Vikings. Je crois qu'il faut chercher dans la

littérature. Et dans la littérature que connaissait Proust. Car si personne, en France, aujourd'hui, ne sait ce que sont les Cimmériens, il y a quelqu'un qui le savait. C'est Renan. Vous vous rappelez la fameuse *Prière sur l'Acropole* qui était au moment où Proust écrivait, vers 1915 ou 1920, dans toute sa gloire. Toute le monde connaissait plus ou moins par cœur ces phrases remarquables du début : « Je suis né, déesse aux yeux bleus, de parents barbares, chez les Cimmériens bons et vertueux ». Il y a, par la suite, toutes sortes d'images marines : les fonds de la mer, les rochers coloriés, etc. Je ne dis pas que Proust ait pensé délibérément à Renan : l'association s'est faite sans doute par réminiscence, car les Cimmériens de Renan sont dans un environnement marin très marqué. Pour compléter ce que vous nous avez dit sur le mot qui met en rapport avec d'autres objets, je dirais que les mots appellent aussi des éléments littéraires qui flottent dans l'esprit de l'écrivain, même s'il ne s'en rend pas compte.

C. Simon : Je ne connaissais pas ce texte de Renan. Je pensais que Proust avait pris cela comme un mot forgé évoquant le monde antique ou plutôt même la préhistoire.

R. Pomeau : Le mot se trouve dans les *Souvenirs d'enfance et de jeunesse* qui ont paru en 1883. Outre la notoriété de l'auteur, Proust avait des raisons de s'intéresser à cette « recherche du temps perdu » de Renan.

ЦИВИЛИЗАЦИЯ И ПЕЙЗАЖ

Владимир Солоухин

Прежде всего необходимо оговориться, что хотя мое выступление называется докладом, все же я не ученый, не исследователь, поэтому то, что я скажу, вряд ли будет иметь научную ценность. В лучшем случае я – поэт, способный своеобразно воспринимать красоту окружающего меня мира, а в крайнем случае – публицист, стремящийся, иногда, поднять в журнальной статье какую-нибудь проблему.

При научности доклада надо было бы договориться о терминологии: что такое цивилизация и что такое пейзаж. И то и другое имеет множество разных определений. Берем самые простейшие источники - энциклопедические словари. В русской старинной энциклопедии под названием «Брокгауз и Эфрон» цивилизации посвящена огромная и обстоятельная статья. Цивилизация определяется в ней как «состояние народа, которого он достиг, благодаря развитию общественности, жизни обществом и которое характеризуется удалением от первоначальной красоты и дикости, улучшением материальной обстановки и общественных отношений и высоким развитием духовной стороны».

Самым близким по значению к цивилизации является слово культура. Однако Вильгельм Гумбольт различает цивилизацию и культуру, а Бокль под цивилизацией понимает преимущественно духовную сторону. «Двойное движение, нравственное и умственное составляет саму идею цивилизации и заключает в себе всю теорию духовного прогресса».

Дальше следуют определния цивилизации Гизо и Клеммом, Фурье и Морганом, Тейлором и Липпертом, Гегелем и Кантом, Толстым и Готтенротом.

Большая Советская Энциклопедия молчит о духовной стороне цивилизации и удовлетворяется всего лишь несколькими строками, если не считать пространной цитаты из

Энгельса. Из нескольких строк явствует, что цивилизация это «уровень общественного развития и *материальной* культуры (подчеркнуто миой - В.С.), достигнутый той или иной общественной экономической формацией».

А Освальд Шпенглер, например, считает цивилизацией заключительную стадию в развитии той или иной культуры, ее старость, ее конец.

Что касается пейзажа, то энциклопедические словари обходят стороной это понятие и говорят о пейзаже лишь как о жанре в искусстве живописи. Зато Жан Зейтун в одной своей статье дает несколько опеделений пейзажа, причем, пейзаж, оказывается, может иметь значение натуралистическое, географическое, биологическое, экологическое, психологическое, социальное, экономическое, философское, эстетическое . . . Жан Зейтун, в частности, говорит[1], что «по мере того как мы рассматриваем многообразие значений, содержащихся в слове пейзаж и многообразие применения этого слова в различных областях, мы приходим к выводу, что понятие «пейзаж» обладает довольно неопреденным смысловым значением . . .».

Правда, в конце концов, автор статьи приходит к формуле, гласящей, что пейзаж нужно рассматривать как продукт взаимодействия человека и окружающей среды в соответствии с определенным пониманием этой среды.

Но это только одна из формул и все это мне напоминает известный момент в человеческой истории.

Когда в 19 веке философы Франции или Германии, вообще философы изощрялись в определении понятия свободы (как философской, нравственной, социальной, психологической категории) болгарам, например, нужна была просто свобода, свобода как хлеб, свобода как воздух, как жизненная необходимость. И оказалось, что важнее для болгар в то время было не то, чтобы философы определили и сформулировали понятие свободы, а чтобы Александр II двинул русские войска и принес болгарам свободу на штыках, этих проверенных орудиях принуждения и насилия.

Таким образом то, что я тут скажу, носит больше эмоцио-

[1] Цитируется по французскому журналу «L'Architecture d'aujourd'hui» 1969, № 145.

нальный, нежели глубокий научный характер.

Условимся на эти полчаса считать цивилизацией современный (двадцатого века) уровень развития человечства, а пейзажем то, что человек, живя на земле и обернувшись во все стороны, видит вокруг себя.

Земля – космическое тело и все мы не кто иные, как космонавты, совершающие очень длительный полет вокруг солнца, вместе с солнцем по бесконечной вселенной. Система жизнеобеспечения на нашем прекрасном корабле устроена столь остроумно, что она постоянно самообновляется и таким образом обеспечивает возможность путешествовать миллиардам пассажиров в течение миллионов лет.

Трудно представить себе космонавтов, летящих на корабле через космическое пространство и сознательно разрушающих сложную и тонкую систему жизнеобеспечения, рассчитанную на длительный полет.

Но вот постепенно, но последовательно, с безответственностью поистине изумляющей, мы эту систему жизнеобеспечения выводим из строя, отравляя реки, сводя леса, портя мировой океан.

Если на маленьком космическом корабле космонавты начнут перерезать проводочки, развинчивать винтики, просверливать дырочки в обшивке, то это надо квалифицировать как самоубийство. Но принципиальной разницы у маленького корабля с большим – нет. Вопрос только размеров и времени.

Человечество, при определенной доле пессимизма, можно рассматривать как своеобразную болезнь планеты. Завелись, размножаются, кишат микроскопические, в планетарном, а тем более, во вселенском масштабе, существа. Скапливаются в одном месте и вот уж появляются на теле земли глубокие язвы и разные наросты.

Стоит только привнести капельку зловредной (с точки зрения земли и природы) культуры в зеленую шубу леса (бригада лесорубов, один барак, два трактора) и вот уж распространяется от этого места характерное, симптоматическое, болезненное пятно.

Снуют, размножаются, делают свое дело, выедая недра, истощая плодородие почвы, отравляя ядовитыми отправле-

ниями своими реки и океаны, саму атмосферу земли.

Неизвестно чем кончится для планеты эта оригинальная болезнь, называемая человечеством. Успеет ли Земля выработать какое-нибудь противоядие?

О нарушении экологического, химического равновесия на нашей планете написаны десятки и сотни книг с цифрами, с выкладками, с прогнозами, с рекомендациями. Но у нас в предмете теперь не это.

К сожалению, столь же ранимыми как и биосфера, столь же беззащитными перед напором так называемого технического прогресса, оказываются такие понятия, как тишина, возможность уединения и значит личного, один на один, интимного, я бы сказал, общения человека с природой, с красотой нашей земли.

С одной стороны, человек, задерганный бесчеловечным ритмом современной жизни, скученностью, огромным потоком искусственной информации, отучается от духовного общения с внешним миром, с другой стороны, сам этот внешний мир приведен в такое состояние, что уже, подчас, и не приглашает человека к духовному с ним общению.

В замечательной статье «Урбанизм и природа» Ив Бетоло (Франция) справедливо пишет: «Постепенная деградация окружающей среды вызывает психические и физические расстройства... в бесчеловечности городов люди превращаются в задерганных паяцев, которых таскают и перегоняют как стадо по коридорам метро... Приходится констатировать, что с начала этого века красота в нашем градостроительстве отсутствует, происходит деградация того, что окружает нашу жизнь, городские зоны больше не отвечают запросам человека, а в сельской местности взору предстают приведенные в полный беспорядок пейзажи...»[2]

Так что проблеме «цивилизация и пейзаж» можно отчетливо различать два аспекта: объективную деградацию пейзажа, во-первых, и изменения в воспринимающем аппарате человека, во-вторых.

Человечество охвачено сейчас, как я бы назвал «вакханалией

[2] L'Architecture d'aujourd'hui 1969, № 145.

доступности». Смею утверждать, уто белоснежная гора на Кавказе, сверкающая в недосягаемых высотах и казавшаяся Лермонтову подножием божьего престола, не покажется таковой, если до нее можно доехать по канатной дороге за 10 минут. Коралловый атолл, до которого надо было на паруснике плыть несколько месяцев, выглядит для нас иначе, если мы подлетаем к нему на вертолете, затратив на перелет время от завтрака до обеда. Эта вакханалия доступности пронизывает весь регистр нашего общения с внешним миром, от тайны цветка до тайны Луны, от женской любви до молнии с громом. Но боюсь только, что со всеобщей доступностью сделается постепенно недоступным для нас такое понятие как красота.

Так же как птицы созданы летать, а рыбы жить в воде, так человек создан жить среди природы и постоянно общаться с ней. Древняя индийская мудрость гласит, что человек для духовного и физического здоровья должен как можно больше смотреть на зеленое убранство земли и на текучую воду.

Человек и жил среди природы и постоянно общался с ней с самого начала, причем, именно с начала существовало два аспекта в отношениях человека к окружающей природе: *польза* и *красота*. Природа кормила, поила, одевала человека, но она же, с ее волнующей, божественной красотой всегда влияла и на его душу, порождая в душе удивление, преклонение и восторг.

Прочитаем полстранички толстовской прозы. Повесть «Казаки». Оленин едет на перекладных из Москвы на Кавказ.

«... Как он ни старался, он не мог найти ничего хорошего в виде гор, про которые он столько читал и слышал. Он подумал, что ... особенная красота снеговых гор ...есть такая же выдумка, как музыка Баха и любовь к женщине, в которые он не верил. И он перестал дожидаться гор. Но на другой день рано утром он проснулся от свежести в своей перекладной и равнодушно взглянул направо. Утро было совершенно ясное. Вдруг он увидел, шагах в двадцати от себя, как ему показалось в первую минуту, чисто белые громады с их нежными очертаниями и причудливую, отчетливую воздушную линию их вершин и далекого неба. И когда он понял всю громадность гор, и когда почувствовалась ему вся бесконечность этой красоты, он испугался, что это призрак, сон. Он встряхнулся, чтобы прос-

нуться. Горы были все те же ... С этой минуты все, что он чувствовал, получало для него новый строго величавый характер гор. Все московские воспоминания, стыд и раскаяние, все пошлые мечты, все исчезло и не возвращалось более»[3].

Итак, красота гор развеяла все мелочное в думе, вызвав к жизни новые, светлые силы, облагородила человека. При виде величавых белоснежных гор, глубокой небесной синевы, морского простора, тихой березовой рощи, колосящейся нивы вдруг тает в думе задерганного жизнью человека вся накипь, все мелкое, суетное, временное. Душа прикасается к возвышенному и вечному. «И в небесах я вижу бога», – сказал про такую минуту наш поэт Лермонтов.

«Старый корявый дуб, вновь зазеленевший и обросший густой сочной листвой, раскрыл Андрею Болконскому тайны неумирающей жажды жизни и вечного возрождения, с той особенной простотой и бесспорностью, которые недоступны философскому трактату. Звездная синева ночного неба вернула Алеше Карамазову пошатнувшуюся было в его душе надежду, а величественные картины степных просторов глубоко залегли в душе маленького героя чеховской степи, потрясли ее»[4].

Это, конечно, уровень восприятия красоты мира высокоразвитым, культурным, именно цивилизованным человеком: Толстым, Достоевским, Чеховым. Но, несомненно, что всегда красота природы воздействовала на человека и организовывала его сознание, воспитывала его, делала добрее, лучше, богаче.

Пейзаж – это красота, а красота категория духовная. Недаром пейзаж издревле сделался объектом искусства, объектом живописи, литературы и даже музыки. Но живописи - в первую очередь. Если в литературе пейзаж всегда играл вспомогательную роль, то в живописи он сформировался как жанр и приобрел самостоятельное значение.

Еще на уровне краснофигурной вазописи древней Греции мы находим образцы тонкого проникновения в природу. Затем, через средние века, через эпоху Возрождения, через Джорджони и Джотто, через Эль-Греко и Дюрера, через Брейгеля и Пуссена,

[3] Л.Н.Толстой. Собрание соч. том III. Москва, 1951 г., стр. 157-158.

[4] А.Т. Ягодовская. «О пейзаже». «Сов. художник», Москва, 1963, стр.4.

Рейсдаля и Дюге, через великих голландцев, через живопись Франции, Германии, Испании, Англии, через живопись десятков и десятков художников, человечество шло к проникновенному и одухотворенному пониманию окружающей его природы, ибо пейзажная живопись всегда имела своим высшим назначением передавать не просто картины природы как таковы, но те ощущения, те чувства, те движения души, которые возникают в человеке при созерцании окружающей природы.

Надо отдать природе справедливость, что при созерцании ее возникают в душе человека самые возвышенные, чистые, светлые чувства, высокие помыслы и в этом драгоценное, неоценимое свойство природы.

Чувство родной природы всегда входило и входит в такое важное понятие, как чувство родины, наряду с чувством родной истории и народа. Каждому народу дорога и близка его природа, но если вдуматься, то это чувство родной природы в нас не стихийно. Воспринимая природу, мы невольно приводим в движение эмоциональные резервы, накопленные нами при чтении наших поэтов и писателей, при созерцании живописи, при слушании музыки. Я хочу сказать, что само чувство природы в нас организовано, воспитано, традиционно, короче говоря – культурно.

У каждого народа были и есть свои певцы природы, которые возможно, иногда мало известны другим народам. Но, если Земля есть наша общая родина, и если в нас воспитывается мало-помалу чувство этой общей родины – перед грозным ликом вселенной – если мы сознаем, что красивее нашей планеты, может быть, и нет ничего в мироздании (а Земля наша, действительно, прекрасна!), то этим мы тоже обязаны нашим воспитателям: художникам, поэтам общечеловеческого значения, которые помогали нам понять красоту, воспитывали в нас любовь к ней.

Не трудно заметить, что художники всех времен и народов, создавая свои пейзажные картины, почти никогда не изображали на холстах природу, лишенную признаков человеческой деятельности. Там мостик, там часовенка, церковь, прясло, замок, деревенька, лодка, всадник, тропинка, дорога, маяк,

парусное судно, пасущиеся коровы, вспаханное поле, колосящееся поле, сад, ветряная мельница, водяная мельница, дымки над крышами . . . Какие бы то ни было признаки человеческой деятельности.

Отчасти это объясняется тем, что землю и правда чаще всего мы видим затронутой человеком. Главное же в том, что человеческая деятельность до определенного рубежа оживляла и облагораживала красоту земли, привносила такие штрихи и детали, которые делали красоту земли одухотвореннее, ближе нашему сердцу и, - если не бояться такого вовсе уж не научного слова - милее.

Признаки человеческой деятельности сначала не портили природы, потому что не могли ее испортить по своим масштабам, а впоследствии – до определенного рубежа – потому что люди думали и заботились о красоте того места, где жили, о красоте своего окружения. До определенного рубежа все те изменения, которые человек производил на земле, вписывались в земные пейзажи. Колосящееся поле, мостик через ручей, пасущееся стадо, одноэтажные домики в окружении деревьев и объективно не могли разрушить земного очарования, не говоря уж о сознательном стремлении людей к красоте.

Но где-то этот рубеж был перейден и перейден в двух значениях.

Во-первых, изменились масштабы человеческой деятельности. Это объективная причина.

Человек не мог еще, не умел ни нагромождать циклопических терриконов, ни строить чудовищных плотин, ни поднимать в небо бесчисленные заводские трубы, ни разрабатывать глубокие карьеры, ни покрывать землю на больших площадях бетонными наростами городов, ни опутывать землю современными автострадами, ни создавать искусственных водохранилищ, затопляющих тонким и серым слоем воды обширные земные просторы, как затоплена, например, вся плодородная луговая, молокообильная и медоносная пойма Волги, как затоплены уникальные цимлянские виноградники. А, если осуществится поворот сибирских рек в Среднюю Азию, в низовьях этих рек придется затопить пространства равные по площади среднему Европейскому государству.

Естественно, что человеческая деятельность такого масштаба не может не менять коренным образом внешний вид земли. Известна трагедия озера Севан, этой высокогорной жемчужины в Армении, этого драгоценного голубого камня в убранстве нашей планеты. Просверлили в горе отверстие и вода из озера стала вытекать. Правда, она при этом вращает турбины и вырабатывает электроэнергию (которую можно было бы вырабатывать другим способом), но озеро мелеет, уровень воды в нем резко понизился, берега обсыхают или заболачиваются, остров превретился в полуостров, в окрестностях пересыхают родники с чистой водой. Величественное превращается в жалкое.

Но нельзя валить все только на масштаб и размах человеческой деятельности. В конце концов, египетские пирамиды по своим размерам превышают многие и многие современные постройки, но можем ли утверждать, что они изуродовали земной пейзаж, что глядя на них, ощущаешь в себе чувства неприятные, угнетающие, то что мы называем отрицательными эмоциями. Напротив, не являются ли они одним из редчайших и удивительнейших украшений нашей планеты.

Можно возразить, что восприятие пейзажа - дело вкуса. Одному нравится Тадж-Махал или Кельнский Собор, а другому Ньюйоркские небоскребы. Но есть же все-таки и объективное разделение вещей на красивые и некрасивые, на вызывающие восторг и вызывающие отвращение.

Смотреть на звезду или на раздавленную лягушку, на цветущую поляну или на мусорную свалку, на чистый ручей, текущий по камешкам, или на сточную канаву, на решетку Летнего сада или на забор автобазы . . .

Конечно, вид кладбища печален сам по себе, но если это кладбище запущено, замусорено или сознательно обезображено, то вид его не просто печален, но невыносим.

Красота живет в душе человека, отсюда и естественная, как есть и как пить потребность человека в красоте.

Забор автобазы нельзя сделать столь же прекрасным как решетка Летнего сада, у него другая функция, а закон функции должен существовать. Но согласимся, что и этот пресловутый забор может быть по-своему красив или по-своему безобразен,

все зависит от того думали ли люди об этом, когда его воздвигали, то есть жила ли в их душе красота, были ли они наделены потребностью красоты и претворили ли эту потребность в жизнь.

Я ездил по свету не так уж много, но все же я был во Франции, Англии, Германии, Дании, Чехословакии, Польше, Болгарии, Венгрии, Китае, Вьетнаме, Албании . . . Кроме того, объездил многие края Советского Союза. Наблюдая, сопоставляя и сравнивая, я могу сказать, что часто самые современные, самые индустриальные и грандиозные сооружения все же по-своему красивы и даже изящны. Нельзя сказать про них, что они вписываются в ландшафт, ибо они сами определяют его, сами и есть ландшафт но все же нельзя сказать и то, что они безобразны, уродливы.

Величавому не обязательно быть огромным. Лебедю, чтобы казаться величавым, не обязательно быть величиной со слона. Двухэтажное здание, вроде Михайловского дворца в Ленинграде, может выглядеть величавее стоэтажной коробки. Но существует и обратная закономерность: не все грандиозное и огромное обязательно уродливо. Земля наша достаточно велика, чтобы «освоить» и адаптировать достаточно большие сооружения. Ведь Эверест, Фудзияма, Эльбрус, Монблан, Килиманджаро не портят внешего вида нашей планеты.

Однако, у людей, увлекшихся только экономическими или только политическими соображениями, может отсутствовать один простейший критерий: «А как это будет выглядеть?» Как это будет выглядеть сегодня и, тем более, как это будет выглядеть завтра?

Советский архитектор Андрей Константинович Буров в своей книге «Об архитектуре» (Москва, 1960 год, Госстройиздат) обронил значимую фразу: «Нужно построить прежде всего и в короткий срок хорошие жилища, не испортив при этом на столетия лицо страны».

Прекрасная и зловещая фраза. Прекрасна она озабоченностью о лице страны, а зловеща тем, что, оказывается, лицо страны *можно* испортить, причем не на год, не на два, а на целые столетия. Самое же главное, что явствует из этой фразы, это то, что существует, существует такое понятие, как лицо страны, и

определяется оно не только географическим ландшафтом (горная страна, равнинная, лесная и пр.), а в не меньшей степени человеческой деятельностью.

Как художник создает пейзажную картину, так и целый народ постепенно, невольно даже, быть может, штрих за штрихом на протяжении столетий создает ландшафт и пейзаж своей страны.

Холмы и реки, деревья и цветы могут быть похожими в двух странах, но штрихи, привносимые человеком (народом) создают в конце концов ту или иную характерную картину и вот лицо Германии отличается от лица соседней Франции или соседней Польши, от лица средней России, Украины, а лицо Японии от лица похожего на нее географически острова Сахалина.

Лицо старой, дореволюционной России определялось, например, в большой степени теми сотнями тысяч церквей и колоколен, которые были расставлены по всем ее просторам на возвышенных преимущественно местах, и которые определяли силуэт каждого города от самого большого до самого маленького, а так же сотнями монастырей, бесчисленным количеством ветряных и водяных мельниц. Не малую долю в ландшафт и пейзаж страны превносили и десятки тысяч помещичьих усадеб с их домами, парками, системами прудов. Но, конечно, в первую очередь и небольшие деревеньки и села с их ветлами, колодцами, сараями, баньками, тропинками, садами, огородами, залогами, пряслами, резными наличниками, коньками, крылечками, ярмарками, сарафанами, хороводами, покосами, пастушьими рожками, серпами, оденьями, соломенными крышами, маленькими единоличными полями, лошадками на пахоте . . . Можно представить как радикально изменилось лицо страны, когда все эти факторы, определяющие пейзаж исчезли с лица земли или изменили свой вид.

Точно так же, как художник-пейзажист вкладывает в свое творение частицу души и творит пейзаж, в сущности говоря, по своему образу и подобию, так и в ландшафт любой страны оказывается вложенной душа народа и то представление о красоте, которое в душе того или иного народа живет.

Но, конечно, плохо дело, если душа спит, если она отвлечена, заглушена побочными обстоятельствами, интересами, шумами,

корыстью или иными соображениями, а хуже того, если она мертва или, скажем точнее и мягче, находится в летаргии. Тогда одухотворенность уходит и из пейзажа. Ландшафт остается ландшафтом, но он как бы пустеет, остается форма при отсутствии содержания, веет холодом, отчужденностью, равнодушием и, вот именно, пустотой. Становится безразличным для отдельного человека и целого народа: а как это будет выглядеть? Как будет выглядеть дом, деревня, река, долина, холмы, страна в целом? Каково будет лицо страны?

Есть ведомства по разработке и добыче полезных ископаемых, по строительству дорог, по земледелию, по электрификации, по легкой, тяжелой и автомобильной промышленности, но нет ведомства по внешнему виду страны (земли), по ее опрятности, прибранности, одухотворенности... Думаем о прочности сооружений, о характере и объеме земляных работ, о количестве древесины, о центнерах и тоннах, о кубометрах и квадратных метрах, но не думаем о том, а как это будет выглядеть? Как это будет выглядеть не только само по себе, но в сочетании с окружающим, с местностью, в согласовании с традициями и с проекцией в будущее.

Ландшафт во всей его сложности и совокупности это не просто лицо земли, лицо страны, но и лицо данного общества. Замусоренный лес, разъезженные дороги, с увязнувшими машинами, обмелевшие реки, исполосованные гусеницами тракторов зеленые луговины, полузаброшенные деревни, сельскохозяйственные машины, ржавеющие под открытым небом, однообразные, стандартные дома, поля, зараженные сорняками, говорят о жителях той или иной деревни, того или иного района ничуть не меньше, чем неприглядная и запущенная квартира о ее жильцах.

Людеи на земле становится все больше, техники все больше. Казалось бы эти факторы должны были обострять потребность людей в красоте и само чувство прекрасного. Возьмите Японию, эту удивительнейшую страну, этот ярчайший цветок планеты. Многочисленный народ, живущий в неимоверной тесноте на нескольких камешках среди великого океана и неуверенный в геологическом будущем этих камешков, не только не растерял чувства прекрасного, не только не отупел, не омерт-

вел душой, но, напротив, может служить образцом подлинной, глубокой, человеческой цивилизованности. Его и надо взять за образец, потому что, может быть, это будущее всех остальных народов, поскольку когда-нибудь на всей нашей планете будет так же тесно, как сегодня на островах Японии. Но сохранят ли остальные народы при этом ту же высоту духа? Смогут ли они так же ритуально преклоняться перед веткой цветущей вишни, так же ритуально любоваться белоснежным шатром горы, так же возвести в ранг искусства составление букета цветов, так же терпеливо выращивать игрушечные, но живые сады, миниатюрные, но подлинные пейзажи? Чувство прекрасного, живущее сегодня в душе японского народа, это не просто эстетическая категория, это мужество и героизм. Глядя на них, понятнее становятся слова Достоевского о том, что красота спасет мир.

У известного советского поэта Василия Федорова есть поэма «Проданная Венера», в основу которой положен исторический факт продажи некоторых великих полотен на нужды строительства и промышленности. В поэме есть такие слова. ·

За красоту веков грядущих
Мы заплатили красотой.

Мне понятны и горечь и исторический оптимизм поэта, но все же возникает вопрос: откуда взяться красоте в грядущих веках, если мы, наши поколения, не сохраним ее в себе и не передадим в умноженном и облагороженном виде нашим потомкам?

От нас, живущих на земле сегодня, зависит не только нынешний, но и будущий вид земли, будем же делать все, чтобы она была прекрасна во веки веков.

CIVILIZATION AND LANDSCAPE

By Vladimir Soloukhin

Let me begin by making one reservation. In spite of the fact that my appearance here has been given the title "lecture", I am neither a scientist nor a researcher. Therefore what I have to say can hardly have any scientific value. At best, I am a poet with a personal way of experiencing beauty in the reality which surrounds me; at worst, I am a journalist who, from time to time, tries to take up a burning issue in a newspaper article.

If my talk were scientific in nature, we would be faced with the necessity of trying to agree on terminology: on what is meant by civilization and what is meant by landscape. Both these terms have been given many different definitions. Let us turn to the most obvious source — encyclopedias. In the old Russian encyclopedia *Brockhaus and Efron* a long and detailed article is devoted to the term civilization. Here civilization is defined as "the state of a people arrived at through the development of social functions, through people living together; a state distinguished by mankind becoming more and more removed from the original state of beauty and wildness; distinguished by a betterment in material conditions and social relations as well as advanced development in spiritual matters".

Closest to civilization in terms of meaning is the word culture. Wilhelm Humboldt, however, holds civilization and culture apart. Buckle gives preference to the spiritual aspect of civilization. "A twofold development, one moral and one intellectual, makes up the very idea of civilization and encapsulates the entire theory of spiritual development."

After this come definitions of civilization by Guizot and Klemm, Fourier and Morgan, Taylor and Lippert, Hegel and Kant, Tolstoy and Gottenroth.

The great Soviet Encyclopedia says nothing about the spiritual aspect of civilization and contents itself with but a few lines, if one discounts a long quotation by Engels. From these lines it appears that civilization is the same as "the level of social development and

material culture [my italics] which a given economic social formation has reached".

Oswald Spengler, for instance, believes that civilization is equal to the last stage in the development of a given culture — its old age and death.

Concerning the term landscape, the encyclopedias are silent, and it is mentioned only in the sense of a genre in painting. Jean Zeitoun gives a number of definitions, however, in an article where we may ascertain that the meaning can be naturalistic, geographical, biological, ecological, physiological, social, economic, philosophical or esthetic. Jean Zeitoun says amongst other things that "upon examining the multitude of meanings found for the word landscape and the shifting usage of the term in different areas, we must conclude that the content of the term is rather undetermined".[1]

The author of the article arrives at a formula towards the end which states that landscape must be viewed as the product of an interplay between man and environment, an interplay which is determined by a certain conception of the environment.

However, this is but one of many formulas, and it reminds me of another historical situation.

At the same time as the 19th-century French and German philosophers — philosophers in general, for that matter — were eagerly occupied with working out more and more exact definitions of the term freedom (as a philosophical, moral, social and psychological category), the Bulgarians for example were experiencing a true need of this freedom. They needed their freedom as much as they needed bread and air to breathe. Freedom was a vital necessity. Obviously the Bulgarians of the time did not consider of prime importance the success of the philosophers in their efforts at defining and formulating the notion of freedom. What rather occupied them was whether or not Alexander II would set this troops in motion to bring them freedom at the point of a bayonet, the faithful instrument of force and violence.

What I am going to say is more of an emotional than of a deep scientific character.

Let us during the next half hour agree that civilization is considered as the modern level of development that man has attained today (in

108

the 20th century) and that landscape is that which a person living on the earth today sees surrounding him.

The earth is a heavenly body, and we men are none other than cosmonauts out on a very long journey around the sun and, together with the sun, through the endless universe. The life systems on board our fantastic space ship are so ingeniously constructed that they recreate themselves, thus giving the billions of passengers the possibility of continuing the journey through space for millions of years.

It is with difficulty that one can imagine a cosmonaut travelling through space in his ship who is zealously occupied with destroying the complicated and finely balanced life-maintaining system which had been constructed to last the entire long journey.

But the fact is that this is just what we are in the process of doing: slowly but surely, with great consistency, and with, in truth, a shocking lack of responsibility we are putting our life-preserving system out of order by poisoning our rivers, chopping down our forests and destroying our great seas.

If the cosmonauts aboard a little space ship were to begin cutting wires, loosening screws or drilling holes in the ship's sides, their actions would be qualified as suicidal. But there is no difference in principle between a big space ship and a little one. It is only a question of dimensions and of time.

A person endowed with any measure of pessimism could describe mankind as a singular illness that has struck our planet. Microscopically small organisms (microscopic as measured by planetary or, greater still, by universal standards) populate the world, they begin quickly to multiply, and soon they swarm over the entire surface. Wherever they collect in one place, deep wounds and various outgrowths soon appear.

The forests' thick green mantle needs only a drop of this dangerous (from the standpoint of the earth and and of nature) culture (a team of lumberjacks, a barrack and two tractors), and almost immediately the typical, symptomatic, sickly blotch begins spreading.

The small creatures rush here and there, multiplying unceasingly, constantly occupied with the job of gnawing away at the earth's riches, stealing the fertility out of the soil, and poisoning the rivers, the seas and the earth's atmosphere with their deadly secretions.

It is impossible to guess how this original illness of the earth which is called mankind is going to end. Will the earth manage to produce an antidote?

Hundreds of books have been written about the disturbances in the ecological and chemical balance of our planet. Books containing figures and calculations, forecasts and proposals. But this is not our subject today.

As vulnerable as the biosphere, as defenseless in the face of so-called technological advancement are, sad to say, also such notions as silence and the possibility of being alone in personal, intimate contact with nature and with things of beauty on earth.

On the one hand, we have man caught in the stress of the inhuman tempo of modern life, overpopulation and the stream of artificial information, who has got out of the habit of spiritual communion with surrounding reality. On the other hand, we have a surrounding reality which has been forced into such a state that it has not always the capacity of drawing man into spiritual communion.

In an excellent article entitled "Urbanism and Nature", Yves Bétolaud correctly writes as follows:

> The continuing degradation of the environment brings about psychic and physical disturbances ... exposed to the inhumanity of our cities, people are turned into overexcited buffoons dragged and pushed here and there in underground corridors like cattle. We are forced to note that, from the turn of the century onwards, beauty has been lost in the construction of our cities, and that all that surrounds our lives has fallen into degradation. The buildings of our cities are no longer able to fulfil man's needs, and in the countryside we are faced with a landscape that has been thrown into complete chaos . . .[2]

Thus, we can distinguish two aspects of the problem of "civilization and landscape": on one hand the actual degradation of the landscape, and on the other hand changes in man's perception apparatus.

Mankind is caught up in what I would like to call "a bacchanal of availability". I would dare to state that snow-clad Caucasian mountain tops shining from indescribable heights, which the poet Lermontov perceived as the base of God's throne, do not give the same impression if they can be reached in ten minutes by ski-lift. A

coral reef that takes months to reach by sail boat appears differently if we arrive in a helicopter after a 'plane trip that started after breakfast and ended before lunch. This bacchanal of availability permeates the entire range of our experiences of the reality around us, from the mystery of a flower to the secrets of the moon, from the love of a woman to thunder and lightning. I am afraid, however, that this general availability is going to cause the idea of beauty to become unattainable for us.

In the same way that birds were created to fly and fish to swim, man was created to live in constant communion with nature. There is an old Indian saying that man, in order to maintain his spiritual and physical health, should as often as possible admire the earth's green garb and the murmuring water.

In the beginning, man also lived in the bosom of nature and was in constant communion. At that time there were two aspects of man's relationship with the surrounding environment: usefulness and beauty. Nature provided man's food and drink, and she clothed him. At the same time, however, with her gripping divine beauty nature constantly exerted her influence over the soul of man and awakened to life such feelings as wonder, veneration and rapture.

Allow me to read a few lines by Tolstoy. They are taken from *The Cossacks*. Olenin is travelling by post carriage from Moscow to the Caucasus.

> ... Try as he might, he could find no beauty in the sight of those mountains he had heard and read so much about. The thought came to him that ... the special beauty which was said to be found in those snow-capped mountains ... was the same kind of contrivance as Bach's music or love for a woman, things he didn't believe in. And he stopped waiting for them to arrive at the mountains. But the next day he was awakened early by the air in the wagon which felt unusually crisp, and he glanced indifferently to the right. The morning was completely clear. At first he had the impression that he could see the pure white massif at twenty paces distance, with its fine contours and amazingly clear line in the air separating the peaks from the distant sky. And when, all at once, he understood the immensity of the mountains, when he suddenly felt their endless beauty, he began to fear that it might be an optical illusion or a dream. He shook himself in order to wake up. The mountains were still there, the same ... From that moment forth, all his

feelings took on the same new and strictly majestic vision as the mountains. All his memories from Moscow, his shame and regret, his banal dreams, everything vanished never more to return.[3]

The beauty of the mountains was able to disperse all pettiness in the main character's soul and to animate new, bright forces, to ennoble him. The sight of a majestic, snow-clad range of mountains, the deep blue vault of the sky or the vastness of the ocean, a quiet birch grove or a field of grain dissolves at once the old deposits, everything petty, vain or passing that has piled up in the soul of a man stressed by existence. At once the soul touches something high and eternal. "And in the sky God I see", says our poet Lermontov at a similar instant.

> An old gnarled oak which once again has burst into greenery and covered itself with a dense, succulent foliage made Andrey Bolkonsky understand the mystery of a never-extinguishing zest for life and of eternal rebirth, and it did so with a simplicity and an uncontestability which is unattainable through philosophical analysis. The blue, star-bestrewn cover of the night sky gave new birth to the hope which had begun to waiver in the soul of Alyosha Karamazov, the majestic sight of the expanse of the steppes struck deep into the soul of the little hero in Chekhov's *The Steppes*.[4]

These are, of course, examples of a level of perception in the presence of the beauty of the surrounding reality which one can find only in highly developed, cultivated, yes, civilized persons: Tolstoy, Dostoevsky, Chekhov. But the fact remains beyond all doubt that the beauty of nature has always exerted an influence on man, organized his awareness, guided him, made him kinder, better and richer.

The landscape is the same as beauty, and beauty is a spiritual category. It is no chance happening that the landscape since the beginning of time has been the subject of art, painting, literature and even music. But it belongs primarily in painting. If landscape has always played a secondary role in literature, it has in painting been developed into a genre by itself, having its own independent meaning.

Even in Ancient Greek red-figured vase painting, we find an example of a finely tuned experience of nature. Across the Middle Ages and the Renaissance, through Giorgione and Giotto, El Greco

and Dürer, through Brueghel and Poussin, Ruisdael and Dughet, through the art of the Dutch masters, the French, the Germans, the Spanish and the English, through the works of hundreds of painters mankind has been developing towards an insight-filled and inspired understanding of the nature which surrounds us. Landscape painting has always had as its highest goal a desire to render not just pictures of nature but even the impressions, feelings and movements of the soul that occur in man as he contemplates his natural surroundings.

We must do justice to nature and establish the fact that as man admires nature, the noblest, purest and brightest feelings and the best in him come out. This is nature's most valuable, better still, priceless quality.

A feeling for the nature surrounding one's home has always been and will always be a part of such an important idea as love of one's country right alongside an awareness of the country's history and the sense of belonging to a people. Every population loves its nature and has an intimate relationship with it, but upon further reflection we find that our feeling for our own tract is not a spontaneous one. Each time we contemplate nature, we involuntarily set in motion emotional reserves accumulated through reading our poets and novelists, looking at paintings and listening to music. I would venture to say that our very experience of nature is organized, educated and determined by tradition — in short, culturally determined.

Each culture has had and has its nature poets. These are often relatively unknown outside cultural boundaries. But if the earth is our common fatherland and if love for the fatherland eventually grows in us — if gradually we come to realize that there is nothing more beautiful than our planet in the entire universe (and our world is truly beautiful!), then we owe a debt of gratitude to those who have taught us: the painters and poets who speak to all of mankind, artists who have helped us to understand beauty and who have taught us to love what is beautiful.

One may note without difficulty that artists throughout the ages and in all cultures have hardly ever depicted nature without any trace of human activity when, on their canvases, they have created landscapes. We always see a little bridge, a chapel or a church, a fence, a castle, a village, a rowing boat, perhaps a rider, a path, a road, a lighthouse or a sailing boat. We see grazing cattle, a newly-ploughed

field or one filled with waving grain, a garden, a windmill, a watermill or smoke rising from the chimney of a house. Some trace of mankind is always there.

This can be explained partly by the fact that we most often see the world as it is after having been touched by man. The most important cause, however, is the fact that human activity up to a certain point animated and accented the beauty of the earth. It added to the earth just those lines and details which brought the earth's beauty closer to our hearts, gave it soul and made it — if we are not afraid to use such an unscientific word — dearer to us.

Traces of human activity could not, in the beginning, destroy nature, for the simple reason that it was limited in scope, and later — up to a certain point — because man constantly thought about and strove after making his place of habitation beautiful. His surroundings should be beautiful. Up to a certain limit all the changes that man wrought on the earth melted into the landscape picture. The field of grain, the little bridge over the stream, the grazing herd, the small one-storey houses surrounded by trees could not, seen from an objective point of view, destroy the earth's graces — even less so since man consciously strove after beauty.

But somewhere along the line the limit was passed, and it was passed in two senses.

In the first place, the scope of human activity was widened. This is the objective cause. In the beginning man had not learned to pile up cyclopean slag heaps or build monstrous dams; to raise countless factory chimneys against the sky or to develop deep strip mines; to cover large areas of the earth's surface with those cement boils that we call cities or to fetter it with a network of modern highways. Nor had he created artificial reservoirs, thus drowning vast expanses of ground under a thin grey film of water as has been done to the rich meadows along the banks of the Volga. In times gone by, these areas flowed with milk and honey. Now the unique Tsimlyansk vinyards lie under water. If plans become reality to change the course of Siberian rivers, making them flow into Central Asia, it will become necessary to inundate an area equal in size to that of a medium-sized European state.

It is natural, when human activity has taken on such proportions, that radical changes in the face of the earth are unavoidable. A well-

known case in point is the tragedy which occurred at Lake Sevan, Armenia's lustrous pearl, a blue gem in the earth's crust. An opening was made in the mountain, and water began rushing out from the lake. Of course the water drives turbines producing energy (which could be produced in another way), but the lake is becoming more and more shallow. The water level sinks, and the shores dry out or change into swamps. An island has become a peninsula, streams of clear water dry up. What was magnificent has become deplorable.

But the scope and proportion of human activity cannot be wholly to blame. In the matter of size, the Egyptian pyramids surpass most modern constructions, but in spite of this we cannot claim that they have ruined the landscape. Could it be said that the sight of them gives an uncomfortable and piteous impression? Are they not rather one of our planet's rare and marvellous jewels?

One could claim that how we experience a landscape is a matter of taste. One man prefers the Taj Mahal, another the Cologne cathedral, a third the New York skyline. But still is there not a division of things in categories of beautiful and ugly? Do not some things produce rapture and others distaste?

There is a difference between looking at a star and a crushed frog, a glade in bloom and a rubbish heap, a clean stream flowing over rocks and a ditch filled with waste water, the lattice-work of a fence surrounding a summer garden and the chain links round a lorry park.

The sight of a cemetery is quite rightly sad, but if the cemetery is ill-kept, cluttered or vandalized, the sight is not only sad, it is intolerable.

Beauty resides in the soul of man: thus man's need for beauty is as natural as hunger or thirst.

The chain-link fence around the lorry park cannot be made as beautiful as the lattice-work fence around a summer garden — it has another function, and functionality must prevail. But let us agree that this now notorious fence can be beautiful or ugly in its own way, it all depends on how much thought the men who erected the fence gave to the problem: how beauty lived in their souls, to what extent they were equipped with a need for beauty and how they expressed that need.

I have not travelled extensively, but at any rate I have been in France, England, Germany, Denmark, Czechoslovakia, Poland, Bul-

garia, Hungary, China, Vietnam and Albania. Moreover, I have travelled in many parts of the Soviet Union. On the basis of my own observations and comparisons, I can say that the most modern, most grandiose industrial buildings are often quite beautiful in their own way — maybe even elegant. One could not say that they fit into the landscape, they form the landscape — they are the landscape, but one cannot say that they are ugly or offensive either.

That which is majestic need not necessarily be enormous. A swan does not have to be as big as an elephant in order to appear majestic. A two-storey building such as the Mikhailov palace in Leningrad, for example, can be more majestic than a hundred-storey high block. But even the reverse is true: everything which is enormous is not necessarily offensive. The earth is big enough to "conquer" and assimilate rather large arrangements. Mount Everest, Fujiyama, Elbrus, Mont Blanc and Kilimandjaro do not ruin the earth's appearance.

People who stare themselves blind looking at purely economic or political aspects often overlook a very simple criterion: "How is it going to look?" How is it going to look today and, what is more, how is it going to look tomorrow?

The Soviet architect Andrey Konstantinovich Burov allowed a significant sentence to slip out in his book *Ob arkhitekture* (On Architecture), Moscow, 1960: "We must first of all build quality lodgings in the shortest possible time and without, in doing so, destroying the face of our country for centuries to come."

This sentence is at the same time both beautiful and ominous. Beautiful in that it expresses worry about the face of the country and ominous in that it assumes that the country's face *can* be destroyed, not for just a year or two, but for centuries! But most important of all in the sentence is that there is, in fact, something called "the face of a country", and that that face is not just composed of the geographic landscape (mountains, level country, wooded land, etc.) but also of nothing less than the works of man.

Just as the artist creates his landscape painting, an entire people through the centuries, piece by piece, perhaps even unconsciously, creates a country's landscape and its landscape picture. Mountains and rivers, trees and flowers can be similar in two separate countries, but those features which man (a people) adds to the landscape finally

create a picture which is typical. Thus Germany's face will differ from that of neighbouring France and Poland's face from that of Central Russia or of the Ukraine, Japan's face will differ from that of the geographically identical island Sakhalin, and so on.

Old pre-revolutionary Russia's face, for example, was determined to a great extent by the hundreds of thousands of churches and bell-towers spread throughout the countryside, preferably on raised places which dominated every populated centre from the largest to the smallest. In addition, there were hundreds of monasteries and innumerable wind and water mills. Also the tens of thousands of country estates with their houses, parks and dam systems contributed in no small way to the landscape picture. But it was primarily the villages, both large and small ... the villages with their willows, wells, outhouses, saunas, pathways, gardens, vegetable patches; with their mortgage systems, fences, their carved window frames, roof ridges and porches; with fairs, brace skirts, dancing in a ring, with hay-making and shepherds' horns, sickles and threshers, with costumes, thatched roofs, small private patches of land and plough-ing with horses ... One can imagine how radically the face of the country changed when all of these factors which had earlier formed the landscape disappeared or changed form.

Just as the landscape painter puts part of his soul into his creation and in reality creates a landscape in his own image, a portion of the soul of a people is present in every landscape as well as the idea of beauty found in that soul.

Of coure, things are in a bad way if the sould of the people sleeps or is constantly distracted and numbed by extraneous circumstances and interests, by noise, greed or other things. Things are worse still if the soul of the people is dead or, putting it more exactly and per-haps a bit more delicately, in a state of lethargy. The landscape then loses its soulfulness. The physical landscape remains a landscape, but it has become, so to speak, poorer, a form without content. One feels the chill, estrangement, indifference and emptiness. To indi-viduals and to an entire people it no longer matters how things will look: how a house, a village, a valley, a mountain, the country as a whole, will look. What will the face of the land be like?

There are agencies occupied with the exploitation of mineral resour-ces, with road building, agriculture, electrification, light and heavy

industry and the automobile industry, but there is no agency responsible for a country's (the world's) appearance. Nobody to see to it that the countryside is neat and clean, soulful . . . We think about our installation's durability, about the type and extent of the foundation, the amount of lumber, we think in terms of tons, of cubic and square metres, but we seldom think about what things will look like. Not just in themselves but in a context, taken together with the surroundings, the terrain, in relation to our traditions, and with a thought to the future.

The landscape, complex as it is, taken as a whole is not merely equal to the face of the earth or of a given country. It also says something about the face of a certain society. A cluttered forest, roads in disrepair with cars up to the running-boards in mud, clogged waterways, green fields cut apart by tractor treadmarks, half-deserted villages, farm machines rusting in the open, monotonous standardized houses, fields overgrown with weeds tell just as much about the people of a small village or an area as an ugly, ill-kept block of flats does about its tenants.

The population of the earth is growing. The same is true of our technical apparatus. These factors should make man's need of beauty more acute and increase our experience of beauty. Take Japan, for example, that amazing land, that colourful flower on our planet. Great numbers of people living in inconceivably crowded conditions on a few stones in the middle of a great sea and not even sure whether those stones have any future or not, geologically speaking. The people of Japan have never lost their sense of beauty. They have never become blunt, and they have not permitted their soul to die. On the contrary, they serve as a shining example of a genuine, profound and human civilization. We are forced to take them as an example, since all the other peoples of the earth will experience what the Japanese have experienced — since at one time it is going to be just as crowded over the whole earth as it is in Japan today. Will other peoples be able to learn to bow down in respect in the same way before a cherry tree in bloom? To show the same ritual admiration for the snow-clad peaks of the mountains? In the same way to raise the ability to compose a bouquet of flowers to an art? To patiently design small, living toy gardens — landscapes in miniature which in spite of their size are so genuine? This feeling for beauty which lives today in Japan is not

just an aesthetic category, it is equally a question of courage and of heroism. Looking at the Japanese, one can understand Dostoyevsky's words to the effect that beauty will in time save the earth.

The well-known Soviet poet Vasily Fyodorov has written a poem entitled "Venus for sale". The background of the poem is an actual incident where a number of famous paintings were sold in order to fill certain building and industrial needs. In the poem one reads the following words:

> The beauty of centuries to come
> We pay for with the beauty of today.

I can understand the poet's bitterness as well as his historical optimism, but I still find myself asking: from where will the beauty of future centuries come if we, the generations of today, cannot preserve it for ourselves, if we cannot increase it and leave it ennobled to those who will follow?

The appearance of the earth today and in the future depends on us alone. Let us do everything in our power to guarantee that the earth will remain beautiful for all time.

Notes

1. Quoted from the periodical *L'Architecture d'aujourd'hui*, no. 145 (1969).
2. *L'Architecture d'aujourd'hui*, no. 145 (1969).
3. L. N. Tolstoy, *Sobranie sochinenii*, t. 3 (Collected Works, vol. 3), Moscow 1951, pp. 157—158.
4. A. T. Yagodovskaya, *O peizazhe* (On Landscape), Moscow 1963, p. 4.

Discussion

Staffan Helmfrid: I should like to ask whether there is any public debate about the vast landscape-changing projects being carried out or planned in the Soviet Union, about the consequences of turning the course of Siberian rivers, of big dam constructions and so on. Is it just a group of poets who realize these consequences?

Vladimir Soloukhin: The change of nature in the Soviet Union takes place in two ways. On the one hand there is the destruction of old monuments and old houses. Up to now about 92 % of these old buildings and monuments have disappeared. In Moscow alone, in the thirties, about 400 old churches were pulled down. It is very easy

to understand how much of the beauty of our country has been spoiled in this way. On the other hand there are all these new constructions, new bulidings, new dams and so on, which I mentioned in my lecture. To take but one example, the river Volga is no longer a river in the old sense of the word but a series of water reservoirs. Of course there is a debate about all this. For instance, there was a lot of discussion in the press about plans for a huge combine (plant) for cellulose and pulp on Lake Baikal. Various writers wrote in the newspapers saying that the idea was out of the question, because Lake Baikal contains 10 % of the world's fresh water and is also unique in other respects. A combine there will inevitably pollute the water. Among writers taking part in the very lively discussion were L. M. Leonov, V. A. Chivilikhin, A. M. Volkov and myself. Unfortunately it did not help: the combine now exists.

Östen Sjöstrand: The Russian literary classics have a very strong position in the Soviet Union, especially those of the 19th century that you mentioned in your lecture: Tolstoy, Dostoyevsky, Chekhov and others. Do you think that this fact is a creative force in preserving nature? After all, it would be natural for people to compare the conditions of today with those that they read about in the books.

Vladimir Soloukhin: Of course our classics and their descriptions of nature have shaped and influenced our way of looking at nature. I believe, for instance, that my own conception of nature would be totally different without Pushkin and his poetry.

THE HIDDEN MUSIC

By Östen Sjöstrand

We probably all know how modern composers have reacted some-
times against so-called programme music, refusing to admit any
connection between the pattern of sounds and the world we experi-
ence with senses other than our ears. The only thing that matters,
we have been told, is the musical score and the musical performance.
Now, ever since my late teens I have been profoundly engaged in
music; I have collaborated closely with composers in translating
texts for operas and oratorios; I have also myself written several
texts for operas and different pieces of music, so I am not interested
in defending programme music in a general, inarticulate way. But I
want to state, and even emphasize, that for very many people music
is an essential and sometimes decisive part of their way of perceiving
and experiencing nature. It may be difficult, judging only by the
music, to find out what a 14th-century *caccia* is describing in the
"outer" world, but the Italian or French text leads you forward to the
suggestion of a hunting party or of some merry men in a narrow,
nocturnal lane in a medieval village. On a wider scale, the Elizabethans
in their ballads, sung everywhere and by everybody, were often very
precise in their praising of their landscape, and we may, in the words
from *The Two Gentlemen of Verona*, remember Shakespeare's general
view of music as a mighty force governing all nature:

> For Orpheus' lute was strung with poets' sinews,
> Whose golden touch could soften steel and stones,
> Make tigers tame, and huge leviathans
> Forsake unsounded deeps to dance on sands.

This interdependence of music and nature may be a particularly
North European phenomenon. Besides England, you find it in Ger-
many, and especially in German romanticism: Beethoven's 6th Sym-
phony, the Pastoral Symphony, bears witness to the composer's intense
love of nature and rural life. Still north of the Alps you find other
examples, Smetana who glorifies the Moldau and the groves and
meadows of Bohemia, or Dvořák who praises the folk-music, folk-life

and natural scenery of Bohemia and Moravia and the vital Slavonic forces in his music. Later on and further north you have Grieg, who in some of his orchestral suites, songs and piano pieces describes "fjällen", the mighty mountains of his Norway. And in Finland you have Sibelius, who in his music expresses the austerity and beauty of a land of long winters and short brilliant summers.

Now, with only a slight touch of chauvinism. I dare to say that in Sweden you will find still more of this interdependence of music and nature. Let me only draw your attention to the fact that when I speak of the poetry and music which is above all a paean in praise of nature, you must be aware of the meaning of the term: nature, in Sweden, is the same as summer. An English critic, and translator of the 18th-century poet Carl Michael Bellman, Paul Britten Austin, has explained this particular feeling of ours for nature in these words:

> The Swedish landscape has none of the leafy prodigality of the English. For more than a third of the year it lies under snow. This lends a peculiar poignancy to spring's return, to the mid-summer flowers and to the high summer which follows. The lakes melt, becoming broad avenues of blue water reaching up into the land. All around, the dark forest hems in the horizon. The shores and the islands of Mälaren are fringed by small oakwoods where in the springtime the white and blue anemones blow, the cuckoo is heard, and the silver birches break into veils of feminine greenery.

The first examples of music and verse praising the Swedish summer are probably to be found in our folk-songs. I say probably, because it is often difficult to distinguish between Swedish ballads and those of Denmark and Norway. And the earliest ballad texts were not recorded until the years 1570 to 1660; the majority date from the 19th century, when the most important pioneer work in research was done by a group of Danish scholars. Nevertheless there are signs of an early, medieval Swedish ballad tradition. With the romantic and national movement in the 19th century the folk-songs became a very vivid force in our way of perceiving nature. In the folk-songs the varying phases of nature are often stylized, but they suffice to evoke the full meaning of the action of the tale:

> Det sitter en duva på liljekvist
> — i midsommartider —

A dove it sits on a lily sprig
— at midsummertide — . . .

The words, in their musical context, suffice to evoke a gentle Swedish midsummer mood: this in contrast to the melancholy, not to say the anxiety and anguish, that many Swedes experience at this turning of the year. Now most of these songs are characterized by melancholy, the minor key, the consciousness of sad and tragic autumnal transformations of nature. Songs expressing a hectic or desperate lowness of spirits, however, are not to be found.

I want to quote two stanzas of two different folk-songs to show you how music and verse interact to bring the Swedish nature and summer, in its given frames, to all our senses.

The first stanza, in English translation, goes like this:

> Here in our grove are blue bilberries fair,
> Come heartsease, come!
> Will you aught of me, so come to me there.
> Come shy columbine and lily,
> Come salvia and rose ablooming,
> Come balmint so fragrant,
> Come heartsease, come!

And this is the Swedish original:

> Uti vår hage där växa blå bär.
> Kom hjärtans fröjd!
> Vill du mig något, så träffas vi där.
> Kom liljor och akvileja
> kom rosor och salivia,
> kom ljuva krusmynta,
> kom hjärtans fröjd!

The second example is as well-known as the folk-song just quoted. It is called "Now far, far eastward I'll hie me" ("Till Österland vill jag fara").

> : Now far, far eastward I'll hie me,
> Where waiteth my loved one for me; :
> Past the mountains high and valleys,
> All under a green linden-tree.

The original runs like this:

> : Till Österland vill jag fara,
> Där bor allra kärestan min. :

123

Bortom berg och djupa dalar
Allt under så grönan lind.

Very many of these folk-songs are known by heart by elderly people, and nowadays they have become even more familiar to younger people as well: they take a definite part in our feeling for nature.

But there are other examples of music influencing our conception of nature. One outstanding example is Carl Michael Bellman (1740—1795). This poet of almost Shakespearean dimensions, unique in our literature, has, especially in his song-cycle *Fredman's Epistles*, given a description, at once lyrical and dramatic, elegiac and drastic, of life and nature in his 18th-century Stockholm and its surroundings. With minute realism, blended with rococo myth and romance, so typical of this age of Gustav III, in Biblical travesties and paraphrases of ceremonial proceedings, Bellman portrays in these songs the characters dear to him in the taverns and houses of pleasure he himself knew so well. Many of these figures are well-known to most Swedes: Ulla Winblad, the sensuous nymph and goddess of the taverns, Watchmaker Fredman in company with Father Movitz, Father Berg and Corporal Mollberg who, from the top of their voices to the bottom of their stomachs, sing and drink like all the members of the Order which Bellman had himself founded, the Order in honour of Bacchus. Comparisons have been drawn between Bellman's art and that of William Hogarth. But in Bellman's work there is nothing of Hogarth's grim social criticism or sometimes cynical preoccupation with criminality. At the core of Bellman's poetry is innocence — and the terrifying knowledge of death, Charon's approaching ferry.

Innocence is the chief characteristic, the nucleus and heart, of Bellman's evocations of nature. All these pictures of the surroundings of Stockholm — the deerpark Djurgården of the shores and islands of Lake Mälaren — are filled with a breezy air, dazzling and glittering like the water which is almost always present in these songs and Epistles. And although painted with an extraordinarily close observation, these pictures breathe at the same time the ethereal air of rococo romanticism — all heightened and given still another dimension by the sweet expressive music. It is this quality of interpenetration, this synthesis of words with music, which has given Bellman his unique position among Swedish poets. It may sound surprising but

it is nevertheless true that several of Bellman's Epistles and ballads, mainly owing to their interpretation of nature, are known by heart by almost every Swedish citizen. When Bellman describes a scene, like the "misty park of Haga", another idyllic resort on the outskirts of Stockholm, is is impossible for any Swede to distinguish between his words and his music.

Now it must be said that the examples of poetry which I have quoted can only give you a glimpse of the contents: it is not only a question of the way words are wedded to music, it is also a question of the Swedish cultural context. And speaking of Bellman, he, probably more than any other Swedish poet, defies translation. Nevertheless, Paul Britten Austin, whom I mentioned before, has made what is, so far as I can see, an attempt which is at least partially successful at translating some of *Fredman's Epistles* and *Songs*. His translation of the first stanza of Song no. 64, which describes "the misty park of Haga", goes like this:

> O'er the misty park of Haga
> In the frosty morning air
> To her green and fragile dwelling
> See the butterfly repair.
> E'en the least of tiny creatures,
> By the sun and zephyrs warm'd,
> Wakes to new and solemn raptures
> In a bed of flowers form'd.

The Swedish original runs like this:

> Fjäriln vingad syns på Haga
> mellan dimmors frost och dun
> sig sitt gröna skjul tillaga
> och i blomman sin paulun.
> Minsta kräk, i kärr och syra,
> nyss av solens värma väckt,
> till en ny högtidlig yra
> eldas vid sefirens fläkt.

Bellman declared himself a heathen. But we have hymn-writers who combine an intense feeling for nature with their Christian, Lutheran belief. In the hymn-book of 1695, which perhaps more than the Bible influenced the thinking and imagination of people at that time, you find one of the most beloved, genuine Swedish hymns.

This hymn has been sung and played for the past 100 years all over the country at the school breaking-up ceremony in June. It is called "Den blomstertid nu kommer", and this is an attempt at a translation of the opening four lines:

> The bloom now is a-coming
> With splendour and great joy:
> Sweet summer, thou art nearer
> When grass and crops wilt grow . . .
>
> Den blomstertid nu kommer
> Med lust och fägring stor:
> Du nalkas, ljuva sommar,
> Då gräs och gröda gror . . .

You may be sure that for a Swede words and music are inseparable in this hymn; they stand for an intense, expected and, at the same time, nostalgic apprehension of Swedish high summer.

There are other religious hymns, originally written in the 17th century, which likewise praise nature in words and music. Take no. 475 in our present hymn-book, for instance:

> In this fair summertime, my soul,
> Go forth and gladden at
> The Good Lord's gifts and riches . . .
>
> I denna ljuva sommartid
> Gå ut, min själ, och gläd dig vid
> Den store Gudens gåvor . . .

There are perhaps more than Platonic trends disguised in Orthodox creed . . .

When in the middle of the 19th century composers in Northern Europe began to throw off their former German training in order to allow their native idioms free play, you find in Sweden a combination of words and music which can be characterized as landscape songs. As the expression suggests, these songs deal with the inhabitants and nature of different provinces. Nowadays we cannot take their hyper-romantic fashion very seriously, but there are two or three exceptions, among them "Ack Värmeland du sköna" ("O Värmeland, of Sweden's fair counties the crown"). Ever since Anders Fryxell wrote the text, incidentally to a folk-tune from another region, this song has enjoyed perennial popularity.

Another phenomenon linked with the nationalistic romantic movement is the celebration which takes place on Walpurgis Night, the last day of April, when all Swedish students fling away their winter headgear and put on their white caps. The white caps are not as common now as they used to be, but the rest of the celebration, especially in the university cities, is much the same. It includes the singing of songs dealing with the departure of winter and the coming of spring: "Winter's rage beyond the hills has vanish'd" ("Vintern rasat ut bland våra fjällar"), "Gay as a bird in the dew of the morning / Out in the open I welcome the Spring" ("Glad såsom fågeln i morgonstunden / Hälsar jag våren i friska natur'n"). It is really a feast and a ceremony, almost a kind of exorcism driving out the evil spirits of nature and hailing the newborn, creative ones.

I hope I have demonstrated convincingly to what extent music leagued with living words influences our conception of nature, our feeling for it. And even if I have quoted only a very few examples of these songs, hymns and ballads, I hope I may have been able to give you a notion of the variety and the abundance of this co-existent verbal and musical landscape-painting. There is only one other example with which I want to bring this brief survey to an end, and that example is by Evert Taube (1890–1976). His ballads, loved as much as Bellman's, are filled with a spontaneous lust for life, with vivid energy and sensibility; his (I may say) adoration of woman is very much in the tradition of the troubadours. These characteristics are always combined with a very strong feeling for nature. Taube wrote about the Argentine, the Pampas, about Australia and San Remo, and other places he had visited as a sailor in his younger days, but in his heart of hearts was the Swedish high summer. In these songs, which vivify the freshness and melancholy of the summer season, words and music are brought together into one, along with another inseparable entity: dance. I want to quote the first stanza of one of his most popular waltzes, "Calle Scheven's Waltz"; a translation may run like this:

> On Roslagen's isle, in a flowery bay,
> Where ripples wash in from the sea,
> The reeds slowly rock, and the sweet new-mown hay
> Is wafting its fragrance to me.
> There I sit alone 'mid the trees by the way

And gaze at the sea-birds on high.
They dive to the water with glitter of spray
And feed, while I watch them and sigh.

The music influencing our conception of nature, the music I have spoken of, may perhaps in some sense be called a hidden music: many people, certainly many Swedes, are not quite aware of its full import, they react primarily to the contents, the meaning of the words.

There is, however, another dimension where the term "hidden music" is definitely appropriate, and I want to finish this lecture with a few annotations on this subject, remarks which are mainly based on my own experience of visualizing nature, the outer *and* inner world, in poetry, through a hidden medium, which is for me, most of all, music. I only want to add that these are just some marginal notes. In his book on my poetry in *Twayne's World Authors Series*, Staffan Bergsten, lecturer at Uppsala University, has given a full account of my views on the matter.

When I started writing — which for me was a revelation, a sudden eruption — the catalysts were Paul Valéry and Claude Debussy. But above all it was music that opened the floodgates, gave the water free flow. For Valéry the genesis of poetry was often a compelling inner rhythm. My head was filled with rhythmic figurations: everything I heard around me, from the spoon in the teacup to the tram bogies and the sound of the lift, I associated, immediately and reflexively, with the music that completely engrossed me, that of Debussy. I took as my point of departure the rhythmic shapes in Debussy, tried to find words to fit them: the rhythmical patterns objectified my dreams, the images from my inner life, while at the same time I grew intensely conscious of the outer world. Music became my counterpart to the spots on da Vinci's wall, that riddle of perception which no psychologist can ever explain satisfactorily. Indeed, I believe that far below the threshold of perception I have access through music (its rhythm and structure) to an immeasurable number of *axes of crystallization* for what are called by some people the psyche's archetypes. I believe that I thus have access to possibilities of expression which are far greater than those offered by too established, usually dead, verse-patterns. Here I should also like to say that French music is very close to me because through the ages it has maintained its close touch with language, with the needs of a

language whose expressive powers have not been allowed to diminish.

I should like to conclude by reading one of my poems entitled in fact "The Hidden Music". To show you what I mean by this hidden creative force I think only one or two comments are sufficient, even if they may seem a bit surprising to you. This poem was in fact prompted by some pages in a book on geometrodynamics by the physicist John Archibald Wheeler, professor at Princeton University. Wheeler compared the singularities which arise in the geometry in the recontraction phase of a closed universe with the curling crests and cusps which develop on an ocean wave as it moves into shallow water. But this scientist of wide perspectives adds: "Also some of the Vedas of old India suggest that the idea is very old, that nature derives its whole structure and way of action from properties of space. Can space be regarded as a marvellous creation of all-encompassing properties?" And in a long footnote Wheeler quotes Sankaracharya and other commentators on the Upanishads who expound the concept of "akasa", or space. Pondering on Wheeler's book, and also on deshi-talas, the Hindu rhythms, carriers of cosmic creativity, I came close to the notion of a primordial substance underlying all reality, prior to matter and energy, manifesting itself in the dynamic temporal evolution of the universe, from the composition of nebulae, stars, and galaxies up to the emergence of life and mind. In one of its aspects this evolution is comparable to music, *is* music. The musical structuring of the primordial substance lies embedded in the physical appearance of reality, it is a "hidden" music to be discovered and liberated by the inquiring, creative mind of man. As the anonymous medieval master-builders erected their cathedrals in the image of and to the glory of God, the Builder of the Universe, so modern mathematicians erect the proud structure of science in the image of and to the glory of the mind of man.

I believe that poetry's foremost task is to preserve and extend the human capacity to react, to prevent us, in its special way, from being seized by paralysis, the fear which makes us sink motionless like the ear-bones of whales or solidified meteorites down to the ocean floor, the everlasting darknesses. By breaking through the barriers of a reified society and activating our sensibilities, poetry can also preserve our sense of justice.

This means that I put our feeling for nature in this wider context. And music, whether it is openly united with words describing nature, or hidden, transcending the merely realistic description, perhaps being at the very core of our existence, can, for very many people, heighten their capacity to break open a way through the powers of destruction, towards the heart, beauty, the living spirit. Now, here is "The Hidden Music", in Robin Fulton's translation:

I

Time of the earth-crust.
Time of the galactic star-clusters.
Time of the wagtail.

Once:
an oceanic movement,
a wave to imitate.

Now: the countless
sunlit dust-specks trembling
in each opening window.

In the rose-window of equations.
In the cathedral of mathematics —

a world which still lives
with us, with the mind and senses of man,
with men who measure —
who discover new, fleeing
star-clusters beyond the horizon
and reach out towards echoes

of voices, beyond the sea ice and the ground frost
and sleepless nights
in cities, where the ground water dries —

voices we loved, love . . .

Patiently, tirelessly,
we seek to free matter itself
the frozen spirit.

Some time: time of man . . .

II

While shining night clouds,
dark nebulae, draw past,
I listen — not

to the sunk cathedral's bells
which fall silent
with the distant ocean.

I hear a pulsing universe
inside my closed eyelids.

Mr. Sjöstrand's paper was illustrated by sound recordings of the songs and hymns mentioned in the text.

Discussion

Erik Frykman: I am afraid it will seem entirely out of tune with your extremely fine and sensitive presentation, if I take you up on a point which has nothing to do with your real theme of the importance of music and poetry. It concerns what you said about William Hogarth and his preoccupation with criminality, which you characterized as cynical. The point I want to make is that to my mind his preoccupation with criminality has always seemed to be moralistic in the same very open-minded way as for instance Fielding's novels.

Östen Sjöstrand: I agree that he is also moralistic. I have pondered a great deal on this question ever since I translated *The Rake's Progress*, Stravinsky-Auden's opera, which is based on Hogarth's paintings. Later on, when I returned to the paintings, I still thought that they are not only moralistic as you say, but that there is also a cynical element in them. It is quite obvious that he is fascinated in some way by criminality.

Erik Lönnroth pointed out that Bellman and the personalities in his poetry lived in rather dubious circles, to put it mildly; that Bellman was once on the run from his creditors; and that some of his acquaintances certainly had much graver crimes to repent. Just like François Villon, who was himself a well-known criminal, Bellman shows no moralism about this at all.

Professor Lönnroth also wished to know if Debussy's piano piece "La Cathédrale Engloutie" had served as inspiration for the poem "The Hidden Music". This was confirmed by *Östen Sjöstrand.*

LE PAYSAGE DE *LA NOUVELLE HELOÏSE* : L'ASILE, L'ESPACE

Par René Pomeau

Lisons l'intitulé inscrit par Rousseau en tête de son roman, dans son intégralité : non seulement le titre, *Julie ou la Nouvelle Héloïse*, mais aussi ce qui suit : *Lettres de deux amants habitants d'une petite ville au pied des Alpes.* Ce sous-titre mérite d'autant plus notre attention qu'il est par la volonté de l'auteur répété en tête de chacune des six parties.

L'énoncé pose la dimension spatiale de l'œuvre. Le lieu, la « petite ville », est situé en perspective dans un espace, même tridimensionnel : « au pied des Alpes ». Ainsi est indiqué un rythme du clos et de l'ouvert qui va se retrouver dans le développement du récit. L'histoire des deux amants progresse par paliers et par crises : or chaque fois que l'équilibre toujours précaire se déstabilise, la rupture entraîne un départ de Saint-Preux. Après la crise du baiser dans le bosquet, l'amant doit pour un temps s'éloigner vers les hautes montagnes du Valais. Après la chute de Julie, le mariage secret — nouveau palier — ne pouvait longtemps échapper au regard des parents, ni à l'espionnage de la petite ville : sous l'anathème du baron d'Etange, l'amant prend la route pour Paris. Puis, après le mariage de Julie, il partira plus loin encore, sur l'immense océan, pour un voyage peut-être sans retour. Il revient pourtant, des « extrémités de la terre », afin de partager avec Julie et M. de Wolmar le bonheur de Clarens.[1] Bonheur fragile encore une fois, que va interrompre un autre voyage — le dernier voyage.

Par cette envergure dans l'espace, *La Nouvelle Héloïse* se distingue du modèle que le romancier avait présent à l'esprit: *Clarisse Harlowe*. Le drame familial de Richardson s'enfermait dans une sorte d'unité de lieu. Plus lyrique que son prédécesseur anglais, Rousseau a ménagé à partir des centres de l'action de larges échappées. Dans son roman on voyage beaucoup. Un personnage qui est plus qu'un confident, milord Edouard, passe son temps par voies et chemins, entre son Yorkshire natal et Rome où l'attirent des amours romanesques. C'est Edouard

qui entraîne Saint-Preux loin de Julie, à Paris. C'est lui qui l'enrôle pour un tour du monde sur la flotte de l'amiral Anson. Lorsque survient avec la mort de Julie la fin de Clarens, Saint-Preux roulait en compagnie de son ami anglais vers l'Italie. Perspectives complétées par les nouvelles d'Europe que la gazette apporte en ce coin de Suisse. Bien loin d'être une sorte de nacelle sans attaches la petite société du roman fut par les soins du romancier localisée, avec toute la précision souhaitable, dans le temps comme dans l'espace.

Mais parmi nos personnages ce sont les hommes, seulement les hommes, qui voyagent. Outre Saint-Preux et Edouard, M. de Wolmar, ancien boyard chassé de Saint-Pétersbourg, a longtemps erré, officier apatride au service de plusieurs princes d'Europe. Ainsi il connut le baron d'Etange, l'un de ces innombrables Suisses au service étranger, et lui sauva la vie sur le champ de bataille. Un comparse, Claude Anet, a couru l'aventure aussi, pendant que sa Fanchon délaissée demeurait auprès de Julie. Car les femmes dans ce roman restent singulièrement immobiles. Chacune vit et mourra sans s'être beaucoup écartée du lieu où elle est née. Au début de la sixième partie, Claire d'Orbe relate comme extraordinaire le voyage qu'elle fait jusqu'à Genève : pour s'y rendre depuis Lausanne, elle a parcouru une soixantaine de kilomètres. Julie son amie n'est jamais allée aussi loin. Elle fut plusieurs fois « tentée » de visiter cette ville célèbre :[2] elle n'a jamais osé. Toute son existence s'est écoulée dans un horizon fort limité : à Vevey pendant ses jeunes années, à Clarens tout proche de Vevey depuis son mariage.

Un telle sédentarité est liée sans doute à une idée de la condition féminine. Rousseau pense que la femme doit demeurer en son foyer. Le récit à un certain moment ouvrait à sa Julie la possibilité de devenir une héroïne errante comme il s'en rencontrait tant dans les romans de l'époque. Milord Edouard, devant l'ultimatum du baron d'Etange, lui a proposé de s'enfuir : il établira les deux amants, légitimement mariés, dans un domaine qu'il possède dans le Yorkshire. Que Julie ose préférer l'homme qu'elle aime, en lui sacrifiant ses parents : elle suivrait alors sur la grand'route les amoureuses de l'Arioste, les héroïnes romanesques de l'abbé Prévost. Mais Julie ne peut faire un tel choix. La raison véritable de son refus se trouve en elle-même. Entre la souffrance de ses parents et celle de Saint-Preux, elle choisit celle de Saint-Preux. Car il n'existe pas pour elle de bonheur possible hors

du cadre de ses affections de toujours. « Je ne déserterai jamais la maison paternelle », déclare-t-elle hautement.[3] Un départ équivaudrait pour elle à une désertion. Sortie du cercle où la retient l'affection filiale, elle ne pourrait vivre. L'amour de Saint-Preux lui a procuré le bonheur aussi longtemps qu'il s'est inscrit à l'intérieur de la famille, le jeune homme à titre de précepteur appartenant en quelque sorte à la maison. Fuir avec lui au loin ? Ce serait un arrachement. Julie adhère profondément à l'idéal rousseauiste de la vie heureuse — idéal plutôt rêvé que vécu par un Rousseau en fait toujours déraciné, un citoyen de Genève hors de Genève. Mais la nostalgie avive chez lui l'aspiration au bonheur réactionnaire obtenu par le confinement dans le pays natal, au sein de la « petite ville » où tous se connaissent, où tous s'aiment, ou sont censés s'aimer. Là se trouve, pour Rousseau comme pour Julie, l'ordre véritable, celui où la vertu coïncide avec le bonheur. Le choix existentiel de Julie prépare la révolution de son mariage, une révolution qui n'est qu'en apparence une rupture avec son passé d'amoureuse. Le jeune fille si attachée aux siens s'épanouit naturellement en son personnage nouveau : la dame de Clarens, âme de la petite société familiale instituée par Wolmar son mari.

La Nouvelle Héloïse fait éclater dans le roman une révolution bourgeoise, telle qu'elle s'affirmait simultanément dans la peinture d'un Chardin, ou dans celle du Suisse Liotard : la célèbre *Chocolatière* ne met-elle pas sous nos yeux un personnage qui aurait sa place à Clarens ? La réforme de cette ancienne gentilhommière répond chez Wolmar et son épouse à une recherche du bien-être bourgeois. Tout ce qui était d'apparat fut remplacé par de l'utile et du confortable. Au lieu des « paons criards », une laiterie. Plus de pelouses, mais un potager. Dans la maison les enfilades, les salles de réception ont été compartimentées en petites pièces intimes. On se *circonscrit*, persuadé que, physiquement rapprochés, les cœurs s'entendront mieux, s'aimeront plus chaudement. L'épisode de la matinée à l'anglaise propose l'exercice type de ce bonheur à huis clos.

La révolution bourgeoise du roman promeut un mot clef : « l'asile ». Le terme désigne dans le vocabulaire de Rousseau le lieu bien enclos où l'âme sensible à la fois se sent protégée et rencontre un environnement répondant à ses aspirations. La maison de Vevey : un « asile » pour Julie jeune fille, surtout lorsque, y vivant avec ses parents, elle passait ses journées avec son précepteur Saint-Preux. « Asile »

assurément, Clarens, ce cocon où Julie mariée est devenue « une mère de famille sans cesse environnée d'objets qui nourrissent en elle des sentiments d'honneur ».[4] C'est un monde singulièrement replié sur lui-même que celui-ci. Wolmar y instaure une autarcie économique quasi parfaite. Les domestiques recrutés par ses soins entrent chez lui un peu comme on entre en religion. Le contrat de travail se renforce d'un engagement moral aussi total qu'il est possible. Le personnel en est d'autant plus durement exploité. Mais il n'en éprouve que du contentement, conditionné comme il l'est en profondeur. « Tout l'art du maître, nous explique-t-on, est de cacher cette gêne sous le voile du plaisir et de l'intérêt, en sorte qu'ils pensent vouloir tout ce qu'on les oblige de faire. »[5] Phrase inquiétante, qui donne raison à ceux qui détectent en Rousseau un précurseur de la société totalitaire. Notre lecture peut effectivement discerner dans « l'asile » surorganisé qu'est le Clarens de M. de Wolmar les linéaments d'un monde concentrationnaire. Mais, faut-il le dire, ni Rousseau ni son public n'avaient la moindre idée d'un tel danger. Ils ne concevaient « l'asile » que comme le foyer d'un bonheur vertueux.

Il est dans *La Nouvelle Héloïse* des asiles plus restreints, asiles dans l'asile : le bosquet du premier baiser, l'Elysée de Julie — cette forêt vierge qui ferme à clé. Ou des asiles seulement rêvés : l'Eldorado valaisan au sein duquel Saint-Preux et Julie vivraient un amour selon la nature ; l'Eldorado du Yorkshire offert par milord Edouard.

Ces divers asiles ont en commun d'assurer une thérapeutique des âmes. En même temps que son roman, Rousseau avait conçu un projet de traité : le *Matérialisme du sage*. S'inspirant du sensualisme, il aurait démontré que l'âme, imprégnée par le milieu physique où elle vit, en reçoit des impressions morales. « Vil jouet de l'air et des saisons »[6], l'être sensible s'allège ou s'alourdit, se corrompt ou s'épure, selon l'environnement. L'art de moraliser les hommes consisterait donc à les envelopper d'un réseau fomentant en eux la vertu. L'asile dans *La Nouvelle Héloïse* assume cette fonction. Car si Rousseau n'a jamais rédigé son traité, la substance en est passée dans son roman, sous forme d'applications pratiques. Tel se présente l'épisode central du mariage de Julie. La jeune fille arrivait au temple bien décidée à conserver à son amant tous ses droits, par l'adultère. Mais « ce lieu simple et auguste » « vint saisir *son* âme ».[7] Elle frissonne, elle est sur le point de défaillir ; à peine peut-elle se traîner devant le pasteur. Les

impressions sensibles la dominent. « Le jour sombre de l'édifice », le silence de tous, et les figures sacrées du Père si imposantes pour elle — celle du vieux baron près d'elle, celle du prêtre qui lui parle, toute cette ambiance intimement ressentie remodèle son être moral : « Je crus, dit-elle, sentir intérieurement un révolution subite. Une puissance inconnue sembla corriger tout à coup le désordre de mes affections et les rétablir selon la loi du devoir et de la nature. »

A Clarens Wolmar va mettre en œuvre avec la compétence du technicien le « matérialisme du sage ». Pour guérir ses jeunes gens, il compte sur l'influence apaisante de cette sorte de sanatorium des âmes — très suisse — qu'est le domaine agencé d'après ses principes. Il a soin de faire visiter à Saint-Preux l'Elysée de Julie, cette fausse « île déserte ».[8] Le lendemain le jeune homme y retourne « avec l'empressement d'un enfant » — tant il est vrai que l'asile relève encore d'une sensibilité enfantine : Saint-Preux s'y sent heureux comme le jeune garçon en vacances consumant de longues heures en songeries dans un trou de verdure. Mais la vertu morale du site opère. Au lieu d'y retrouver l'image d'une Julie voluptueuse, il n'évoque que la mère de famille, « si chaste, si vertueuse » ; près d'elle, « le grave Wolmar, cet époux si chéri, si heureux, si digne de l'être ».[9] Le nom même d'Elysée, choisi par Julie, « rectifie » en son ancien amant « les écarts de l'imagination ». Il se dit : « La paix règne au fond de son cœur comme dans l'asile qu'elle a nommé. »

L'asile chez celui qui rêve en son sein suscite des imaginations qui l'emportent bien loin du lieu présent. C'est là l'expérience proprement rousseauiste. Le roman même de La Nouvelle Héloïse n'a pas d'autre origine, on le sait. Jean-Jacques, au printemps de 1756, erre dans les bocages de son Ermitage. Mais tout de suite sa rêverie lui dérobe les objets présents sous son regard. Du paysage de l'Ile de France où il se promène naît le paysage si différent de son roman. Pénétré par le panthéisme de la nature en éveil, sa sensibilité oblitère la réalité offerte à ses yeux. Aussi constate-t-on que, dans les textes autobiographiques comme dans les pages du roman, les asiles ne sont guère décrits. Le musicien Rousseau, qui n'est pas un visuel, traduit plutôt que les spectacles l'impression émotive d'un ensemble. Lorsque Saint-Preux prétend retracer à l'usage de milord Edouard une « description » de Clarens,[10] il s'agit en fait d'une analyse de cette organisation si savamment combinée. Si la plume du narrateur nous livre sur l'Elysée

de Julie d'assez abondants détails, c'est qu'il lui plaît de s'étendre sur les procédés de fabrication par lesquels, à force d'artifice, les Wolmar ont reconstitué en ce lieu la nature la plus sauvage.

Mais dans la cérémonie du temple, nulle description en forme. Julie qui parle n'a pour ainsi dire rien vu. Trop intensément bouleversée, c'est à peine si elle « aperçoit les objets ».[11] Elle sent surtout le volume autour d'elle de ce lieu « tout rempli de la majesté de celui qu'on y sert ». Dans une rumeur de tout son être elle en éprouve en elle la présence. L'asile : un état de l'âme circonscrite, vécu au niveau de la sensation.

Du lieu clos à l'espace, une relation dans le roman s'établit. De l'intérieur même du temple Julie s'élève en pensée vers la « Providence éternelle qui fait ramper l'insecte et graviter les cieux ». [12] L'asile ne pouvant se concevoir que comme inscrit dans une étendue beaucoup plus vaste, on passe de l'un à l'autre par le mouvement, par exemple d'un voyage. Au début du récit, Julie depuis Vevey, où « l'automne est encore agréable », désigne à Saint-Preux l'horizon là-haut : la Dent-de-Jamant dont on voit déjà « blanchir la pointe ».[13] Son ami part pour ces sommets. Ce qui nous vaut une page qui constitue une « première ». Les Alpes n'étaient pas tout à fait inconnues dans la littérature européenne. Quelques années plus tôt le Suisse Haller avait publié sa grande composition en vers *Die Alpen*. Mais en français le sujet était neuf. Rousseau par cette lettre 23 de sa première partie remplissait la promesse du sous-titre situant les deux amants « au pied des Alpes ». Il ne peint pas un tableau fixe : la montagne surgit à mesure que le marcheur Saint-Preux y progresse. Autour de lui se lèvent successivement des notations impressionnistes : roches abruptes, « bruyantes cascades », « torrent éternel », gouffre, « agréable prairie »,[14] se prolongeant en longs aperçus sur des lointains diversement éclairés.

En cette phase du roman, l'espace déploie ses plus amples dimensions, y compris la verticale, car la perspective en montagne « frappe les yeux tout à la fois bien plus puissamment que celle des plaines qui ne se voit qu'obliquement en fuyant » . . .[15] Mais ici encore la vue marque moins l'âme sensible que l'impression cénesthésique de l'espace : « plus de facilité dans la respiration, plus de légèreté dans le corps, plus de sérénité dans l'esprit ». Car l'espace comme l'asile a ses vertus curatives. Volontiers Saint-Preux préconiserait « des

bains de l'air salutaire et bienfaisant des montagnes » comme « un des grands remèdes de la médecine et de la morale ».[16] Au soir il s'arrête dans un hameau de bons Valaisans : société délicieuse, avant-goût, en altitude, du Clarens de M. de Wolmar.

Ainsi le voyage à travers l'espace le plus immense l'a conduit d'un asile à un autre. Rousseau au temps de sa jeunesse avait vécu selon un tel rythme. Ses errances même les plus lointaines le ramenaient au foyer de « Maman », dans la maison de Mme de Warens à Annecy, puis à Chambéry et aux Charmettes. Avant les *Confessions*, c'est dans *La Nouvelle Héloïse* sous le nom de Saint-Preux qu'il a dit sa « violente palpitation », son trouble au bord de l'évanouissement, à l'approche du lieu béni où il retrouvera la femme aimée. Saint-Preux suffoque, il doit s'arrêter pour recouvrer un peu de calme. Il voudrait ne jamais arriver auprès de celle dont l'image le met dans un tel état. Déjà, étant encore en pleine mer, « à la vue des côtes de l'Europe » il avait commencé à ressentir de pareilles transes.[18] Comme si le continent européen n'était qu'un vaste asile recélant sa Julie. Il fait lui-même un rapprochement significatif : il remarque à ce propos que « la même chose » lui était arrivé autrefois à Meillerie « en découvrant la maison du baron d'Etange ».

En plusieurs passages du roman, la relation de l'espace et de l'asile apparaît comme celle du lieu réel au lieu rêvé. Dans le haut Valais, le voyageur Saint-Preux imagine sa Julie en son intérieur, à Vevey. Du milieu du Pacifique, il se dit : « Je suis mal ici, mais il est un coin sur la terre où je suis heureux et paisible. » Il se « dédommage au bord du lac de Genève de ce qu'il endure sur l'Océan ».[19] Mais il est un épisode, redoublé par un effet d'écho, qui pose comme simultanément présents et l'asile et l'espace. A son retour du Valais, Saint-Preux n'a pu regagner la « petite ville au pied des Alpes ». Il s'installe en face, de l'autre côté du lac, à Meillerie. Il passe ses journées sur « une petite esplanade »,[20] au sommet de la falaise dominant le Léman. « Lieu sauvage », désolé par l'hiver, à l'unisson de son désespoir : cet « asile » (le mot est prononcé) fomente ici les sombres pensées de l'amant. Devant lui un large horizon : tout au loin, parmi les maisons de Vevey il discerne à peine celle de Julie, « ces murs fortunés qui renferment la source de *sa* vie ». Pour mieux voir il emprunte le télescope du curé : moyen qui en réduisant la distance rend plus évidente la dimension spatiale. Or quelques années plus tard, il revient sur ces mêmes lieux,

en plein été, en compagnie de Mme de Wolmar. Il prend alors la peine, dans la célèbre lettre du lac, de composer un tableau. C'est qu'il s'agit ici de présenter ensemble les deux éléments du paysage et de souligner leur relation. Parvenus sur l'esplanade, Saint-Preux et Julie découvrent un imposant panorama : derrière eux des « rochers inaccessibles », « d'énormes sommets de glaces qui s'accroissent incessamment [. . .] depuis le commencement du monde » : « des forêts de noirs sapins » à droite ; « un grand bois de chênes », à gauche, « au-delà du torrent » ; au-dessous d'eux, « cette immense plaine d'eau que le lac forme au sein des Alpes » les séparait « des riches côtes du pays de Vaud, dont la cime du majestueux Jura couronnait le tableau ».[21]

Au centre du « tableau », en contraste, le « petit terrain » portant les deux visiteurs : « séjour riant et champêtre », agrémenté de ruisseaux aux « filets de cristal », couvert « d'herbe et de fleurs », orné de « quelques arbres fruitiers sauvages [qui] penchaient leurs têtes » sur les têtes de Julie et de Saint-Preux. « En comparant un si doux séjour, conclut le narrateur, aux objets qui l'environnaient, il semblait que ce lieu désert dut être l'asile de deux amants échappés seuls au bouleversement de la nature. »

Les deux thèmes de l'asile et de l'espace, après le prélude de la première partie, reçoivent ici, en ce temps fort du roman, le plein développement qui les établit dans leur relation réciproque.

Le paysage de *La Nouvelle Héloïse* ne se réduit pas à un simple décor. L'ambiance des choses, nous le savons, agissant sur les sensibilités contribue dans le roman à l'évolution des êtres. Rousseau pouvait-il placer ses personnages ailleurs « qu'au pied des Alpes » ? Non sans doute, ni ailleurs qu'au bord du Léman. « Il me fallait un lac »,[22] écrit-il dans les *Confessions*, quand il s'explique sur la genèse de *La Nouvelle Héloïse*. Il avait songé au lac Majeur et à ses Iles Borromées ; mais il y avait là-bas « trop d'ornement et d'art pour *ses* personnages ». Son choix se fixe sur la partie du Léman où vécut sa « pauvre Maman ». Outre l'attrait du passé il rencontrait en ce paysage « le contraste des positions, la richesse et la variété des sites, la magnificence, la majesté de l'ensemble qui ravit les sens, émeut le cœur, élève l'âme ». Il a « toujours aimé l'eau passionnément »,[23] déclare-t-il, au moment d'en venir dans les *Confessions* à cette retraite dans l'île Saint-Pierre dont le souvenir suscitera la rêverie panthéiste de la *Cinquième Promenade*.

« Passionnément » ? La page des *Confessions* rappelant le choix
d'un séjour romanesque n'évoque que la quête d'un lieu agréable :
d'un « bocage frais », d'un « paysage touchant ». Mais le texte même
du roman suggère qu le «il me fallait un lac» répondait à une motiva-
tion plus essentielle. Cette eau «passionnément» aimée : une eau dange-
reuse, pour employer le vocabulaire de Bachelard. Le lac et plus géné-
ralement l'eau n'apparaissent jamais dans le roman pour introduire
une notation riante. Le plus souvent même ils sont absents. On
oublierait que Vevey, que Clarens[24] sont baignés par le Léman, si en
quelques moments dramatiques le lac n'offrait soudain sa vaste sur-
face liquide. Son étendue présente un espace où le regard volup-
tueusement s'étend au loin, sans obstacle. Transparence perfide. Cette
eau profonde, sombre en sa profondeur, exerce une fascination péril-
leuse. Dès la première partie, Saint-Preux, juché sur l'esplanade de
Meillerie, est tenté par ce « dernier refuge d'amants malheureux » :
« La roche est escarpée, l'eau est profonde, et je suis au désespoir. »[25]
Dans la quatrième partie l'eau séductrice appelle Saint-Preux et Mme
de Wolmar pour une promenade sur le lac, d'abord fort agréablement
ensoleillée. Mais en quelques instants se lève une de ces brusques
tempêtes dont le Léman est coutumier. La barque, sous le choc d'une
lame plus violente, va-t-elle sombrer ? Saint-Preux dans un éclair
a la vision de Julie morte : il croyait voir « le bateau englouti, cette
beauté si touchante se débattre au milieu des flots, et la pâleur de la
mort ternir les roses de son visage ».[26] Complexe d'Ophélie, ou ten-
tation de Saint-Preux. A leur retour le soir, sur ce même lac main-
tenant paisible, l'évidence de leur situation le saisit : les deux amants
vivent côte à côte, mais définitivement séparés. Alors dans un « trans-
port » il est soudain « violemment tenté » de se précipiter avec Julie
« dans les flots », « et d'y finir dans ses bras *sa* vie et *ses* longs tour-
ments ».[27] Il semble qu'initialement Rousseau avait prévu de terminer
son roman par cet épisode, les deux amants périssant noyés dans
les abîmes du lac.

L'eau image de la mort, et recélant la mort : ainsi apparaît-elle en
un autre moment dramatique, à la fin de la troisième partie, lorsque
Saint-Preux prend la mer pour un tour du monde dont il n'espère pas
revenir. Il avait songé à mettre fin à ses jours en apprenant le mariage
de Julie. Son départ est un succédané du suicide. Sur le port, soulevé
déjà par le vent du large, de la même manière qu'il se livrerait à la

mort, il s'enfonce dans la « mer vaste, mer immense, qui doit peut-être l'engloutir dans son sein ».[28]

Julie finalement n'échappera pas à la menace fatale du lac, tout proche quoique quasi absent. Elle mourra non pas noyée dans ses eaux, mais des suites d'une chute qu'elle y fit pour sauver son fils : l'incident confirme la fonction dramatique dans le roman de cette image sensible de l'espace.

Les deux thèmes associés reparaissent une dernière fois après la mort de Julie. L'agonisante avait imaginé « qu'une âme libre d'un corps qui jadis habita la terre puisse y revenir encore, errer, demeurer peut-être autour de ce qui lui fut cher ».[29] Claire se persuade qu'il en est bien ainsi, que de l'espace de la mort, « du séjour de l'éternelle paix cette âme encore aimante et sensible se plaît à revenir parmi nous [...] . Non, elle n'a point quitté ces lieux qu'elle nous rendit si charmants. » Claire s'en convainc mieux encore lorsque « deux fois la semaine » elle visite « le lieu triste et respectable ». « Beauté, soupire-t-elle, c'est donc là ton dernier asile. »[30]

C'est ainsi qu'au finale le double thème posé dès le départ en vient à dégager la note fondamentale de *La Nouvelle Héloïse*, roman tragique.

Notes

1. P. 393: nous revoyons à notre édition de *La Nouvelle Héloïse*, Paris, Garnier, 1960.
2. P. 625.
3. P. 185.
4. P. 484.
5. P. 435—436 : dans cet emploi « gêne » conserve quelque chose de son étymologie, « géhenne ».
6. P. 63.
7. P. 332—333.
8. P. 469.
9. P. 470.
10. P. 511, Edouard à Saint-Preux : « Continuez vos descriptions » . . .
11. P. 332—333.
12. P. 335
13. P. 39.
14. P. 50.
15. P. 51.
16. P. 52.

17. P. 402.

18. P. 401.

19. P. 393.

20. P. 64—65.

21. P. 501.

22. *Les Confessions*, dans *Œuvres complètes*, Bibliothèque de la Pléiade, Paris, 1959, t. I, p. 431.

23. *Ibid.*, p. 642.

24. P. 497, il est précisé que la maison de Clarens est proche de la rive.

25. P. 67.

26. P. 499.

27. P. 504.

28. P. 377.

29. P. 716.

30. P. 732.

Discussion

G. von Proschwitz : Permettez-moi de vous exprimer, cher maître, au nom de la Société Royale, toute notre gratitude et notre admiration pour votre communication si nourrie et si riche. Son caractère si riche. Son caractère si brillant, presque définitif, pourrait nous intimider, mais je pense qu'il y aura, certainement, quelques-uns pour vouloir vous poser des questions.

C. Simon : Je voudrais remercier M. Pomeau de cette conférence qui m'a passionné, mais je voudrais lui demander qu'il m'éclaire un peu sur quelque chose qui m'a frappé en l'écoutant. C'est cette position de l'asile et de l'espace. Vous avez terminé en disant que *La Nouvelle Héloïse* est un roman tragique, n'est-ce pas ? Et j'ai pensé tout le temps à ce que disait Barthes que les pièces de Racine se déroulaient dans un espace complètement clos, qui est terrifiant, alors que l'asile semble rassurant. Par contre, l'espace, l'extérieur, chez Rousseau, apparaît au contraire, terrifiant. Est-ce qu'il n'y a pas là une espèce de curieuse figuration du conflit entre une époque qui s'achève, l'époque, si vous voulez, de l'Ancien Régime, et le Romantisme que va commencer le XIXe, où l'espace va s'ouvrir. Je souhaiterais vous nous précisiez un peu cela.

R. Pomeau : Je ne crois pas que l'espace soit uniquement terrifiant chez Rousseau. Il est profondément ambivalent. Il y a cet espace de la haute montagne où Saint-Preux s'épanouit : sa respiration est dégagée,

son être sensible se libère. Il y a, évidemment, cet espace effrayant du vaste océan. Dans ce cas, l'espace, c'est la mort, surtout dans le dernier épisode. Julie morte est perdue quelque part dans l'univers ambiant. Peut-être son âme voltige-t-elle, on ne sait comment, revenant vers l'asile où continuent à vivoter, tant bien que mal, ceux qu'elle a aimés. Il y a une ambiguïté de l'espace qui apparaît très bien dans le thème du lac, de cette eau qui est à la fois une eau de romance, séduisante, et une eau dangereuse. Sous sa forme aquatique, sous sa forme océanique, l'espace est tragique. La menace est là, dès le début, d'autant plus inquiétante qu'elle reste sous-jacente, puisqu'on ne parle, pour ainsi dire, jamais du lac tout proche. Mais si quelquefois il en est fait mention, c'est une tonalité de mort qui est indiquée. Je pense qu'effectivement, si l'on songe à Racine, une évolution s'est produite. Le tragique racinien se joue dans le huis-clos théâtral, tandis que Clarens demeure ouvert, malgré les aspects « concentrationnaires » que nous y apercevons, *nous*, auxquels Rousseau n'a pas pensé, non plus que ses lecteurs. Car, si vous me permettez d'ouvrir une parenthèse, il y a une chose très curieuse, c'est qu'aucun lecteur de *La Nouvelle Héloïse* et aucun de ceux qui ont fait une lecture politique de *La Nouvelle Héloïse* n'a aperçu cette exploitation éhontée des domestiques.

C. Simon : Je pensais en écoutant aux salines de Ledoux, qui, ensuite, a été avec les anarchistes, mais je ne sais pas si vous avez visité. C'était un véritable camp de concentration.

R. Pomeau : Oui, mais personne, alors ne l'a remarqué. Cela nous frappe aujourd'hui parce que nous avons d'autres perspectives. Cet asile, qu'il s'agisse de la maison familiale de Vevey ou qu'il s'agisse de Clarens, avait quelque chose de nourrissant, de bénéfique. C'était un foyer de vie que l'asile. Certainement quelque chose, depuis, a changé.

G. von Proschwitz : Vous avez montré fort clairement combien, chez Rousseau, le paysage agit sur les âmes et que les asiles, à vrai dire, ne sont guère décrits. Chez Rousseau, l'impression émotive qui se dégage de la nature l'emporte sur la description visuelle. Est-ce qu'il serait exact de dire que Rousseau annonce par là moins Lamartine que Stendhal ?

R. Pomeau : Assurément. Il est certain que cette qualité d'un certain bonheur, chez Stendhal, a une origine rousseauiste. On connaît les pages de *La Chartreuse de Parme* où Stendhal évoque le Lac Majeur et le bonheur de Fabrice, au bord de ce lac. Il y a une tonalité pré-stendhalienne dans *La Nouvelle Héloïse*. Et Stendhal, comme la plupart de ses contemporains, était nourri de ce roman. Cette fameuse quête du bonheur, thème stendhalien, prend ses racines dans *La Nouvelle Héloïse*. *La Nouvelle Héloïse*, roman tragique, est aussi le roman du bonheur.

ENVIRONMENTAL PERCEPTION AND SPATIAL BEHAVIOUR: A TREND IN GEOGRAPHIC RESEARCH

By Staffan Helmfrid

As a geographer I feel very much like an engineer among poets in this symposium on "the Feeling for Nature and the Landscape of Man". As a geographer, too, I feel more comfortable when dealing with landscape than with feelings.

The *concept of 'landscape'* has played a very special and very fundamental role in the history of geographic thought. At times it has been very much in disrepute for its lack of logical clarity and the uniqueness claimed for it, adverse to generalizations. 'Landscape' then was used as a term for what geographical philosophers meant to be God-given 'natural regions', the homogeneous spatial units making up the mosaic of landscapes on the Earth's surface. When I argue that geographers are still professionally concerned about describing and explaining landscape among other spatial phenomena, landscape has *not* this specific meaning, but is just the totality of natural and man-made environment on the earth's surface, interacting in many ways with man and society in the global eco-system.

Geographical landscape research has mainly been *morphogenetic* in scope, i.e. it has aimed at tracing landscape history and that of man-land relationships, in order to explain the landscape of today as an accumulation of remnants from different phases of landscape change. This is a specialized, yet multidisciplinary branch of research. The morphogenetic approach to the landscape of man was introduced by the American geographer Carl O. Sauer in the 1920s. The concepts were taken over from geomorphology, the study of land forms. It was an important achievement, giving the geographical study of man-made landscape a basis as a positive science. It was part of the specialization process that dominated geography, partly fragmented it, in the next 50 years. It was a process enabling geography to find more solid theoretical and methodological foundations, but it stopped for a long period efforts to deepen the approach to geographical totalities intuitively described by early geographers, the wholeness of

man, natural environment, economy and culture in long historical perspectives that constitutes the geographical region.

Carl Sauer rejected these early efforts under the headline "Beyond science" in an essay in 1925, but not without some sympathy:

> A good deal of the meaning of area lies beyond scientific regimentation. The best geography has never disregarded the esthetic qualities of landscape to which we know no approach other than the subjective. Humboldt's 'physiognomy', Banse's 'soul' (Landschaft und Seele), Volz's 'rhythm', Gradmann's 'harmony' of landscape, all lie beyond science. These writers seem to have discovered a symphonic quality in the contemplation of areal scene, proceeding from a full novitiate in scientific studies and yet apart therefrom. To some, whatever is mystical is an abomination. Yet it is significant that there are others and among them some of the best, who believe that, having observed widely and charted diligently, there yet remains a quality of understanding at a higher plane that may not be reduced to formal process.

Works like those cited by Sauer were for a long period a severe drawback, a burden for a human geography which was striving for recognition as a modern social science, sharing theoretical concepts and analytical tools with other social sciences such as economics, sociology and statistics. *Classical geography* had, intuitively, touched on the psychology of human spatial behaviour but had no tools for a closer examination of perception and behaviour. In the best cases, like the old French school of regional geographers headed by Vidal de la Blache, they reached literary qualities.

Methodological advance in psychology, allowing quantitative analysis of perception and behaviour, opened up new areas of interdisciplinary contacts for geography. At the International Geographical Congress in Stockholm in 1960 an American geographer, David Lowenthal, in his lecture on "Geography, experience and imagination", started what evolved in the 1960s as a rapidly expanding school of behaviour geography which pretended to give a new basis to the whole subject, the perception approach.

Lowenthal requested geographers to take up exploration of the terrae incognitae "within the minds and hearts" and to study the relations between the world outside and the pictures in our heads, to analyze the "personal geographies" of individuals and their group

characteristics. "Every image and idea about the world is compounded then of personal experience, learning, imagination and memory." "The places that we live in, those we visit and travel through, the worlds we read about and see in works of art, and the realms of imagination and phantasy each contribute to our images of nature and man." "We are all artists and landscape architects, creating order and organizing space, time and causality in accordance with our apperceptions and predilections." "The geography of the world is unified only by human logic and optics, by the light and color of artifice, by decorative arrangements and by ideas about the good, the true and the beautiful. As agreement of such subjects is never perfect or permanent geographers too can expect only partial and evanescent concordance."

Together with his English colleague Hugh C. Prince, Lowenthal illustrated his ideas in a very amusing study of "English Landscape Tastes", published in *The Geographical Review* in 1965, and based on literary evidence from the last two hundred years. The English landscape preferences were classified into groups of characteristics like "The Bucolic", "The Picturesque", "The Deciduous", "The Tidy", "Façadism", "Antiquarianism", including "Rejection of the present", "Rejection of the sensuous", "Rejection of the functional", and the demand for historical associations and a genius loci for the full appreciation of a place or a building.

"Townsmen though they are they still think of rural England as home" (D. H. Lawrence). Stanley Baldwin once stated: "To me, England is the country, and the country is England. The sounds of England, the tinkle of the hammers on the anvil in the country smithy, the corncrake on a dewy morning, the sound of the scythe against the whetstone, and the sight of a plough team coming over the brow of a hill, . . . the one eternal sight of England." This was in 1924, at a time when all this had already practically disappeared! Ebenezer Howard's concepts of the "Garden cities of tomorrow" are to be seen against the experience of early industrialization and urbanization in England, as a protest.

The English, it is said, prefer inhabited, warm, comfortable, humanized landscapes and broadleaved trees as against "German conifer-worship". Returning from the Hebrides, a traveller disappointedly reported: "There was nothing but scenery up there."

Park and garden are called "all nature, and yet look'd all like art". Geometry is not picturesque, and hated. A medieval town like Chester is characterized as "a perfect feast of crookedness". The only straight lines in the English landscape are Roman roads! In the 18th century laws of picturesqueness were strict. An enthusiast in 1772 explains at length why "at least three cows are needed for a picturesque grouping". Art was model for landscape!

"Façadism" is characterized as a preference for "dressing up landscape" — façades to create the proper atmosphere, as at Blackpool. Façades "are employed to restrain more than to adorn, to conceal rather than to advertise". "The Palladian house Lord Burlington designed for General Wade was so inconvenient that 'he could not live in it', but so elegant that he planned to buy the house opposite in order to look at it."

The architect John Soane sketched buildings "as they would look not only in youth but in a state of ruin".

"Certainly, we love old buildings, but we love them for what they stand for rather than for what they look like." "The soot-encrusted façades of the Foreign Office courtyard make it 'a monument to the age of smoke'. No other people seem to consider deposits of dirt worth preserving for their own sake." Amusing and subjectively convincing as the quotations may be to those who know England and the English, nobody knows whether they are representative in a stricter sense of "the English landscape taste"! For a systematic enquiry into environmental perception and spatial behaviour *this*, however, is crucial.

In his pioneering and often quoted work *The Image of the City* (1960), Kevin Lynch laid the foundation of a promising methodological development for controllable enquiries into "the inner space" of man and studies of its relations to environment. Interviews, including the freehand sketching of a map by the interviewed person, formed the basis for an exploration of the public image of each of three American cities in the eyes of their inhabitants, represented by a statistical sample. General coincidences as well as specific group differences were clearly identified. There followed a veritable explosion of similar studies all over the world, and new ways of application are still being explored today.

The "mental map" is a key concept of geography's perception approach. An impressive set of studies explored the "mental maps" of different groups in different countries for their regional preferences within the frame of their home country. Special mention should be made of the contribution of Peter Gould for his methodologically advanced studies in African and European countries, including Sweden, on regional living preferences of different groups.

The "mental maps" held by *decision-makers* should be of special interest for explanation of geographical patterns. Gunnar Törnquist pursues investigation of this group's cognitive maps of the business environment in a search for explanations of existing systems and location patterns and for a prognosis.

The weaknesses of the "mental map" concept and the studies presented have been discussed intensely. Here I have only reason to point to the fact that we do not really know what we map, when we are mapping regional preferences (or local preferences) of areas to live in. Clearly the preferences are based on quite different factors known to the respondent from quite different sources. It is unsatisfactory for the analysis not to know exactly the role of each specific factor. The larger the space, the more composite and vague the subjective preference value. Neither "place preference" nor "knowledge of places" reveals the specific qualities of localities. The "mental map" is a tool for analysis of aggregated space perception and behaviour on a national and regional level.

But there is also a wealth of studies within the framework of both psychology and geography which try to measure the human response to specified qualities of the environment.

What fascinated geographers most in "behavioural geography" were the new ways it offered to *explain spatial patterns*, which so seldom coincided with optimum patterns based on the concept of "economic man".

A distinct school of research evolved in the USA in the 1960s to investigate the response of human populations to natural hazards like flooding, droughts, hurricanes. Its most important contribution to the field of "behavioural geography" was the full exploitation of contemporary techniques and concepts of perception psychology. In this context Thomas Saarinen should be mentioned. He explored the border-areas between geography and psychology, thus opening

up this new interdisciplinary frontier to geography, already so rich in neighbouring fields (Thomas F. Saarinen, *Environmental Planning: Perception and Behavior*. Boston 1976).

The behavioural impact of environmental perception is clearly composed of *what we know* about places and *what we feel about what we know* about places. The types of studies mentioned here do not differentiate between these two aspects but, methodologically, they are clearly most interested in pure cognitive perception, apperception of "utility qualities" in economic terms. But there is no sharp distinction in principle from the evaluation of "feelings for nature and the landscape of man".

The bridge to "emotional perception" is constituted by studies of recreational land-use, recreational place-utilites and recreational behaviour.

Because of its direct applicability in planning, the thesis of Hans Kiemstedt, *Zur Bewertung der Landschaft für die Erholung* (1967) has had a great impact on recreational land-use studies and landscape evaluation studies. Kiemstedt stated that the recreational qualities of landscape operated in three ways:

1. directly upon our senses, above all optically,
2. through usefulness for recreative activites, and
3. physically, above all climatically.

Kiemstedt picked out a number of quantifiable landscape features in order to combine these into indices of recreational value. The features selected, measurable in maps and air photos, were:

length of the attractive borderlines in nature: shorelines and edges of forests per areal unit of land,
relative relief,
land-use types,
climate.

These features were weighted, added to a quantitative index and mapped. The outcome was compared with the distribution of actual visitors in the well-developed tourist region he examined. The high correlation found supported the usefulness of the index, which could thus be an easy device for exploring the recreational-use values of other territories.

In Sweden Hans Aldskogius, an Uppsala geographer, was the first to quantify landscape properties for the analysis of recreational be-

haviour. Relief, openness and distance to shorelines were among the factors he used to explain the distribution of vacation houses around Lake Siljan in Dalecarlia. Aldskogius has made a very useful survey of research concerning evaluation of landscape as a resource for recreation, in the series of research reports from the Department of Human Geography, University of Uppsala.

The Kiemstedt line of research was taken up by Sven-Olof Lindquist. I cannot deny that it was I who introduced him to the theme at a seminar on geographic environment research for planning in 1968. Various reports from the Lindquist research project were published in a thematical issue of the journal *Plan* in 1973. The concepts and techniques of landscape description and landscape evaluation for open-air recreation were thoroughly discussed and improved. An experimental area, Skaraborgs län, was mapped to show the accessibility of its landscape in four dimensions: mental, economic, perceptive (visual), and physical. The first factor is illustrated by the cognitive (mental) map of the interviewed population sample, the second by a cost-distance zoning from urban areas, and the third by delimiting the "visibility" areas from a network of viewing points, while the last factor, physical accessibility, is a mapping of areas you may set foot in all the year round in zones next to roads.

In a second step, a series of variables were mapped describing the character of the landscape in relation to the demands raised by different activities. These, carefully selected from a number of possible variables, were: length of forest edges, shorelines, relative relief, brokenness of land surface, and percentage of arable land, all variables measured in a grid of 1 km² squares. The usefulness of landscape for different activities ranged from a *must*, a sine qua non, like shorelines for water-sports, via *better conditions*, to *"more attractive"* for skiing, walking etc. This inventory could be made by simple techniques on topographical maps and is thus well adapted to the needs of planners. This system of evaluation involves both *landscape character* and *landscape qualities*, inevitably necessary for any analysis of landscape. The fundamental methodological difficulties arise when selecting and measuring/evaluating the *landscape qualities*.

In principle two ways are possible — and both have been tried.
1. *Studying actual spatial behaviour*, i.e. seeing where people prefer to do what, and knowing basic *musts* for special kinds of recreative

activity, a catalogue of resource criteria may be established and presence/absence may be mapped. In some cases, scales of usefulness may even be established.

Fundamental difficulties arise when one leaves specific sports and looks at the general "recreative use" of landscape which is basic for the "feeling for landscape". Duffield and Owen, in publications from the Department of Geography, University of Edinburgh, tried to operationalize the concept of "scenery" into a classification of "land-form landscapes" and "land-use landscapes" respectively. The quantification was based on a subjective ranking of the attractiveness of the different landscape types for "informal passive recreation". At the end the values were mapped in a square grid, each square with a measured total sum of "scenic resources". The mapping procedure itself is strictly objective.

From a methodological point of view, to base an objective mapping procedure on values derived from the subjective judgment of the investigator is naturally unsatisfactory. What is the relation between the sum of indices and the valuation of the landscape total? This is where geographers found perception psychologists indispensable partners for the second type of exploration.

2. *Asking people about their preferences and reactions.* Craik (in *Environmental Psychology.* Ed. by H. M. Proshansky *et al.* 1970) has formulated the methodological problems for this type of investigation (cited from Aldskogius):

1. What sample of population?
2. How to present "stimuli" (landscape) to the test population (in the field, pictures, just place-names)?
3. How to measure responses to stimuli? Ranking semantic scales, lists of attributes, free descriptions etc.
4. How to classify and measure the stimuli, the landscapes? Fundamentally this should be based on the reactions of the test population.

The methods have been very much elaborated and applied in architectural perception studies. When applied to evaluation of the extremely composite and ever-changing appearance of natural and cultural landscapes great difficulties arise. The reactions are as composite as landscape and as changeable.

Tests with landscape photos in systematic series as stimuli have given interesting results.

Shafer and others (in *Journal of Leisure Research* 1, 1969) classified the photo contents into 10 categories (vegetation, no vegetation, water, sky as foreground, middleground or background) described by 4 parameters, giving for each picture 40 values, to which were added another 6 values for variations in "tone". In a factor analysis this set of indices was reduced to 6 picture-describing variables, to be correlated to the test-population's ranking of the photos. The authors claimed to be able to predict preferences. But as has been pointed out, photos and nature are quite different things. It is very doubtful whether any "translation" of the results is possible.

In order to evaluate the relevance of the landscape-describing variables chosen for landscape inventory, Sven-Olof Lindquist made some pilot experiments with student groups. The test group was taken to a selected number of places and asked to register their valuation of the "scenic attraction" of the landscape with the help of a semantic scale of evaluating words.

It was obvious that the results represented reactions in a snapshot situation to a changeable environment. Even during the trip from one point to another a change in weather from sunshine to rain may wholly change the outcome.

Methods used in a study of recreational life in Oslo (Sorte, 1974) may give more useful results. The evaluation of landscapes and landscape features according to a given semantic scale was based on experience from many trips in all kinds of weather the year round. The test was based on vivid descriptions of situations and "things that may happen on a tour", or situations "that you meet".

The whole field of landscape perception as a basis for planning or as a means of explaining spatial behaviour is experimental. But the experiments have revealed more and more problems during efforts to eliminate the subjective dimension. For a geographer — and a planner — it is necessary that the relevant landscape description, however its categories are based, can be projected into a map, perception categories being clearly linked to landscape features or complexes.

Many behavioural geographers are definitely resigning themselves to the impossibility of ever finding ways of generalizing and trans-

ferring results from one environment and one population to another, or even from one point in time to another.

The main interest of investigators has been in the visual perception of landscape. This has a long tradition and is derived from the perception of paintings and methodologically influenced by architectural perception experiments. But as Hans Aldskogius has stressed, landscape influences us through all our senses and, I must add, through the accumulation of previous impressions that everybody carries with him.

Research into mental maps as well as into responses to natural hazards has also shown fundamental differences between populations of *"natives"* and populations of *immigrants* into an area.

Obviously the factor "landscape as seen" plays a very different role for the recreation experience of individuals.

Thus critical questions about methods and results in behavioural geography have been raised and have made its practitioners apt to be rather less self-assured. Crucial questions about the complex man-landscape relationships clearly cannot be solved by quantitative analysis and cause-and-effect models. Yet they are observed phenomena. The emotional impact of landscape on man cannot be ignored by geographers. On the contrary, people have become more aware of these phenomena, and this has even had political consequences. Attachment to the landscape "where I was born" is part of the anti-concentration, separatist and "green wave" movements affecting highly urbanized industrialized countries. The emotional attachment of human beings to places has proved strong enough to influence political and economic geography. It meets a basic need which, in certain circumstances, has subjective priority even over the evident economic interests of the group concerned.

There are, then, definite signs of a return among some geographers to holistic views and old concepts of "understanding" combined with "quality of life" concepts. Geographers are urged to deepen their insights into social patterns, local community life and cultural inheritance. Concepts of classical geography have been reconsidered by a geographer-philosopher like Anne Buttimer. The "feeling", emotional attachment, is again recognized as a reality, even if it is out of reach of our analytic tools.

154

Are we better equipped today than 50 years ago to master this field? Should the geographer leave it to the poet to describe the phenomenological aspects of life in a region? The unique experiment of a geographer and an author both in lifelong direct contact with the area and people studied and described may show a way of solving the methodological problem. I am thinking of the fine description of a small fishermen's community in the Åland archipelago, Simskäla, in a recent book by the geographer Stig Jaatinen and a fisherman's wife Anni Blomqvist, known as the author of successful TV plays (*Simskäla. En skildring av en åländsk utskärsbygd.* 1978).

Discussion

Hemming Virgin believed that the physical surroundings, the landscape in which people live must have some sort of effect on their behaviour and way of thinking, and that in this sense the much debated term *national character* could be said to have some meaning.

Staffan Helmfrid: Certainly attachment to the place where one was born is a very strong factor in one's life. This can be seen to be reflected in all manner of separatist movements, and also in the struggle which the Swedish immigrants to America had with their nostalgia. But there is no need to use the term *national character* — instead you can speak of group traditions, group preferences and so on.

K. G. Izikowitz: You spoke about *understanding* a landscape. This understanding depends on what kind of information you get from the landscape, and that, in turn, depends on what questions you are asking. Eventually this will be determined by your general view of the world and on your previous experience, especially if you were born in that landscape. The understanding may be of an emotional character, but it could also be a scientific one. We may analyze its elements, but we must assemble them into a totality and look at the relations between them in order to grasp the wholeness. Furthermore, our view should not be a static one, but one which takes account of all the changes. If I may take myself as an example, I grew up among the bogs and swampy areas in the Swedish province of Småland. This summer I returned to my native region to look at these bogs. I found them quite changed, intersected by new roads which had destroyed

the whole landscape. I could not find the old plants which I used to know, the dwarf birches which I used to see there. In my youth there were no human beings there at all. Geographers often seem to forget that sometimes a certain kind of landscape, such as a bog, can impede human activity.

Staffan Helmfrid: I entirely agree. You may remember what Linnaeus wrote about his return to the place where he was born. He also found it very much changed and never wanted to come back again.

Östen Sjöstrand: I have listened with very great interest to Professor Helmfrid's lecture and must confess I did not know that geographers are now working in this very wide cultural context. When I heard Mr. Adams and Mr. Blythe give their very sensitive descriptions of different parts of England, I thought that in Sweden we seem to have lost a tradition of writing which we used to have in this country. Around the turn of the century we had writers, most of them living in the province of Skåne, men such as Hans Larsson, who really knew the landscape and were also able to describe it. Perhaps part of the explanation was the proximity to Denmark, where there has always been this kind of tradition.

Mr. Blythe mentioned Norman Nicholson, a poet who has interested me a great deal. As a matter of fact he writes in exactly the way you were telling us about. He sees the landscape in different perspectives, not only perceiving immediately with his senses, but getting deeper and deeper into e. g. the geological aspects and the way people live, their traditions and background. There are other examples, of course, such as Auden speaking in praise of limestone, or Harry Martinson about whom Professor Hallberg spoke yesterday.

Carl-Axel Moberg: I was very glad to hear Mr. Sjöstrand mention Denmark, because I believe that, for instance, the influence of Johannes V. Jensen on this kind of writing and thinking has been enormous and has penetrated into Sweden as well, as may be seen in the case of Harry Martinson.

To me the most important point in this very interesting lecture was the account of the attempt at finding an objective way of working with these questions in modern geography. I just want to emphasize the enormous complexity of feedback which has to be taken into

account here. To what extent can you geographers yourselves keep free from feedback from quite different fields? There is an old tradition of cooperation between archaeology and geography in landscape studies. As an interesting case in point I might mention the name of Karl Alfred Gustawsson. In the first half of this century he created special areas run by the Swedish National Office of Antiquities, which were modelled after quite definite ideas of landscape and which have evidently had a great influence on value scales in landscapes in this country today. It is always said that this development was scientifically based. This was true to a certain extent — for example, botanical studies in the beginning of this century in Sweden influenced the choice of landscape to be built (for they really *built* landscapes in Sweden, sort of national parks). But on the other hand, can we deny that they were also influenced by painters and writers around 1900 who in their turn had close contacts with the so-called Homestead Movement ('hembygdsrörelsen') in Sweden — a rather anti-intellectual movement in fact?

This influence of painting and literature on administrative agencies, creating and recreating old landscapes, also has links to politics. I think it may be linked with conflicting views based on stability or change. Some people prefer stability for political or economic reasons, others prefer change. In this case I think it was a tendency towards having stability in the landscape that was being expressed.

I should like to conclude by mentioning the tree that occupied a key position in this entire movement: the spruce. The people who built these antiquarian landscapes hated the spruce. One of the main reasons was that they were also responsible for the care of prehistoric monuments, which are very effectively destroyed by the roots of the spruce. Therefore the spruce was banned from any area where there was anything antique whatsoever to be seen. This is just one instance of the very complex network of feedback which should not be overlooked in this context.

Staffan Helmfrid: I think the aspects you have just brought up are very important indeed. No landscape analysis can afford to neglect the study of ideas which change in the course of time, the humanistic aspect of geographical research.

Richard Adams: While listening to Professor Helmfrid's talk I found myself preoccupied with the very interesting question of the inadvertency of what we so often do to our environment and landscape. I was wondering whether the long-term effects are predictable at all. I should like to illustrate what I mean by referring to the case of the British Isles. In the Middle Ages this was a fissured and divided country, because in those days of very poor communications different areas of the country were much closer to parts of Europe than to the central authority. Much the easiest and quickest means of communication was by sea. For example, the Newcastle-upon-Tyne Valley was very close to Norway, it was not close to London. Kent and Sussex on the south-east coast of England were very close to Holland, they were not particularly close to London. Cornwall of course was miles away from London, but it was very close to Brittany. All through the British Isles you get these very interesting intermixtures of art, place-names, folklore, all of which have affinities with the closest point on the European continent rather than with any sort of central authority. The attempts of the English medieval kings to centralize the country failed very largely because of the hopelessness of communications and the lack of any real centralizing power. The effect of this geographical set-up was to turn the English into a very seafaring people. The development of a powerful and effective navy culminated in the battle of Trafalgar, giving the British virtually total world sea power. But during the 19th century the attention of the British began to be turned inwards. Roads began to be built, important bridges were made, the railway came along. The geographical energies of the country were turned inward upon itself, and almost without the British knowing it their sea power began, inside the woodwork as it were, to decline to the extent that by the time of the battle of Jutland in 1915 it was already obsolete. I suggest that this was very largely due, in a paradoxical, humorous and perhaps rather ridiculous way, to the turning of the country's geographical mental energies in upon itself to solve the problem that the medieval kings longed to see solved. In developing the country, however, we actually destroyed its traditional geographical characteristics.

In fact, as Ophelia remarks in *Hamlet*, 'Lord, we know what we are, but know not what we may become.' The long-term results of our geographical efforts with our environment are often quite unpredict-

able, and whether we are ever likely to be able to predict them accurately and entirely we do not know.

Ronald Blythe: In about 1818 a little book was published called *The Climate of London*, which was loved by Goethe and by Shelley, but particularly by John Constable. A recent critic of John Constable's has said that his painting 'The Hay Wain' is the ideal landscape of every English mind. I live near the site of this painting, and all through the summer months for many years since my boyhood I have seen crowds of Englishmen trying to get into this picture. They come in buses and on foot and on bicycles, hundreds and hundreds, destroying the picture, naturally. They don't go into Turners, they don't go into Richard Wilsons, they don't go into other pictures — they get into *this* picture if they possibly can. And they try to create this "landscape of every English mind" in the countryside around them. But because of modern suburbanized conditions, they also bring with them the need to have a car, the need to have good roads, the need to get to supermarkets. The result is that every village now all around me in Suffolk and Norfolk and in many other parts of Britain is a little bit of the Constable-scape recreated with the right kind of plants and trees and the right attitudes and the right dreams, but at the same time with the carport, with the pylons going over, with the motorways. Every time people want the things which most people do have to have these days, they are fought against by the people who want to have the Constable too.

And so we, the English (I don't know about the Welsh and the Scots) are really the victim of our cult of the landscape which Constable produced for us, and simultaneously of our need to live in the modern world; and so our politics, locally as well as nationally, are in conflict the whole time.

NATURE IN MODERN EUROPEAN PAINTING
FROM THE ROMANTIC PERIOD TO THE PRESENT

By Jiří Kotalík

The topic of my paper is so broad that it would require a whole book. In fact, a whole series of books have been written on this subject, setting out to trace the systematic interest in landscape shown in European painting, beginning with the Renaissance (parallel in Flemish and Italian painting) and including the vital contribution of the Dutch and the French in the seventeenth century, right down to the mighty spread of landscape painting in the course of the nineteenth and in part also the twentieth century.

What I am concerned with is only a brief outline of some essential stages in the fashioning of *Man's relation to the landscape,* providing for the continuity of modern art as it followed up Romanticism, Impressionism and the basic trends of the twentieth century. At the same time, I am concerned with the question of what has survived of all this, and what it is that still leaves such an impact upon the consciousness and sensibility of people in our own days.

I

There can be no doubt that *Romanticism* in its complex ideology and breadth of expression meant the starting point at which *landscape painting* as a topic in itself ceased to be limited to the description of a specific, concrete piece of scenery, and broadened out into an all-round experience of *Nature* in its totality and boundlessness.

Priority in this respect, as is well known, goes to the English painters of the first third of the nineteenth century, who in persons like John Constable understood and expressed the very matter of rocks and trees, the stirring of the leaves, the undulating of grass, the dampness of the water and the gusts of wind, in vibrations of light and air. In this concept of the picture, *Man remains an independent observer* with a refined sensibility gazing upon the landscape and its changing moods.

In the case of Turner, and especially in his later works, the picture of the landscape is transposed into a fairy-tale vision of shining light, stormy waters, a shimmering atmosphere, which turns into an exalted metaphor of the forces of Nature determining cosmic events. In that concept of the picture *Man is felt to be an integral part of Nature* and entirely subjected to its dynamic forces.

The fact that it was English painting that left such a decisive and unexpected mark on the development of European painting is strikingly explained by similarly profound experiences of Nature in poetry: in the inner pathos of Wordsworth's verses, in the works of that "poet hidden in the light of thought", Shelley, or in the crystal-clear images of Nature in the writings of Keats, where we can find relationships in significance and expression to many oil and water-colour paintings.

There can be little doubt that this concentrated interest in Nature was partly brought forth by the onset of the Industrial Revolution and forebodings about its possible consequences, forebodings later repeated frankly though vainly almost in the manner of sermons by Ruskin and the Pre-Raphaelite Brotherhood.

The subsequent and concurrent trend of systematic interest in the landscape began to crystallize in French art; especially in the pictures of Corot who, from concrete and restrained, thickly and smoothly painted views of Italy, gradually advanced to his quiet, delectable scenes, reduced to a melodic scale of silver and grey, olive green and soft blues. In that concept of the picture, *Man entered into a dialogue with Nature as a subject in its own right*, changing in the imagination all the commonplace nooks of Nature into poetic scenes and events.

Mention needs to be made, too, of the obvious connection between the painter's vision and the experiences of French poetry and prose in the Romantic period, which in its culminating forms evoked the scenery of Nature in direct resonance to human emotions and ideas, as we see from Chateaubriand to Alfred de Musset.

And finally, in German art we encounter the personality of C. D. Friedrich, whose pictures became a vision of moonlit nights, the silent waters of the North Sea, the loneliness of mountain peaks; here reality is enveloped in dream and turned into enigmatic symbols. In this basically metaphysical concept, *Man remains outside Nature,*

which is strange and even horrifying to him, as he stands dazed and enraptured by its immensity and mystery.

It is natural that in these pictures we often find reminiscences of the verses of Novalis and Hölderlin, or of the involuntary resemblances to pictures of Nature found in the music of Beethoven, Weber or Schubert — a reaffirmation of the close inner links between all the arts.

What is particularly typical is that already under Romanticism there developed an entirely different attitude on the part of *Man as observer of Nature, as an integral part of the universe, a subject projecting his poetical images into the landscape, an exile outside Nature* abandoned in its inexplicability; we can find these attitudes identically or in differing variations in the further periods of art right down to the twentieth century.

C. D. Friedrich often painted on the ridges of the Giant Mountains in Bohemia and among the volcanic outcrops of the Czech Středohoří mountains. His message found a response, one or two decades later, on the other side of the mountains, from the greatest poet in the Czech language, K. H. Mácha. In his poem "May" the most delightful verses contain an evocation of Nature, whose immensity becomes humanized in the enjoyment of participation:

> Where you pass from me on your long, wide way
> To the distant shore, there for a moment stay,
> There, pilgrim clouds, greet reverently the earth.
> Ah, well-beloved earth, beautiful earth,
> My cradle and grave, the womb that gave me birth,
> My sweet, sole land, left to my spirit's keeping,
> Ah, vast and single of beauty as of worth.
>
> (1836)
> (Translation by Edith Pargeter)

This is a confirmation of the fact that in the Romantic period similar experiences found similar forms of expression among painters, poets and musicians in the various corners of Europe. This can be further demonstrated by the remarkable pictures of Russian nature and the Caucasian mountains in the poetry of Pushkin and Lermontov and in the real views and poetical visions in the verses of Adam Mickiewicz and Juljusz Słowacki.

This similarity of view and expression is particularly maintained in the trend of Realism after the middle of the nineteenth century, in the grandiose and materialistic approach to Nature on the part of Courbet in his pictures of the Ornans rocks, dark forests and the stormy ocean; or in the works of François Millet depicting the countryside around Barbizon in emotional colours. Again one can observe elsewhere how the intense appreciation of the Russian landscape in prose works from Tolstoy and Turgenev to Chekhov found its parallel in painting, ranging from the concrete views of I. Shishkin to the poetical and melancholic pictures of I. I. Levitan; or how the attitude to the landscape became more profound in the works of Hungarian painters like László Paál and Szinyei Merse, approaching sensually fresh and brightly coloured expression.

II

The period of *Impressionism* was the second decisive stage in the creation of Man's attitude to Nature; its significance must be seen not only in the formal achievements in the painters' reassessment of light and the atmosphere, in the revolutionary concept of colour, the loosened brushwork and the isolated dots of paint. The major contribution of the group of French Impressionists should be seen in its noetic scope; in the common work but differentiated approach and setting they reached a comprehensive view of Nature, in which the intellectual and the sensual, the emotional and the imaginative became integrated.

Again, starting points differed: take the objective and impartial observation of Bazille and Pissarro, the poetical resonances of Renoir and Sisley, the cold feeling of Man's alienation from Nature in the works of Degas (in whose pictures, mainly taken from the life of the big towns, the landscape forms but an occasional background). The endeavours of the Impressionists found their most characteristic expression in the work of Monet, who, from an original impression of light and colour via an exact record of moods of the fleeting moment, advanced to the giddy image of the cosmic unity of Man and Nature expressed on many an occasion in the verses of Verlaine and the music of Debussy.

In Impressionism, too, which, as time passed, spread to all the countries of Europe, there continued to be a general awareness of the

identical problems involved in the various tasks of the period, culminating in the self-satisfaction of the first phase of the Industrial Revolution; and again greater stress began to be laid on Nature's phenomena. That becomes clear from the interesting variations of Impressionism in German, Dutch, Belgian, Italian, Russian, Czech, Yugoslav, Polish, and Roumanian painting; or in the original world of the first stormy pictures and later painful drawings of Carl Hill and in the pointedly expressed impressions of August Strindberg. In fact, in Swedish painting of the past, ranging from the Romantic sceneries of Marcus Larson to the real views of Bruno Liljefors, the enjoyment of Nature always played a significant role.

Among the creators of Impressionism and those who went beyond it there appeared the duality which the verses of Baudelaire found either in the traditional interpretation marked by Romanticism:

> La Nature est un temple où de vivants piliers
> Laissent parfois sortir de confuses paroles;
> L'homme y passe à travers des forêts de symboles
> Qui l'observent avec des regards familiers.
>
> ("Correspondances")

or in the discovery of the "town landscape", whose scenery he evokes in the part called "Tableaux parisiens" in his *Fleurs du mal*:

> Je verrai l'atelier qui chante et qui bavarde;
> Les tuyaux, les clochers, ces mâts de la cité,
> Et les grands ciels qui font rêver d'éternité.
>
> ("Paysage")

In the work of Cézanne these two elements merge in a remarkable unity of the material and the spiritual approach, involving motives of mountains and forests, hillsides and water as well as the cubes of human habitation and the terse forms of objects of everyday life. I think that the monism of his thought and art, which encompasses the tension of dialectical contradiction and therefore opens up possibilities of developmental motion, forms one of the most permanent and pioneering achievements of modern art.

At the same time in the pictures of Gauguin, in their firm structure of stressed lines and rich colours, there emerges a symbolic vision of the fate of Man bound up with archetypally conceived motives of the landscape. In the last works of van Gogh the drama of

Fig. 1. Vincent van Gogh (1853—1890): *Green Corn*. 1889—90. Oil on canvas, 73,5 x 92,5 cm. National Gallery of Prague.

subjective fear and anxiety became projected into the sunlit nature of the south of France. In a similar sense, the balladic landscape of fjords and woods in Norway in the pictures of Edvard Munch, especially in his cycle of the "Frieze of Life", became a means whereby to express the artist's innermost dreams and visions. The landscapes in Henri Rousseau's pictures are a magic symbiosis of strictly seen reality and poetical fantasy.

The road to the twentieth century was fully opened up by these innovations: Fauvism among the French and Expressionism in Germany and their variations in other countries of Europe organically continued in the creation of Man's subjective attitude to Nature. In the works of Matisse there is the idea of relaxed ease in conformity with the titles of individual pictures: "Joie de vivre", "Lux, calme

et volupté". The paintings of Emil Nolde reveal a stormy and dramatic vision of Nature; Franz Marc has a pantheistic experience of Nature in the rhythmical painted coexistence of vegetation and fauna. This is equally true of the young generation of Czech artists, who came on the scene in the years 1907 to 1908, and who made Edvard Munch their John the Baptist.

In the struggle of European painting on the eve of the First World War (in works whose revolutionary approach and intensity, I believe, remain valid and have not been superseded), the picture of Nature does not lose any of its structural stimulus and significance for further development. The début of Cubism in the years 1907 to 1908 was determined by the presence of several intermingled sources and stimuli, among which an important role as catalyser was played by the denuded landscape at Horta del Ebro in the pictures of Picasso, or the mighty rocks and tree trunks near Marseilles in Braque's paintings.

It is characteristic, too, that the birth of abstract art in the years 1910 to 1913 was in surprising concord derived by each individual protagonist from direct impulses and originally applied experiences of Nature. In Kandinsky we see this in the free rhythm of the smooth line and resounding colours, which moved away from the expressively cast and loosely designed landscapes at Murnau. In the case of Mondrian we have the strict order of a right-angled network of squares and rectangles; here the shapes of the natural objects, especially tree trunks and boughs, became fused with the image of the flat and geometrical landscape of Holland. In the work of František Kupka we have the visionary merger of organic growth and inorganic structures into a homogeneous image of the universe. The clear point of departure from Symbolism and the reminiscences of Art Nouveau — not unrelated to the setting of Czech culture — make one think of the verses of the painter's contemporary Otakar Březina, who presented a similar contamination of motives and forms at the turn of the century, and whose basic sensual concreteness was transposed on to an abstract plane:

> Our dreams were merged in a single dreaming and myriad
> trees of a single forest rustled,
> When by their tremor the boughs one to the other give
> tidings of a single wind from unknown oceans.

166

Upon our meadows lay fragrance of all blossoms, sweetened
 into a single welded accord,
And radiance from our souls, fused into a single flaring,
 they invisibly garbed with colours
And by the voice of all our united wishes in marvellous
 gardens powers blossomed unto us.

<div align="center">("The Brotherhood of Believers", in Polar Winds, 1897)</div>

<div align="center">(Translation by Paul Selver)</div>

<div align="center">III</div>

In the development of art between the two wars, a period of conflict-
ing views, when trends of artistic work appeared in rapid alternation,
the inspiration of Nature was not one of the topical problems. In-
toxicated with technical civilization, Man at first rejected the theme
of the landscape as allegedly a conservative remnant of the art of the
past; at a time when Fascism threatened up to the middle of the thir-
ties, culture turned to real or symbolical pictures with a strong hu-
manist accent.

And yet, out of the experiences of landscape scenery there grew
important and lasting works in all spheres of art. The precipice of
cliffs in the bare landscape of the carst near Trieste inspired Rilke to
his *Duino Elegies* and the bitter recognition

dass wir nicht sehr verlässlich zu Haus sind
in der gedeuteten Welt. Es bleibt uns vielleicht
irgendein Baum an dem Abhang, dass wir ihn täglich
wiedersähen . . .

<div align="right">("First Elegy")</div>

In those verses we can find a fitting definition of the meaning of
painting in its specific relation to the realities of the visible world:

. . . Sind wir viellicht hier, um zu sagen: Haus,
Brücke, Brunnen, Tor, Krug, Obstbaum, Fenster, —
höchstens: Säule, Turm . . . aber zu sagen, verstehs,
o zu sagen so, wie selber die Dinge niemals
innig meinten zu sein . . .

<div align="right">("Ninth Elegy")</div>

(It seems to me that it would be hardly possible to give a better and
more profound explanation of the significance of the legacy of Cé-
zanne, permanently present in the art of the twentieth century.)

For his gloomy similes of the fate of the modern world T. S. Eliot turned to picture with a nature motive, as shown in his *Waste Land*, where the image of parched barren Nature expecting life-giving moisture forms the very core of the impressive poem; the same is true of others of his poems, among them the cycle entitled "Landscapes".

The nature of the native village in the vicinity of Rjazan continued to inspire the robust imagination and the melodious tune of the verses of Sergey Yesenin, who used traditional pictures of fields and forests comprehended with the sensibility of modern Man and pure, intimate experiences to express the pathos of the march of time. The mighty realm of Nature, understood in its entirety and with a precise knowledge of details, yet profuse with human participation, determined, in the early stage of the building of Socialism, an important current in the development of Soviet prose, as shown by the work of Mikhail Prishvin among others.

In the rich and complex panorama of painting, too, landscape painting was likewise allotted a subsidiary place; but it did not vanish from the horizon of creative interest, and over and over again Man's differing attitudes to Nature made their appearance.

For a long time the work of Bonnard was not fully appreciated, being taken as a later outcrop of Impressionism; yet he used his sovereignly fine fabric of brushwork and magic reflection of colours to express in profound manner the inner drama hidden behind the veil of daily life. In that sense he also emphasized the landscape as a simile of events in the universe.

Kokoschka has been defending convincingly the principle of a subjective interpretation of objective reality. Similarly Dunoyer de Segonzac stressed the truth of Nature; in his pictures the optic and the tactile experience of landscape scenery achieved a balance. The same is true of a number of other painters deriving their structural solutions from the nature of the landscape in which they happen to live.

Carlo Carrà and Giorgio Morandi took theirs from the striking plasticity of the landscape and towns of northern Italy; Martiros Sarian from the brilliant colours of Armenian nature. In the circle of Flemish Expressionism, Constant Permeke showed an inward relation to the robust objects of the countryside. The Czech painter

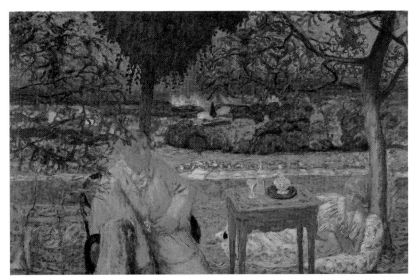

Fig. 2. Pierre Bonnard (1867—1947): *Conversation in Provence (In the Garden)*. 1912. Oil on canvas, 129,5 x 202 cm. National Gallery of Prague.

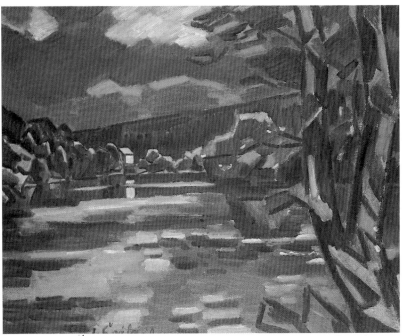

Fig. 3. Václav Špála (1885—1946): *River Otava before a Storm (Mill on the River Otava)*. 1929. Oil on canvas, 82 x 101 cm. National Gallery of Praque.

Václav Špála expressed the lyrical rhythm of the forest-clad land-scape on the banks of rivers in summer-time. His fellow countryman Václav Rabas depicted in a striking way the face of hills and plains as they were formed by hard human toil over generations.

The frequent poetical expression of phenomena and events in Nature helped to determine the work of other important and original artists. The novel shapes in the pictures of Graham Sutherland expressed organic forms in the vegetative world of Nature. Josef Síma, a Czech who settled permanently in Paris, changed his pictures of the landscape into painted poems composed of the solid matter of the terrain, vibrating clusters of trees and the fragile tissue of light.

The real stimulus of Nature can likewise be distinguished in the sphere of the imagination. This is clear in part of the work of Paul Klee, who gave landscape motives the rhythm of visual poems. In the circle of Surrealism we can find visionary hallucinations of miraculous virgin forests and zoomorphic vegetation in the pictures of Max Ernst, where the dream prevails as a newly developed legacy of Romanticism. Strange and deformed strips of landscape magnify the obsessed vision of Salvador Dali — in certain respects an involuntory prefiguration of the world shattered by catastrophe caused not by Nature but by Man.

And to what extent the experience of Nature enabled the painter to encompass the whole range of human pain and anxiety can be convincingly shown in the pictures of Chaim Soutine, a refugee of the stormy age of force and hatred.

IV

The years of the Second World War meant a break in the social and political history of the world, and also marked the borderline of a new epoch in the development of culture. In his attitude to Nature, Man broadened his rule and enhanced his knowledge by penetrating into the core of matter and into space. The development of technology made it possible for him to undertake immense changes in the landscape according to economic considerations and ideological conceptions. Hand in hand with this went the problem of the inter-disciplinary development of scientific research in the sphere of ecology and the environment.

Modern architecture, too, undertook a concentrated and considered search for a balance between Nature and human dwellings in grandiose town-planning schemes; in this respect, it is Sweden in particular that can pride itself on important and exemplary achievements in the construction of new residential quarters and housing developments.

In works on aesthetics there appeared frequent discussions about "another art", said to have settled accounts with the traditions of the past. In painting we have become witnesses to the creation, in breadth and width, of contrasting views. Contrary to developmental logic, which formerly determined the gradual treatment of problems, these novel ideals and means are being applied in sudden jumps or explosions.

In the initial domination of abstract art certain trends tried *a priori* to exclude any basic relation with the realities of the world. This was the case in "op art", in its consistent reduction to optical values or a geometrical order; and similarly so in the share of technology in kinetic art and in experiences of how to use computers in artistic work.

On the other hand, in the field of abstract painting which concentrated on expressing or indicating subjective attitudes Nature retained its validity; but not in any descriptive depiction, but in comparisons of energy and creativeness, biological vitality and growth. This is confirmed by pictures made by painters who belong to the sphere of gestural painting, known as Tachism or Action Painting, where expression is often directly inspired by experiences in Nature. To pick a few random samples we might mention Jean Bazaine, Alfred Manessier and Giuseppe Santomaso. In the sphere of structural painting, where the significance and expression of the picture became concentrated in the dramatic brushwork of layers of coloured paint, a striking example is the work of Jean Dubuffet, who has always stood on the borderline of figurative work.

In the sixties, the renewed entry of reality which upset the hegemony of abstract painting is linked with the expression of the environment of urban civilization in the broad and varied current of "pop art", to which the artists of the United States contributed in significant measure. In the complex picture of the modern world as to significance and expression, and in the amalgamation of shapes

171

Fig. 4. Josef Šíma (1891—1971): *Landscape, 1930*. Oil on canvas, 80 x 130 cm. National Gallery of Prague.

and colours, inscriptions and readymade things with a sub-text of irony approaching absurdity, they remind one only too frequently of the realm of Nature and the changes inflicted by civilization (e. g. some pictures by Robert Rauschenberg or the graphic sheets of Andy Warhol, one of the creators of the New Sensibility).

Similarly, we have the other trends of recent years, e.g. what is known as Conceptualism, consisting of mere suggestions of creative intents in sketches or graphs, photographic records, the imaginary projection of ideas into the world of reality, where Nature appears indirectly or directly. This is no different in the case of Hyper-Realism, which picks out a sector of the visual world with great concentration on concrete details.

But it is not my intention to comment on the panorama of contemporary art. I only wanted to recall that the world of Nature as comprehended generally in its totality and in concrete forms continues to live in the consciousness of painters of the present time, that Man's attitude to Nature constantly appears and in no different form than it did in the period of Romanticism or Impressionism or on the threshold of the twentieth century (though, of course, from a

172

different angle of view and with changing media of expression). This attitude shows either in the objective view of reality of the landscape or in its identification with the cosmic unity of the world, and frequently likewise in the poetical expression of natural phenomena and events; more than once in metaphysical giddiness resulting from a feeling of disinheritance and the unknowable.

There are painters who seek the sense of their work in a search for a balance between the subjective experience and the objective interpretation of Nature. The work of the prematurely deceased Nicolas de Staël takes a most important place in this trend.

Painting with a consistent figurative orientation similarly survives and is developing in certain currents of contemporary art, as becomes clear when we examine the circle of Italian Neo-Realism in, for example, the pictures of Renato Guttuso, who often turns back to the landscape of his native Sicily.

In all corners of Europe we can today find mature artists who have passed through the dynamic development of modern art from the late thirties to the present time, and who see the meaning of their work in Man's complex relations to the world, determined in equal measure by the complex machinery of civilization and by living Nature. Such a synthesis can be found in the pictures of Endre Nemes, who in his youth experienced the atmosphere of the cultural life of Prague and who for years has been among the leading figures in Swedish art.

In the painting in my own country, too, we can find a tradition of long-standing interest in Nature, which corresponds to the lyrical accents in Czech culture. This tradition found its most convincing expression in music, where pictures of the landscape have always played an important role, dating back to Bedřich Smetana and Antonín Dvořák and leading to Leoš Janáček and Bohuslav Martinů.

Among the mature artists of the present time I can cite Ludovít Fulla, whose work is a transposition of the basic images of folk art in Slovakia, or Ester Simerová, whose pictures are artistic metaphors of Nature enhanced by the sensibility of modern Man. It is no mere chance that some of her work has direct reference to the verse of Saint-John Perse.

In landscape painting with a fullness of sensual and emotional comprehension lies the core of the work of Bohumír Dvorský and František Jiroudek; poetical landscapes of the modern age, city sub-

urbs and sportsgrounds, arise from the oils and drawings of Kamil Lhoták. Among the younger generation Josef Jíra often turns to the expressively presented picture of the landscape pulsating with emotional agitation. The prematurely deceased Jiří John managed to express the poetical symbolism of the landscape suggestively on pictures and graphic sheets. In our own days Jan Smetana, in particular, has worked his way through to pictures that are an all-encompassing expression of experiences of Nature in its totality, its organic and inorganic phenomena and events.

In conclusion, allow me to express my conviction that at the present time, when the landscapes of different parts of Europe are undergoing enormous and far-reaching changes and are being put to the service of Man but, in certain cases, also being inconsiderately and inevitably destroyed, the interest of modern painting in an all-embracing or concrete picture of Nature is no outmoded hobby or sign of infertile conservatism. It is not a matter of an external depiction but of an inner appreciation, which opens up possibilities of stimuli and development, and, at the same time, is an inner core of modern culture, essential for its further growth.

For painting is not only an aesthetic matter or a game nor an exclusive means of subjective self-expression; it has a noetic aspect and a social meaning in helping to find and interpret Man's destiny in the world, and it can often do so more effectively than other branches of culture. It can, therefore, anticipate and confirm the desirable balance and harmony of Man in his attitude to the civilization which he himself has created; and it can express Man's attitude to Nature, to whose laws he must subject himself.

GENERAL DISCUSSION
ON 'THE FEELING FOR NATURE AND THE
LANDSCAPE OF MAN'

Chairman: Erik Lönnroth

Erik Lönnroth:

We have come to the last session of this symposium. the general discussion on 'The Feeling for Nature and the Landscape of Man'. As a matter of fact we are faced with an *embarras de richesse* of viewpoints after listening to all the lectures that have preceded this discussion: the sensitive interpretations of inherited landscapes by Mr. Blythe and Mr. Adams, the abstract interpretation of a landscape by M. Simon, the sharp and learned analysis of the linguistic expressions by Professor Schützeichel, the historical surveys of landscape gardening and painting by Professors Karling and Kotalík, the geographical viewpoints given us by Professor Helmfrid, the literary expositions by Professors Hallberg and Pomeau, the 'hidden music' conception of nature presented by Mr. Sjöstrand, and the comprehensive survey given by Mr. Soloukhin from the Soviet part of the world, which showed us in such an illuminating way how the basic problems of reconciling nature and technology are the same as in the West.

I should like you to take up the general and central theme in all this: what are we going to do in the future? How are we to preserve the values which we all love and which we have tried to interpret here? Which values are we to fight for, and which have to be exchanged for others in human life?

Richard Adams:

What I find depressing in the history of the Western world during the last 100—150 years is the growing emphasis on material prosperity. This is of course in many ways an excellent thing: nobody would deny that to be able to live longer, to be free from serious diseases, to destroy the appalling rate of infant mortality that obtained throughout human history, and well on into the 19th century —

these are great conquests and achievements. As always, however, the solution of some great problem like mortality has had its negative side. We are now suffering from very serious overpopulation, which in itself is liable to lead to war and conflict.

What troubles me particularly is the enormous extent to which the resources of this planet are being destroyed by overuse. I don't know how long the coal or the oil will last - I am not qualified to speak on these things. But smaller things occur to me, such as that people have had to be stopped going through the cave paintings at Altamira, simply because the effect of the breath of thousands and thousands of people altering the humidity and the temperature of the cave is beginning literally to soak the paintings off the wall. Not long ago, in England, people had to be stopped going round Ludlow Castle, a beautiful example of an early castle, because it was being destroyed by the impact of more human feet in a single year than can possibly have walked over its stones in the whole of its previous history.

It occurs to me that in exactly the same way as we look back now on the 18th or the 17th century and think, 'Did they *really* go to Africa and put black people in chains and take them across the Atlantic and sell them, and pitch half of them overboard because they died on the way? How *could* they do it?', or we look back on the 19th century and think, 'Did they *really* send little boys up to clean chimneys, and a lot of them suffocated, and did they *really* have children working 14 or 16 hours a day in factories? How *could* they do it?' — in the same way it would not be surprising if in 100 or 200 years they looked back on this century and thought, 'Did they *really* exhaust all the oil and all the coal and all the copper and all the tungsten and all the timber and just use it up and throw it away, so that we haven't got any now? How could they do it? It seems so incredibly shortsighted and foolish!'

I would not be surprised if in about 200 or 300 years' time the majority of the world's material resources had been expended, so that human energies turned away from materialism *faute de mieux* and the human spirit began concentrating more on intellectual and spiritual matters, as it did in the 13th century, or in ancient Greece in the 5th century B.C. A Marxist would say (and I am not sure he would not be right) that the ancient Greeks achieved their extraordinary flights of the spirit, of the arts, of poetry, drama and sculpture,

largely because they simply hadn't got the means to produce material luxury. The Romans had rather more in that line, with the result that their energies were turned more in that direction. The human spirit feeds upon whatever there is to feed upon. If you know that you cannot afford a yacht or a Mercedes, you don't crave for either. But if you suddenly find that a Mercedes is within you grasp, you become positively rapacious for a Mercedes. This is rather the situation wherein today a tremendous improvement of material standards of living is within the reach of amost everybody, and therefore everybody wants it to an extent that they didn't before. This seems to me to be the kind of problem that is facing us at the moment. We are destroying the environment because the potential to do it, the capacity to get something out of it is within our grasp as it never was before.

I don't know the answer to this any more than anybody else does, but this is a line of discussion that I would be very interested to see taken up and pursued by somebody else.

Östen Sjöstrand:

The various aspects of the feeling for nature and the landscape of man that we have been discussing here constitute fundamentally an epistemological question. I recall the well-known words of Oscar Wilde that nature imitates art. That is true not only of painting but of literature and music as well. I have pondered a great deal on the question of whether or not there may be some structural resemblance among the various arts, particularly between music and literature. It is of course very difficult to define such a structural resemblance, but I think there may be one, and that it may be worth trying to find its true character.

The nature that we want to preserve and save is essentially a living tradition, a living substance, something that we feel to be part of ourselves. As a matter of fact it has to do with our mental health. I think there is a very profound connection between words, poetry, literature on the one hand and mental health on the other. I believe that words and language are very deeply related to mental health — describing and verbalizing what we feel, the pains in our lives, the new possibilities opening up, the new opportunities, spiritual avenues . . . But this may also include nature. I am thinking of what M. Simon told ut about realism, or the so-called realism, for of course there

is always a choice. It does not matter if it is a novel written by Bal-zac or by Proust — however minute the observation is, there is never-theless always a choice, *un choix*. Most of what we have inside our-selves or in the outer world surrounding us is still there and is, in the last instance, inexpressible. By intuition we may perhaps get into contact with it, but most of it stays in these unknown depths of our-selves.

I think that the description of nature and our dependence on nature have to do very much with these hidden depths — what I call the 'hid-den music' in ourselves. When we very spontaneously describe a scene or a landscape which has an emotional impact on us, we are perhaps giving voice to something which may be quite inexpressible in any other way. This is really why I feel the loss of a tradition in Swedish literature comparable to the English one, a tradition in which both Mr. Adams and Mr. Blythe are working.

I believe that we should be looking for more than an outward, geographical description of nature when we engage in this new ad-venture of finding nature in all its aspects. If we are able to cooperate this may also mean new ways of communication and new ways of discovering the hidden depths in ourselves.

Hemming Virgin:

The word 'nature' is being used a great deal here. I should like to know more exactly what nature is actually taken to mean. We often talk about 'urban areas' and 'rural areas'. We all know what cities are, but apart from that? Practically all of the landscape we see around us in this country was formed by man, except for a few areas, par-ticularly in the north, where we do have the original land. In all other parts of Sweden man has transformed the original land into some-thing else. We have cultivated fields, meadows, forests, and so forth — all created by man. What would we like to have? What do we find most beautiful? To what kind of land would we like to go for our recreation? I don't think there can be just one answer to this question, for I am convinced that human ideas of what is beautiful etc. change considerably from one period to another. Nothing is static, every-thing is dynamic. I think it is very important, therefore, to ask our-selves: what do we mean by nature?

178

Staffan Helmfrid:

I fully agree with Professor Virgin. Landscape all over the world is created, changed or affected by man. Changes in landscape are brought about by changes in land use, and human land use is governed by economic rules, tradition, technical skill and everything that constitutes our civilization and culture. Each generation adores the landscape as it was when they were children, and as they grow old they feel nostalgia for the landscape where they were born, as it used to be before the changes that have taken place in their lifetime. But their children start from a later point in time and then look back to *their* childhood.

Thus the planners in Sweden, as in any other country, are faced with the problem of deciding what to preserve. Which and where are the values that we should take care of, and how much are we prepared to pay for keeping them? At what level of change should we freeze the development of our environment — for it is a matter of freezing, of taking a snapshot of an everlasting change.

It is interesting to note in the perspectives of time past and time future that the natural resources that we use have in fact grown from generation to generation, when seen from an economic point of view. Technology has solved problems of lack of resources and opened up new resources — in fact we are part of a civilization that has enjoyed growing resources for centuries. What is important to realize, however, is that there is one resource that is and will always be definitely limited, and that is the space of the surface of the earth. Nobody will want to spend his whole life on the moon in the future. The air surrounding the earth is absolutely limited too. In our context one of the most limited resources is historical monuments, as illustrated by the case of Ludlow Castle mentioned by Mr. Adams. Every historical monument is unique, and one of the great disasters affecting the historical landscape is mass tourism, which is made possible by mass transportation means. This will grow worse in the future, unless the cost of fuel should rise dramatically. What we have to do is to plan the course to be taken for the future, to find out how populations will grow, where the congested areas will be, and how we should design the human landscape. The European megalopolis must be planned today. Municipalities and counties are units which are too small for planning today. Even many states are, today, too small for planning

for the year 2000. Geographers and others have been very much concerned about the future of European urbanization and landscape: the congestion of urban areas, traffic and things like that, which create stress in these very densely populated areas, seem to be a major problem, worse than the supply of coal and oil.

And then there is the question of what to employ people with in the future, when the production process will be wholly automated — the problem of leisure or spare time. We have machines, we need them and we must accept them, but we should organize machines, buildings, roads and landscape according to the true needs of human beings. We should build in beauty, we should create new beauty. Beauty is not merely something which we have inherited and are about to destroy. We must teach architects and authorities to pay for having beauty built in. Let us work positively to create a new world in a fashion which we can stand as human beings, and not only freeze an inherited world.

Carl-Axel Moberg:

We who have had the opportunity to attend both of the two symposia organized by the Royal Society of Arts and Sciences of Göteborg have every reason to feel very much privileged. The relationship between the arts and sciences has varied a great deal over the centuries. Nowadays we feel the difference between the two much more strongly than we used to — possibly owing to the influence of C. P. Snow. But here we have been privileged to be able to assist in the merger of the two symposia — one on 'The Condition of Man' and one on 'The Feeling for Nature and the Landscape of Man'. It is true that the symposium on 'The Condition of Man' contained more natural science — there was more discussion of the forces working on man from outside. This symposium, on the other hand, dealt more with the inside, with questions of values. The scope of the first symposium could be said to be wider, but if you change the perspective it is just the other way round.

While listening to the two symposia one was able to make some interesting observations. Both within each of the symposia and between them, the same phenomenon was noticeable: how a spark could suddenly spring from one lecturer to another in a most unexpected way. We noticed this today when we heard old Humboldt mentioned

first by a Soviet poet and then by a Professor of Geography from Sweden. We could see it when Mr. Sjöstrand was telling us about the central experience in his poetry: suddenly there was something about geometrodynamics, about waves breaking in curling crests and cusps and the mathematical properties of that — excatly the field of the first speaker in the first symposium, René Thom. Exactly the same words by T. S. Eliot were quoted in both symposia. During this symposium, which might have been expected to be one of the more traditionally arts-oriented ones, words like 'energy' and 'ecology' have been remarkably frequent — in fact almost as frequent as during the first symposium. And in this final discussion our chairman defined our central theme as the question of directions for the future, just as in the first symposium.

I have a feeling that this symposium on 'The Feeling for Nature and the Landscape of Man' has turned into a symposium on 'The Knowledge of Nature and the Landscape of Man', thus being brought quite close to the first one.

My point is that the role of science in its broadest sense, 'vetenskap', 'Wissenschaft' and so on, for the future direction of mankind has to be *holistic*. Conventional boundaries between sciences as well as between science and the arts have to be broken in order to open up the possibility of grasping the full perspective which is needed for mapping roads towards the future.

This brings me to my last and very important point, which is that holism in this sense presupposes communication. We have difficulties of communication between ourselves (we have tried to overcome some of them during this week), and we have dangerous difficulties of communication in society today, between science in its broadest sense and political and economic society and the general public.

Erik Frykman:

There seems to me today to be a very noticeable and also very regrettable tendency to consider literature that does not deal with topical social realities as not legitimate. I think this is a tendency which must be combatted. A creative writer should naturally have the right to express himself on whatever subject and in whatever form he wants to. At the same time I think it is also extremely important that crea-

tive writers should be able and should actively want to express themselves in different media, in different forms and in different moods. Byron in his young days was quite capable of writing rather silly romantic poems, but at the same time he was also capable, in the House of Lords, of defending the workers who smashed machinery in despair. Wordsworth, whom Keats called the egotistical sublime, rather surprisingly was also among the first people really to feel responsible for the evil effects of the Industrial Revolution in England, to see the break-up of families and the break-down of human health. Matthew Arnold, who was much in favour of a quiet, secluded life, disciplined himself into analyzing the superficiality of laissez-faire liberalism and of the superficial belief in progress. Ruskin and William Morris, whose real love was probably for the beauty of medieval art, came to take very active parts in the debates of their day. All these writers managed in different ways to shame their contemporaries into an awareness of what was wrong in England at the time.

To my mind Mr. Soloukhin's contribution this morning was very impressive in the way that he managed to combine very traditional regard or love for nature with a very obvious sense of social conscience. And for all that Mr. Adams says about the limited aim of his own first novel, I think he too is an example, as is also of course Mr. Blythe, of somebody who shows a keen sense of social conscience. Writers nowadays, through many media, have a chance to express such feelings, and I think it is very important that they should do so.

Lars Gyllensten:

As Professor Moberg has already hinted, there was a lot of fuss some years ago about 'the two cultures'. I am not quite sure that the problem was not overstressed by Lord Snow. As far as I can see, there is a growing feeling among natural scientists of the need for a close scrutiny of what they are actually doing. They seem to experience a lack of confidence in their own programmes and methods, and a great number of transdisciplinary symposia like this one are being held all over the Western world. Scientists are anxious to supplement their own perspectives with viewpoints from the humanities, including arts and letters, and they are eager to analyze the ethical presumptions in their work and in their policies. This is not a question which can

be solved by the natural scientists themselves — they also feel the necessity of discussing what science is and what science ought to be with the rest of society. Perhaps we are approaching a new kind of renaissance, a fusion of humanistic aspects with values from the natural sciences, including technology and medicine. This is an optimistic view, but maybe in this way a new culture may emerge, a new integration which may open up new roads for future scientific work.

Ronald Blythe:

One of the things which struck me during these days was how amazed our forefathers would have been to hear some of the things being said here. By our forefathers I don't mean people two or three hundred years ago but our grandfathers. Perhaps what has been noticeable in the postwar years is the amount of guilt in our feelings about nature and about landscape. We feel perhaps in a sense that we have deserted it, and we want it back, and so we try to live in the countryside where we believe it is, although of course it exists in the towns as well. By living in the countryside we take urbanization with us and therefore destroy what we are looking for.

We are also encapsulated from nature to a degree which our grandparents and all preceding generations never could have understood or experienced. All through the year we can live in a house which is always warm, or air-conditioned, or tolerable. We don't feel the wind or the sun coming in as people used to feel it all the time. We don't walk very much. Once upon a time people had to walk a long way every day in nature on rough paths and get wet or hot. They felt the stones under their feet. In the villages nearly everybody touched the soil. You might say they touch it now by gardening, but it is not like touching the soil when you have to touch it to live, to exist.

We use nature for recreational purposes; we go for walks; we have holidays in landscape; we are informed about landscape, perhaps as people never were before; we know a lot about it scientifically; we have marvellous reproductions of the great landscape painters. We have got all this within us as a kind of common culture; but the ordinary landscape doesn't impinge upon us, as it did upon society and men generally for centuries. Therefore we are slightly amazed by our detachment from it; and so we ge to it, sometimes through the poets, through the painters, and of course most essentially, as has

been proved here, through the scientists. But if we really want to understand landscape, we may have to be out in it more naturally in the future — otherwise it could become something we shall merely think of preserving, like certain obsolete buildings.

In connection with what I might call the Ludlow Castle idea, I would like to add that we may have to recover the idea of journeying. In the Middle Ages, if you were going to Compostella or somewhere like that in search of transcendence (because this is what it was really about), you had to go through wind and weather and experience hard labour, walking along. I think there are certain sights in this world which one should not drive up to in a bus or in a car, right to the doorstep or to the woodside or to Stonehenge. I think that at the end there should be a bit of an effort, and if you cannot make it that's too bad. To expect to get to the centres of transcendence, whether they are historic or whether they are some rare plants or some beautiful mountain, in the most convenient way, with all the things waiting for you there, is a mistake. I think there should be a bit of a struggle. This would be one way of stopping these vast hordes of people getting to them and perhaps not, when they get there, feeling what they should feel. By struggling along to get to some of these wonderful natural and historic places we may begin to recover our idea of nature, to be rained on a bit, to get our legs a bit tired, and to feel the air.

Erik Lönnroth:

I am faced with the impossible task of summing up this discussion. I quite agree with Professor Moberg that these two jubilee symposia have somehow ended up pointing in the same direction. What we learned from the first symposium on 'The Condition of Man' was two very important things. Firstly, that in the future the role of the bio-logical sciences and of the humanities will be much greater than now. The importance of physics, especially, is decreasing. Secondly, that in society the organizational power of consumers is increasing at the cost of the importance and power of the producers. This all points in one direction, I think: that the importance of being conscious of human values will be extremely great in the future. We are afraid, at least in this country, of the world spiritual — it has certain religious overtones. But I am inclined to think that that will be the way to find

a new way of living, a noble and refined art of living, for mankind. This is what we have been lacking, and we must find it again.

As for energy resources, we have lacked them before. As a medievalist I could point to occasions in several countries when woods and forests disappeared. For instance, the landscape around here lacked forests completely from the 16th century up to the time of my childhood. How did people manage? They lacked the elemental means of heating and building, and so on. Well, they did survive without losing their human dignity, and I think that is what we have to do.

Finally, I agree entirely with Professor Moberg's conception of the fusion of the two cultures. All the sciences and all the humanities are approaching each other again.

In the other symposium we had some very elucidative lectures on what we know about the intellectual life of the vertebrates, excluding man. We now know that birds and monkeys have much greater possibilities for intellectual life than we had thought. Perhaps in the future a vegetarian mankind will ask, just as Mr. Adams did, 'How *could* they do it?'

I now have to conclude this symposium, and I will do so by expressing the general wish that we shall go on keeping in touch with each other, because I think we have all felt during these days that it is important that we should join forces and try to solve problems together.

Lecturers and Chairmen

Richard Adams, Esq.; Knocksharry House, Lhergy Dhoo, Peel, Isle of Man, Great Britain

Ronald Blythe, Esq.; Bottengom's Farm, Wormingford, Colchester, Essex, Great Britain

Torsten Dahlberg, Emeritus Professor of German, University of Göteborg; Västra Lyckevägen 2, S-433 00 Partille, Sweden

Erik Frykman, Professor of English, University of Göteborg; Rangeltorpsgatan 31, S-412 69 Göteborg, Sweden

Lars Gyllensten, Professor, Member of the Swedish Academy; c/o The Swedish Academy, Börshuset, Källargränd 4, S-111 29 Stockholm, Sweden

Peter Hallberg, Professor of Literature, University of Göteborg; Iskällareliden 5 A, S-416 55 Göteborg, Sweden

Per Gustaf Hamberg, Professor of Art, University of Göteborg, †

Staffan Helmfrid, Professor of Human and Economic Geography, University of Stockholm; Björkhagsvägen 40, S-186 00 Vallentuna, Sweden

Gunnar Jacobsson, Professor of Slavic Studies, University of Göteborg; Glasmästaregatan 26, S-412 62 Göteborg, Sweden

Sten Karling, Emeritus Professor of Art, University of Stockholm; Sturegatan 52, S-114 36 Stockholm, Sweden

Jiří Kotalík, Professor, Director of the National Gallery in Prague; Národní galerie v Praze, Hradčanské náměstí 15, 119 04 Prague 012, Czechoslovakia

Erik Lönnroth, Emeritus Professor of History, University of Göteborg, Member of the Swedish Academy; N. Liden 13, S-411 18 Göteborg, Sweden

Carl-Axel Moberg, Professor of Northern and European Archaeology, University of Göteborg; Landalagången 8, S-411 30 Göteborg, Sweden

René Pomeau, Professeur à la Sorbonne; 37, avenue Lulli, F-92320 Sceaux, France

Gunnar von Proschwitz, Professor of French Language and Literature, University of Göteborg; Fjällbackagatan 5, S-416 74 Göteborg, Sweden

Rudolf Schützeichel, Professor of German Philology, Universität Münster; Potstiege 16, D-4400 Münster in Westfalen, German Federal Republic

Claude Simon, 3, Place Monge, F-75005 Paris, France

Östen Sjöstrand, Esq., Member of the Swedish Academy; c/o Tidskriften Artes, Kungl. Musikaliska Akademien, Blasieholmstorg 8, S-111 48 Stockholm, Sweden

Vladimir Soloukhin, Esq.; Krasnoarmejskaja ulica 23, floor 21, Moscow A 319, USSR

Hemming Virgin, Professor of Physiological Botany, University of Göteborg; Torild Wulffsgatan 58, S-413 19 Göteborg, Sweden

Erik Wistrand, Emeritus Professor of Latin, University of Göteborg; Övre Husargatan 25 A, S-413 14 Göteborg, Sweden

Published Nobel Symposia

39. Theory and Practice of Translation — *Edited by Lillebil Grähs, Gustaf Korlén and Bertil Malmberg*
40. Biochemistry of Silicon and Related Problems — *Edited by Gerd Bendz and Ingvar Lindqvist*
42. Central Regulation of the Endocrine System — *Edited by Kjell Fuxe, Tomas Hökfelt and Rolf Luft*
44. Ethics for Science Policy — *Edited by Torgny Segerstedt*
45. The Feeling for Nature and the Landscape of Man — *Edited by Paul Hallberg*

Symposia 1—17 and 20—22 were published by Almqvist & Wiksell, Stockholm and John Wiley & Sons, New York; Symposia 23—25 by Nobel Foundation, Stockholm and Academic Press, New York; Symposium 26 by the Norwegian Nobel Institute, Universitetsforlaget, Oslo; Symposium 27 by Nobel Foundation, Stockholm and Almqvist & Wiksell International, Stockholm; Symposium 28 by Academic Press, New York; Symposium 29 by Nobel Foundation, Stockholm and Trycksaksservice AB, Stockholm; Symposia 30, 31, 33 and 36 by Plenum Press, New York; Symposium 32 by the University of Stockholm; Symposium 37 by Raven Press, New York; Proceedings from Symposium 38 published in *Ambio,* a bimonthly international journal published by the Royal Academy of Sciences, Stockholm; Symposium 39 by Peter Lang Verlag, Bern; Symposium 40 and 42 by Plenum Press, New York; Symposium 44 for The Royal Swedish Academy of Sciences by Pergamon Press, Oxford; Symposium 45 by the Royal Society of Arts and Sciences, Göteborg.